Wolf Kahn

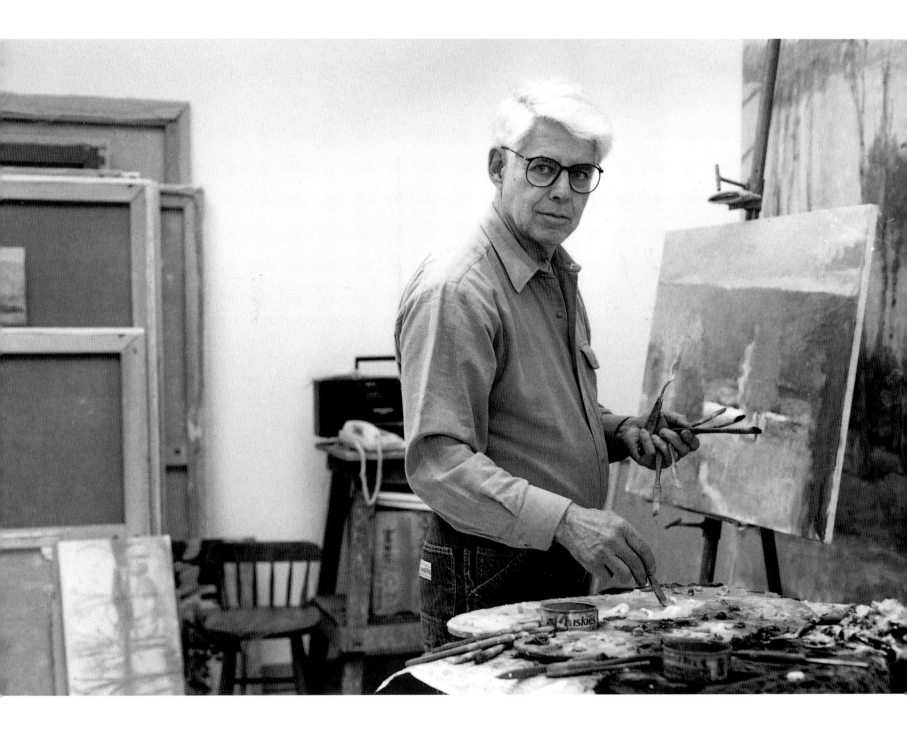

Wolf Kahn

By Justin Spring

With an essay by
Louis Finkelstein

Harry N. Abrams, Inc., Publishers

Editor: Elaine M. Stainton
Designer: Dirk Luykx

Frontispiece: Wolf Kahn in his studio, 1995. Photo: Phong Bui

Library of Congress Cataloging-in-Publication Data
Spring, Justin.
 Wolf Kahn / by Justin Spring ; with an essay by Louis Finkelstein.
 p. cm.
 Includes index.
 ISBN 0–8109–6322–1 (clothbound)
 1. Kahn, Wolf, 1927– . 2. Artists—United States—Biography.
3. Kahn, Wolf, 1927– —Criticism and interpretation.
I. Finkelstein, Louis. II. Title.
N6537.K229S67 1996
759.13—dc20
[B] 96–4309

759.13
KAHN

Published in 1996 by Harry N. Abrams, Incorporated, New York
A Times Mirror Company
Printed and bound in Japan

CONTENTS

Introduction 7

Acknowledgments 8

Wolf Kahn and His Art 9

The Development of Wolf Kahn's
Painting Language 99

BY LOUIS FINKELSTEIN

Index 161

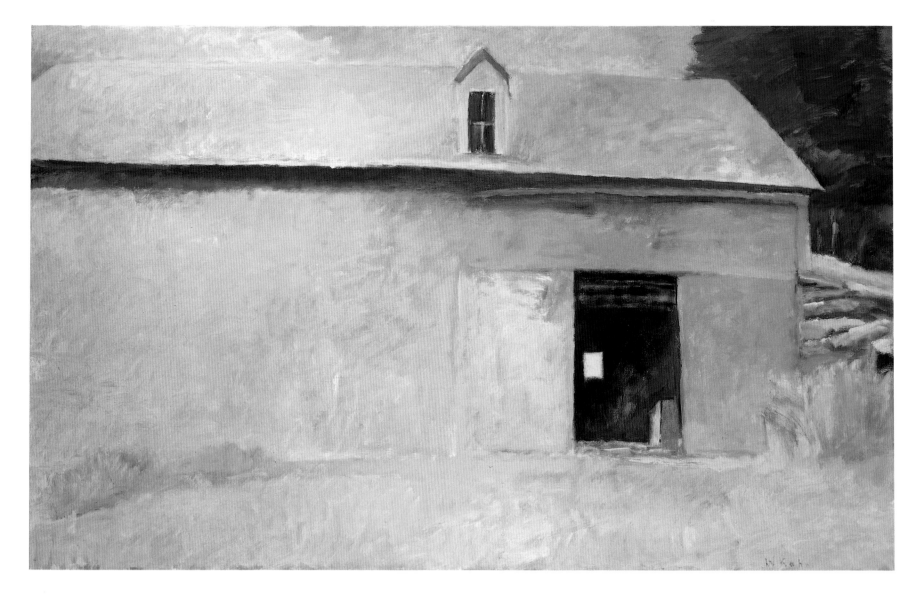

Pl. 30
The Yellow Square
1981. Oil on canvas, 44 x 72″
Collection of the Artist
Photo: Peter Muscato

Introduction

Writing about any artist, living or dead, is a challenge; but when that artist is not only very much alive, but an accomplished, articulate author in his own right, the challenge becomes nearly overwhelming. All the same I have accepted this challenge with pleasure, for I not only admire Wolf Kahn's work, but take great pleasure in knowing the man. Kahn is an alert, sensitive, and insightful individual, terrifically self-conscious and utterly dedicated to his work. And he is clear and direct in his thinking, afraid neither of expressing a strong opinion nor of receiving one in return.

In addition to granting me full access to his archives, Kahn has enriched this project by inviting me to interview him at length, both in his New York studio and at his farm in West Brattleboro, Vermont. During this time we have discussed the development of his art in the context of his life, and I have been given a privileged, first-hand glimpse of the artist both at home and in the studio. If I have lost some critical distance as a result of this intimacy (I don't think I have), my project, at least, has benefitted from it—for surely in writing about landscape painting, one ought to have at least an acquaintance with the landscape in question.

While the difference in our ages is significant, Kahn and I share a good deal of life-experience. My familiarity with many of the places Kahn has lived and painted through the years—Martha's Vineyard, Maine, Vermont (and, to a lesser extent, Venice, Tuscany and Umbria)—have made the task of describing their landscapes (and comprehending Kahn's representations of them) somewhat less difficult. Growing up in New York City in an Upper West Side intellectual and artistic environment, I have been close enough to Kahn's world to have an intuitive sense of the one in which he grew up, and my involvement with the New York art scene for the past ten years has assisted my understanding of the challenges Kahn has faced in shaping a career. Finally, my acquaintance with the issues and personalities of Kahn's era follow from the research I have conducted for a forthcoming critical biography of the artist and critic Fairfield Porter, who was not only an contemporary of Kahn's, but a supporter of his work.

What follows is decidedly not a critical biography—the writing of which would be a much larger undertaking, requiring greater distance from my subject—but rather a chronicle of the artist's life which draws as much as possible on primary documents and the artist's own formidable memory. I have kept my speculative opinions to a minimum and tried, whenever possible, to act as a conduit rather than an authority, hoping to capture Kahn's development by recreating as fully as possible the dialogue which surrounded him as he worked, while simultaneously tracing the development of the work through the course of the life. I hope that, by describing life along with work, I will give the reader some insights which, without benefit of biographical fact, might otherwise escape notice. By following the critical dialogue which concerned the work, I have attempted to demonstrate the extent to which Kahn was understood and appreciated by his contemporaries.

Finally, I hope to relate the story of an artistic success which seems to me both happy and admirable. Biography is, as the saying goes, the handmaiden of history; but for those who, like Wolf Kahn, read art history "primarily as inspirational literature,"[1] this monograph may prove not only a supplementary tool for understanding, but a pleasure in itself. It certainly has been a pleasure to write, for Wolf Kahn's life, despite its monumental early tragedies, has been a peripatetic and ultimately joyful one, which reads, despite the many years' hard work of which it is comprised, like a modern-day adventure story.

Justin Spring
August 1995

Acknowledgments

The author would like to thank the following people for their help in the research, writing, and realization of the book: Ellen Russotto, Kahn's tireless archivist; Martica Sawin, author of *Wolf Kahn: Landscape Painter*, whose earlier research was a valuable source of information; Jonathan T. Gregg, of the Vermont Studio Center, who first urged Kahn to document his life's work; Margaret L. Kaplan, Senior Vice President and Executive Editor at Harry N. Abrams, who fostered the book at Abrams from the beginning; Elaine Stainton, Senior Editor, whose attention to the project has been extraordinarily sympathetic and thorough; Dirk Luykx, Executive Art Director, who designed the book; and Emily Mason, whose memory proved on many occasions to be more formidable than that of her husband. Last but not least, I would like to give special thanks to Hannelore Roston, whose kind hopitality at her Vermont farm home made the summer-long composition of this monograph an unexpectedly delightful experience.

Wolf Kahn and His Art

Hans Wolfgang Kahn was born on October 4, 1927 in Stuttgart, Germany. He was the fourth (and last) child of Nellie (née Budge) and Emil Kahn, a comfortably well-off Jewish couple originally from Frankfurt. At the time of Wolf's birth, his father, as conductor of both the Stuttgart Philharmonic and the South German Radio orchestras, was a prominent figure in the music world.

Emil and Nellie Kahn had known each other since childhood. Nellie, a beautiful and a privileged young woman of sudden passions and supposedly psychic powers, found in Emil Kahn a man of similar background and interests. He, too came from a well-to-do Jewish family, and took a keen interest in the arts.

Nellie's parents, Siegfried and Ella Budge, were cultivated people who collected Chinese bronzes and porcelains, art nouveau, and some contemporary art, including a Picasso. Siegfried Budge, a professor of economics at the University of Frankfurt, was professionally accomplished; his three-volume work, *The Theory of Money*, was considered an important contribution to international economic theory.

Emil Kahn's father Bernhard was a banker; he and his wife Anna also collected art. Their collection included works by Thoma, Spitzweg, Trübner, Winterhalter, Hodler, and Segantini, and a number of paintings by Bernhard's brother, Max, an academic artist and portraitist who had exhibited in the Paris Salon. Interest in the arts was strong enough in both families for young Wolf to consider his own involvement in art entirely normal, and in fact part of a family tradition.

The Kahn family owned a commercial bank in Frankfurt, Kahn & Company, which had been founded by Bernhard's grandfather. Bernhard Kahn was a leading citizen of Frankfurt, a well known public figure active in civic affairs, who had organized an air show and a rowing regatta on the Main river. Something of his love of showmanship would be passed down not only to his son Emil, the conductor, but also to his artist grandson, Wolf.

Shortly after Wolf Kahn's birth, his mother, always eccentric and somewhat unstable, left her family to live with her instructor in Anthroposophy, the spiritual and intellectual movement founded by Rudolf Steiner. Shortly thereafter, she moved with the instructor to Berlin, where she suffered a nervous breakdown. Four years later, in 1932, she died in a sanatorium. Sadly, Wolf did not learn of her death for more than a decade afterward; to this day, he does not know where she is buried.

Emil Kahn soon married a second time. His new wife was a young singer, Ellen Beck, who had little interest in caring for an infant, and thus, when Wolf was three, his father decided to send the boy to live with his grandmother, Anna Kahn, in Frankfurt. What may at first appear to have been a heartless act was, in fact, just the opposite. In Frankfurt, Wolf, though separated from his brothers and sister, enjoyed the attention not only of a doting grandmother, but her maid, Kätchen, and an English governess, Ethel "Mim" Wilkins. His equally devoted maternal grand-

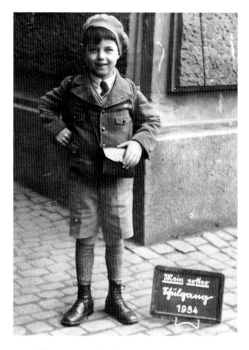

Fig. 1. "My first day at school" (*Mein erster Schulgang*), Frankfurt-am-Main, Germany, 1934

parents, Siegfried and Ella Budge, lived close by, as did Anna Kahn's very elegant daughter, Ida. And so, like a child in a fairy tale, Kahn, after being banished from home by a disapproving stepmother, entered a world of exceptionally loving foster-parents.

Kahn's first memories of the natural world date from this time. *Grossmutter* Anna took him out frequently for walks in the botanical garden, where he gathered nasturtium seeds with her, and he remembers being urged into the flower beds to fetch huge, perfect dahlias that had been knocked down by rain, which would later appear as centerpieces for *Grossmutter*'s bridge club. He was also given a garden plot of his own in Anna's back yard.

This bright, if solitary, childhood of almost Nabokovian richness lasted for nearly a decade. Though Kahn & Co. failed in 1932—caught short by the German depression—*Grossmutter* Anna retained a private fortune, and in her large, old-fashioned apartment on Palmengarten Platz, Wolf had plenty of room to grow. Amid the heavy Edwardian furniture there were paintings to look at and books to read, and few diversions, particularly as the 1930s progressed and political circumstances prevented Wolf from leaving the house unsupervised.

Indoors, he was mightily indulged. On the desk in his bedroom his grand-mother set a bronze of Schiller and Goethe standing arm in arm; in deference to Wolf's love of military pageantry, she allowed him to hang British and American flags upon the wall. Not to be outdone, his *Tante* Ida and his Budge grandparents provided him with anything a boy could want, including books, toy soldiers, a stamp collection, a bicycle, and an erector set.

With the devotion of his grandmother and her friends, Kahn was shielded from much of the anti-Semitism that was sweeping Germany throughout his childhood. But while his understanding of what was going on was limited, disturbing memories lingered with him in the years that followed. He clearly remembers seeing demonstrators shot down in the street in front of his grandmother's house during the anti-Nazi riots of 1932, and later, he remembers crying as he watched a visit by Hitler to Frankfurt in 1937, upset because he could not be part of the parade.

During the 1930s, Jews were increasingly segregated from the general population, and were often the victims of assault. One holiday afternoon, Kahn was knocked from his bicycle and beaten by a group of adults who knew he was Jewish because he was not wearing a Hitler Youth uniform. At school, Jewish children were at first placed in separate classes, and later made to attend their own schools. Thus began a pattern of moving from one school to another, which would persist through Kahn's graduation from high school in 1945.

Kahn's family encouraged his early interest in art, although as a boy he was no aesthete, generally using his artistic talents to make people laugh. When not drawing caricatures, he preferred military or athletic subjects. One example of these, of about 1938, is *Sioux Indian Group with Chief* (*Sioux Indianergruppe Mit Häuptling*; Fig. 2), in which Kahn imagined a formidable group of warriors—some sporting goatees and jackboots as well as war bonnets—in front of their teepees on the American Great Plains.

During the summer of 1938, Kahn had to forgo a hiking holiday because of a Nazi decree forbidding Jewish children to leave the city on vacation. His grandmother hired a young artist, Fräulein von Joeden (who painted "somewhat in the manner of Cézanne"[2]), to give the boy private art lessons. Every day he made a draw-

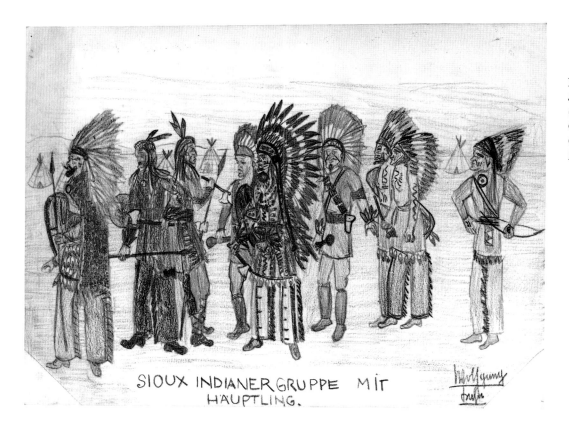

SIOUX INDIANER GRUPPE MIT HÄUPTLING.

Fig. 2. Wolf Kahn (aged about 10), *Sioux Indianergruppe mit Häuptling* (Sioux Indian Group with Chief). Ca. 1938. Crayon on paper, 8½ x 11″. Collection of the artist. Photo: Peter Muscato

ing of the Napoleonic Wars, inspired by the extraordinary illustrations by Menzel for a history of Frederick the Great. At the end of the summer the drawings were bound together in a book that he presented to his grandmother.

In 1937, Wolf's father, stepmother, and his brothers and sister had left Germany for the United States. Emil Kahn had lost his appointment to the Stuttgart Philharmonic Orchestra when Hitler came to power in 1933, and since then had been unable to find steady work. With finances so uncertain, he thought it best that his youngest son remain in Frankfurt; no one sensed at that point that the boy might be in mortal danger if he were left behind.

Emil's sister, Wolf's *Tante* Ida, had meanwhile managed to establish a home in England, where her son, Eric, was attending Cambridge University. Unfortunately, by 1939, when Anna Kahn realized how dangerous it was to remain in Germany, most possibilities for escape were closed. When she and Wolf were added to the waiting list for emigration to the United States, there were approximately 60,000 names ahead of theirs. At that time the immigration quotas for the United States would admit only 10,000 refugees a year.

Just before war broke out, the British Government responded to the Jewish refugee crisis by allowing 5,000 refugee children to enter the country under the auspices of the Joint Distribution Committee. *Tante* Ida and her son Eric were not permitted to take Wolf in, since only English families could shelter refugee children, but a well-known don in Eric's college at Cambridge agreed to sponsor him. At the beginning of the summer of 1939, therefore, Wolf kissed his grandmother goodbye, and with a numbered tag around his neck departed with a trainload of Jewish children for the Hook of Holland, where he was transferred to a ship sailing for England.

Wolf never returned to Germany, nor saw his grandparents again; letters from Anna Kahn continued to arrive at his father's home in New Jersey until sometime in 1942, when they ceased. By then, the Budges had been sent to the Theresienstadt concentration camp, where Anna Kahn also was sent sometime later. No record exists of how or when Kahn's three grandparents died. The only objects to survive

either household were Wolf's drawings, which were gathered up after Anna's arrest by her maid, Kätchen. They reached his father by mail at the end of the war.

By the spring of 1939, Wolf Kahn was a precocious 11-year-old. Bilingual and talented both artistically and academically, he had enjoyed nearly a decade of devoted family attention, as a result of which he had been "able to keep infantile megalomania going for a lot longer than most people."[3] The life that awaited him in England was traumatically different.

Kahn's host family, the Wades, expected to take a confused, needy waif into their home; what they got instead was a robust, self-assured pre-adolescent, whose coming in July of 1939 had been heralded earlier by the arrival of a well-packed steamer trunk, a bicycle, and a stamp collection, and who introduced himself by "making cheeky remarks in perfect English."[4]

Wade, a professor at St. John's College, Cambridge, detested the boy's cocky manner, and was outraged by the fraud he thought had been perpetrated upon him. He informed the new arrival that the only possible way he would be allowed to remain in the house would be as a servant. Kahn spent the next three months doing chores in the house and garden. He was punished often, and on one occasion, as he was working in the vegetable garden, Wade struck him with a rake.

By the end of summer, the situation had become so impossible that the boy was placed in the household of a schoolteacher in the nearby town of Histon. To Kahn's relief, the Purvis family were as kind as the Wades had been cruel. He stayed with the Purvises from September, 1939 to April, 1940, attending the Cambridge and County High School, where by second term he was the number one boy in the class. A report card features the comment by his rugby coach that he was "a keen forward who does not always abide by the rules."[5] The comment well described Kahn then and for some time after: an enthusiastic participant in his new life, who, as an outsider, could never afford to take things for granted. Kahn was well-treated in Histon, although being the only refugee for miles, he was somewhat lonely; but to his delight, on the weekends he was allowed to take the bus into Cambridge to visit his cousin Eric.

When, in 1940, the U.S. quota laws were changed slightly to allow families to be reunited, Kahn sailed for America on the S.S. *Volendam*, of the Holland-America line. He was in the care of the first mate, who thrilled the boy by allowing him on the quarterdeck with a pair of binoculars to search the ocean for U-boats. As part of a convoy, the ship had to move slowly, so the journey took two weeks, during which time Holland was invaded by Germany and the *Volendam* became a stateless ship. Kahn was less aware of the catastrophe that had befallen the crew than he was of being allowed into the first-class dining room from time to time; he enjoyed his voyage thoroughly.

The life that awaited him in New York was somewhat complicated. Emil Kahn, after conducting the Havana Symphony, had traveled across the United States as a guest conductor, in his son's words "conducting every orchestra once." In Kahn's recollection, "He was too temperamental. Americans didn't know what to think of him."[6] By the time the war began, Emil Kahn had been forced to take a part-time job at Montclair State Teachers' College in New Jersey simply to retain his residency in the United States. Though in later years Kahn would share his doubts and ambitions with his father in a heartfelt correspondence, the two would never live easily together.

After leaving Europe, Emil and Ellen Kahn had divorced, and Wolf's 17-year-old sister Eva was running the house, cooking for five, and managing the groceries on twenty dollars a week. She also acted as a surrogate mother, counseling her brother on American manners, clothing, and even sex.

Kahn's life in the United States continued its unsettled course as the family sought a permanent residence. Over the next several years he attended three different schools, during which time, Kahn recalled,

> I was always drawing. Drawing was how I defined myself. Because I always had to make new friends, I used my ability for drawing to gain social success. I did caricatures—I was very good. . . . I could draw Churchill, Roosevelt, and Hitler. David Low was my hero, but I knew all the famous old cartoonists. Thomas Nast was a favorite.[7]

In 1942, the Kahns moved to an apartment at 102nd Street and Riverside Drive on the Upper West Side of Manhattan. Kahn was accepted for his sophomore year at the High School of Music and Art, a New York City public school for artistically talented young people. It was his fifteenth transfer. As he would later recall,

> Music and Art was like any other school, except that you had three hours of drawing and painting every day as well as your other subjects. Of course coming from Germany I didn't have to do any academic work—everything here was so easy compared to what I'd done overseas. In my three years I barely studied—just crammed the night before the exam—and even so I had the highest academic average in the history of the school. I got perfect marks on the Regents exam, too. With time to do what I liked, I was able to be the art editor of the school newspaper, the *Overtone*.[8]

Eight years later, at the time of his first one-man exhibition, the same school newspaper would report,

> [A]s Graphics Editor, Wolf generally did one-third of the thirty cuts that used to appear in every issue of *Overtone*. During his last three years at M&A, he had a commercial art job after school at 25 cents an hour. Superior academically, "I always sat in the back of the room during the easier subjects and drew all period," he admitted.[9]

The commercial art job had been passed along to him by his brother Peter, also an artist, who had been drafted into the U.S. Army. After school, Kahn would take the Broadway subway from high school in Harlem down to lower Manhattan, where he worked at the Louis Hahn Studio doing "spots and illustrations," which eventually appeared in the house organ of the National City Bank. Commercial art held little appeal, for Kahn's ambition at the time was to be a political cartoonist; but work for the Hahn studio was valuable to him because "that 25 cents an hour gave me more pocket money than anyone I knew."[10]

In his free time, if not playing handball or lifting weights with a group of friends that included Allan Kaprow, Kahn went sketching:

> I used to take the 125th Street ferry to the other side of the Hudson . . . to

Fig. 3. Wolf Kahn, *Rhino (at the American Museum of Natural History)*. 1944. Graphite pencil on paper, 12 x 10″. Collection of the artist. Photo: Peter Muscato

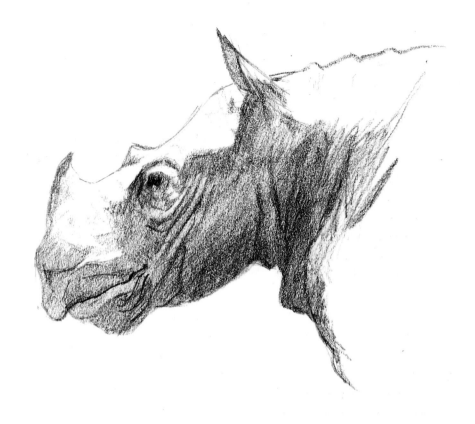

Fig. 3. Wolf Kahn, *Rhino (at the American Museum of Natural History)*. 1944. Graphite pencil on paper, 12 x 10″. Collection of the artist. Photo: Peter Muscato

Fig. 4. Wolf Kahn in the autumn of 1945, while at the Great Lakes Naval Training Center

paint just regular picturesque-type stuff. We'd go on Saturday, a bunch of kids. . . . The Jacob Riis park had houses that were built on stilts in the marshes. This was New York, then. We'd go out there and to the boatyards on Staten Island, just regular stuff.[11]

One of his sketches from this period is *Rhino (at the Museum of Natural History)* (1944; Fig. 3), which shows both Kahn's ability to render three-dimensional form and his interest in character; the creature's gentle eyes and quizzical smile are unexpectedly charming.

In June of 1945, directly following high school graduation, Kahn entered the Navy radio technician's school. His perfect score on the G.E.T. (General Education Test) had the unfortunate result that "every time I got something wrong on a test after that, I was hauled up to Captain's Mast and called a slacker."[12]

Kahn, who was moved often from base to base but never saw action overseas, continued to draw and paint throughout his uneventful year in the Navy. His talents were noted to the extent that he was commissioned to paint the portraits of his commanding officers; in his free time he made sketches of the other recruits, such as *A Navy Buddy* (1946; Fig. 5). He left the Navy in July, 1946, working as a waiter and water-ski instructor at Lake George, New York before returning that fall to Manhattan to resume his education.

At first the recently discharged naval recruit thought he would use his GI Bill benefits to earn a liberal arts degree.

When I got back to New York I wanted to go to Columbia even though it had no fine arts program. But as it happened I was too late to apply. So I enrolled instead at the New School to study painting with Stuart Davis and print-making with Hans Jelinek. I got fed up with them almost immediately. Davis in particular was a terrible teacher. By March I'd heard about Hofmann's school from my brother Peter, who was already there. So I enrolled. It wasn't a hard decision. By that time I knew that Hofmann was the only game in town.[13]

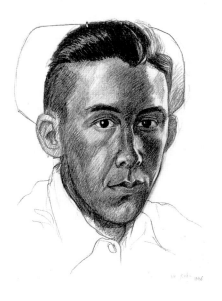

Fig. 5. Wolf Kahn, *A Navy Buddy.* 1946. Conté crayon on paper, 14 x 11". Collection of the artist. Photo: Susan Wells, 1985

When he entered the Hans Hofmann School of Fine Arts, Kahn was young, ambitious, and self-asssured, an excellent student who had been praised since childhood for his ability. He arrived at Hofmann's doorstep perhaps a little too ready for the recognition he presumed would be his due.

As Kahn would later recall, "I was . . . one of those awful students who took everything the teacher said literally. I was nineteen years old . . . looking for certitudes."[14] But as Kahn quickly learned, Hofmann's teaching method was hardly reassuring:

> Leaving aside Hofmann's broad Bavarian accent and his cavalier mode of inventing words or changing their meaning, one never knew exactly what his feelings were regarding art terminology. Certain terms were used with careless disregard as to meaning. The word "expressionist" could be used as a term of opprobrium one day and of praise the next. . . . Thinking back on the Hofmann school, I am convinced that part of Hofmann's success as a teacher can be ascribed to his uncanny ability to make his students anxious. The mystery was always temptingly placed within reach—if only we knew how to stretch. He would say to us, "Years later you will understand what I tell you today, after you have discovered it in your own work."[15]

Until the passage of the GI Bill, Hofmann had been forced by financial necessity to accept just about anybody who wanted to enroll. "Hofmann was teaching on a very high level of insight, but the students were a very mixed bag."[16] By the end of the first class, however, Kahn had little doubt of Hofmann's genius. Since leaving Munich in 1932, where he had taught art since 1915, Hofmann had taught a number of New York artists, including Robert De Niro, Burgoyne Diller, Carl Holty, Harry Holtzman, Alfred Jensen, Lee Krasner, Louise Nevelson, Irene Rice-Pereira, and Ludwig Sander. Arshile Gorky, Clement Greenberg, Willem de Kooning, Jackson Pollock, and Harold Rosenberg regularly attended his Friday critiques. Kahn found himself in class with a very talented group of younger artists including Nell Blaine, Jane Freilicher, Allan Kaprow, Jan Muller, and Larry Rivers.

Hofmann's involvement in the development of so many diverse talents has interested art historians through the years; Kahn has spoken and written about Hofmann's teaching on several occasions, describing "the Hofmann Experience" and demonstrating his own devotion to the memory of this exceptional teacher. Writing for *Art In America*, Kahn recalled,

> The emergence of diversity out of uniformity, like many paradoxes, is not easily explained. Part of the shift is implied in the very substance of Hofmann's teaching, in Hofmann's contradictory message. Some of it derives from the

example of Hofmann's personality. He provided a center and a structure for the school, which generated a unique kind of esprit de corps among the students, who learned to feel a salutary sense of "us against them"—"them" being the established art world of the historical moment when all these esthetic developments took place.

The core of Hofmann's teaching was composed of ideas which, while well known in Paris, were news to a young American art student—and good news. The good news was that art was a high calling reaching beyond the pale documentary critique of American regionalism or the polite semiabstraction which was the current approximation of modernism then being celebrated at the Whitney Annuals. We who studied with Hofmann felt ourselves to be the bearers of a more profound message, one better suited to give content and weight to the calling of "artist." We felt we were learning the essence of modernism, art stripped of everything extraneous. What remained was its esthetic/philosophical foundation, its raison d'etre.

Hofmann's teaching could be divided into two parts, an art-historical message and a practical one. Central to the art-historical analysis was the idea of mainstream art, a straight unbroken line from Cimabue to the Abstract Expressionists. . . . The practical side of Hofmann's teaching was directed toward the attainment of the "perfect painting." Tying these two strands together was a strategy for progressing as an artist. You progressed by studying crucial works of mainstream art so as to gain a stronger and eventually personal command of . . . the formal issues. . . .

By focusing his critique almost exclusively on formal values, Hofmann was able to devise a language and a set of procedures which enabled his students to see what was really going on in their pictures. . . . It was the student's job to respond to these emerging potentialities . . . the teacher, having a wider knowledge of available possibilities, could provide a sorely needed "extra pair of eyes."

Although there was always a colorful still life setup or two to work from, most of the day-to-day activity at the school centered around drawing from the nude model. Here Hofmann's instructions were explicit. We were told to draw not merely the model but "the space." "Form exists through space and space through form."

Those of us who liked to use nature as a jumping-off point Hofmann trained to look at landscape analytically, to see the space as a whole. We tended to think that a tree was relevant only if it defined the edge of a plane, and the sky only insofar as it was a volume and exerted weight.

The best known of Hofmann's didactic formulations is the theory of "push and pull." The space of a picture, so this theory goes, has to be a coherent volume, equally penetrable in all its parts. The thrust of a form into deep space must be reciprocated by a countermovement out of deep space back to the picture plane. It is important that these thrusts, which *in toto* define the volume of the picture, must never become one way, else the eye would remain "stuck" in one area, rather than able to move freely throughout all parts of the picture. In painting practice this dictate means that any area, while pushing into space, must also be pulled back in relation to some other area. Each part of the picture pushes at the same time as it pulls, carrying out an essential double duty.

Twice a week Hofmann came into the school, put on his smock and proceeded on his rounds. Most of the students would suspend their own work

to hear what he had to say. Hofmann would ask to occupy the exact location from which the student was working and, taking in hand a piece of charcoal and a chamois, would make his points directly on the student's drawing. Sometimes he really got into it—a drawing would undergo a storm of corrections, each one carefully explained; the result of such a session was a complete Hofmann drawing.

Hofmann's physical energy in these exercises was impressive: the charcoal would explode, the chamois would be used in wide swaths over the whole of the sheet to indicate large dynamics. To explain his point about the necessity for a "shift" of the planes, Hofmann often asked a student's permission to tear up the drawing into six or eight parts which he would reassemble with tape or thumbtacks, justifying each move by referring to what was going on "outside"—as he called the natural element upon which the picture was based. "You must learn to see the space" was Hofmann's admonition to beginners, who would peer hopefully at the model, expecting sudden illumination, which usually remained elusive.

Hofmann encouraged us to "struggle"—his favorite exhortation. "Struggle" seemed to be the worthiest activity at the Hofmann school. Students would submit a piece of defenseless charcoal paper to such a barrage of changes over the five-day length of a model's pose that at the end all that was left was a limp gray rag with holes in it, upon which Hofmann might gaze sympathetically, nodding yes, it was important to struggle. . . . the end product . . . was valuable only as the accumulated history of a process, as a sign of energetic action and reaction. (Before Harold Rosenberg invented the term, Hofmann encouraged his students to become "action painters.")

If Hofmann saw something to admire in a student's work, he said so and gave reasons. He fostered the careful attention with which we regarded each others' work. Over a period of time there emerged among the students a cast of characters, each of whom embodied a set of problems. We became adept at predicting what Hofmann would say about each picture. When Hofmann admired the progress of the student, the admiration became general. If on the other hand, he seemed to be bearing down too heavily on someone, a fellow student might venture to disagree, if only to give the afflicted colleague a sense of community support. Hofmann, a great expert at dealing with such encounters, would most likely turn aside the possibility of confrontation with a good-natured evasion.

If a student worked in a purely descriptive or illustrational mode (Hofmann included most Surrealism, and, interestingly, German Expressionism in this category), Hofmann would simply tell that student that he or she was going in the wrong direction.

Certainly Hofmann was aware (as were all the better students) of the constant danger that his pedagogical concepts could, if applied in too orthodox a fashion, give rise to an academy. Running counter to his fully formulated concepts was a discourse regarding the need for spontaneity, the value of automatism, and the impossibility of intellectual control of the artistic enterprise . . . In his own work Hofmann had never worried about being derivative. He cared that his students, rather than assimilating the look of any particular well-known work, would grapple with the formal concepts which organized its content—which, in Hofmann's view, *were* its principal content. "Anyway," he often said, "the first 500 paintings you will have to throw away."[17]

In those first few months, Kahn began to sense the excitement of the work that lay ahead. In Hofmann he had an inspiring role model: a rigorous intellectual who was at the same time comfortable with paradox; a man who cared passionately about art history, but was not reactionary in his tastes; and a teacher whose formulations presented a "specific, practical, unsentimental discourse [which went] beyond strategies for making pictures."[18] Perhaps most important, Kahn saw Hofmann as a dedicated purist for whom the artistic vocation was an unapologetically heroic undertaking. Best of all, Kahn recalls, "he claimed for his ideas a kind of universality which I found congenial to my own need for absolutes."[19] For the first time in his life, Kahn was in the presence of someone for whom contemporary art was not a subject of skepticism or ridicule, but a matter of certainty: a sacred calling, a crusade.

With full GI benefits, Kahn chose not to return home to his father, but rather to begin his adult life as an artist with a tenement studio in the East Village. Moving to Avenue B and Sixth Street, he soon established what would be a long friendship with his next-door neighbor, the painter Lester Johnson, who, being a decade older and farther along in his career, impressed Wolf deeply. Johnson's influence can be seen in the colors of *Still Life in the Style of Braque* (1947–48; Pl. 1), an experimental effort, consciously derivative, which Hofmann praised highly.

Braque, though not a primary influence on Kahn's later work, was always a great favorite of both Hofmann's and Kahn's, Braque being, in Kahn's words, "the first artist I felt I understood completely."[20] While the heavy colors and thick paint owe a specific debt to Johnson, the practice of borrowing from other painters—of seeing all painting as an impersonal activity, the participation in an ongoing discourse—was a staple of Hofmann's philosophy.

The pictured arrangement—a saucepan, a lamp, and a cloth atop a kerosene stove, and beside it, a chair—gives some sense of Kahn's austere existence in his coldwater flat; but the image itself seems coincidental. Rather, this is a work in which, true to the Hofmann ideal, colors and shapes are established in (to paraphrase Hofmann paraphrasing Mondrian) "equivalent but unequal oppositions,"[21] where, moreover, the image itself exists in both two- and three-dimensional space, and where, also, the work possesses an overall harmony, balance, and grace. As such, *Still Life in the Style of Braque* gives a good indication of the extent to which Kahn was absorbing and working through Hofmann's ideas as well as the styles of his fellow artists during this formative period of his career.

As spring of 1947 came to an end, Kahn found himself at a loss. Hofmann would be teaching in Provincetown for the summer, and many of the students planned to follow, but Kahn's GI benefits would not pay for summer school. At the same time, he sensed that Hofmann wanted him around; Kahn would often translate his teacher's expressions from German. He persuaded Hofmann to waive his tuition in exchange for work in and out of class.

Upon arriving in Provincetown, Kahn found lodgings for himself in an empty barn, but since it lacked kitchen facilities or running water, he took his meals with the Hofmanns—a lucky break, since his teacher often extended hospitality to visiting artists, critics and dealers. Kahn helped Mrs. Hofmann with errands, and in the classroom was given the title of class monitor, which meant that, in Kahn's own words, "I swept the floors, put the chairs in order, and brought out the paintings for crit sessions."[22] The last of these responsibilities was particularly important to Kahn's development, since Hofmann had privately asked Kahn to "always show the most

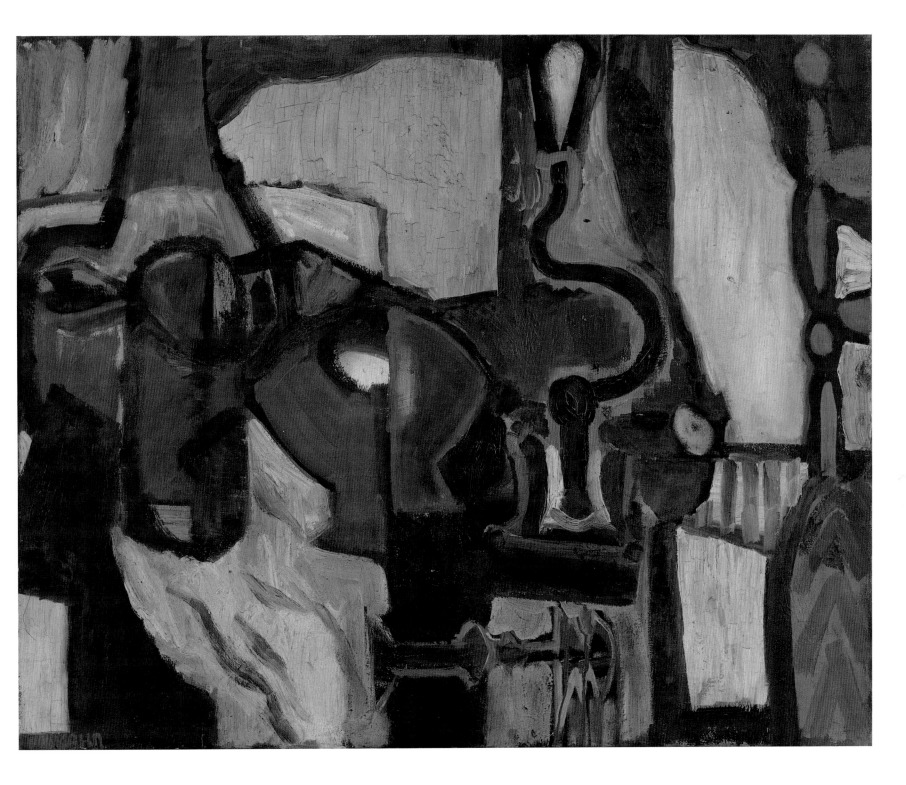

Pl. 1
Still Life in the Style of Braque
1947–48. Oil on canvas, 26 x 36″
Collection of the Artist
Photo: Peter Muscato

Wolf Kahn 19

interesting work first."[23] Kahn's awareness of his teacher's constant scrutiny helped to hone his powers of discrimination. Moreover, since Hofmann did not approve of one-on-one critiques—he felt they were a waste, since all students were working on related problems—Kahn's choice of paintings could also be noted by his fellow students, which, while constructive, left his judgment open to both direct and implied criticism by his classmates.

If any of the students resented Kahn's privileged position that summer, they never told him; for his part, Kahn felt himself a lesser member of the group on account of his youth. Besides, Hofmann actively advanced the idea of art as a self-less undertaking, a community enterprise. Competition between individuals was not encouraged. What was important was the painting, never the painter.

Hofmann, however, continued to surprise and confound Kahn with his contradictory pronouncements as well as with the nearly incomprehensible example of his own painting. Hofmann's painting in particular was a source of wonder to Kahn, who would later write,

> I had a theory I concocted at the time that seemed to explain the inelegancies and the unrelenting expressionism of Hofmann's work. (Remembering that expressionism was a dirty word in Hofmann's lexicon, designating lack of formal relations.)
>
> My theory: the stridency and lack of fluency in Hofmann's work were the direct result of Hofmann's natural expressionism at variance with his conscious desire to compose in a classical way. This always explained why he had gone farther in finding verbal equivalents for the secrets of structure than any other teacher . . . he was forced to analyze what others simply did naturally.[24]

Kahn concludes his theory with a dryly humorous aside, "I was wrong . . . but not 100% wrong." About Hofmann's utterances Kahn was equally sardonic:

> Hofmann never spoke of composition. He always said "Composition is a dirty word"—instead he used expressions like "symphonic color," "color chords" and "structural color." My father was a conductor and I had a background in music, but even so I don't think I knew what he was talking about.[25]

Kahn has since come to understand that Hofmann's obscurity was intentional—a teaching device that kept his students uncertain, and consequently, questioning, each student "perfectly entitled to misinterpret Hofmann in his or her own way."[26] At the time, though, Kahn found a state of perpetual questioning uncomfortable. For a young man in search of certitudes, it was a time of intellectual "growing pains."

Outside the studio Kahn consoled himself with the pleasures of a Provincetown summer, making a number of friends, including Larry Rivers, Jane Freilicher, Nell Blaine, and Jan Muller. Student bonhomie led to informal cook-outs, trips to the beach, and an occasional wild party. So far as day-to-day life was concerned, Kahn found this existence entirely to his liking, and a considerable improvement over both Riverside Drive and the naval barracks.

At the end of summer, Kahn returned to New York, where he remained at the Hofmann School throughout the winter, during which an important event took place:

My brother Peter [Kahn] knew the owners of Seligmann Gallery on 57th Street. They had the most wonderful paintings in their back room which we would go and see, mostly Impressionists, but a little contemporary work as well. Peter got them interested in the Hofmann students, and they did a show curated by Greenberg called "New Provincetown '47" with work by Larry Rivers, Jane Freilicher, Paul Georges, and me, among others. Greenberg then wrote it up in the *Nation*, saying he thought it was amazing student work "of a higher level of sophistication than work by recognized artists showing at the Whitney."[27]

Greenberg specifically praised the show as exemplifying a kind of painterliness that he saw as superior to much established work, noting that this painterliness was the direct result of the working fluidity that all Hofmann students developed in their struggle to realize the perfect painting. Kahn exhibited a painting of a wicker armchair in the style of Bonnard. It was the first time he had exhibited in his professional career.

Through the years Kahn has acknowledged his debt to Hofmann through testimonial speeches and published articles. In a 1973 address to the College Art Association he recalled,

> The most useful idea [I gained at the Hofmann school] . . . has been . . . that there is such a thing as formal *control*, and that any influence is legitimate as it helps the artist gain it . . . accidental processes are often superior to willed ones, but still, the framework in which one works is formal intentionality.[28]

Nevertheless, within eighteen months, Kahn's time with Hofmann was drawing to a close. As summer of 1948 approached, Kahn realized he would not be able to take a second trip to Provincetown; he simply did not have the money. And increasingly he felt discouraged with his own work and intimidated by the accomplishments of his more advanced colleagues. Needing time to think things over, he spent the summer working on a friend's farm in upstate New York.

Upon his return that autumn, another of Kahn's GI benefits became available to him: twenty dollars a week for 52 weeks. He was thus able to return to the Hofmann School part-time, although he would have to work part-time, too. For a while he worked nights doing gallery repairs on 57th Street, along with Larry Rivers. He also began attending Meyer Schapiro's art history lectures at Columbia University and at The New School For Social Research—lectures that reminded Kahn that his GI benefits might well run out before he could earn his bachelor's degree. Troubled about his sense of vocation, uncertain about the future, facing a daily struggle in his studio, Kahn underwent what he later described as a *crise de confiance*. Meeting his favorite art teacher from Music and Art High School, Helen Ridgway, on the street, he described his problems to her and invited her to the studio. After a look around, Miss Ridgway, herself a former Hofmann student, remarked, "Well, at least you're having fun." Kahn later wrote:

> Fun was what I was having less of than anything else, except perhaps money, and not so long after I determined to stop this art nonsense and do something practical. I decided to go into philosophy.[29]

Later in life Kahn would realize his crisis was due simply to the speed at which he had developed. In Hofmann's class, for the first time in his life, he had been exposed to a community of individuals whose talent was equal to his own, and the experience—namely of being one artist among many—had come as a most unwelcome surprise. Though Kahn may have accepted Hofmann's idea of art as a selfless, communal enterprise, he was still a precocious and naturally competitive young man who had been conditioned from childhood to expect attention and praise. The lack of either, despite Hofmann's genial support, left him baffled and shaken. "Under these circumstances," Kahn wrote twenty-five years later,

> It seemed less and less likely to me that I would ever reach the impossibly high plateau where I believed true artists lived, and I spoke to Hofmann about quitting the school. Hofmann said I would do well to leave the school because he said I suffered from "mental indigestion."[30]

In the spring of 1949, Kahn applied to the University of Chicago's Hutchins Program, which allowed students to earn a bachelor's degree at their own speed, and was promptly accepted. That September, Kahn closed up his studio and moved to Illinois.

At the University of Chicago, Kahn spent the year reading the "great books" of Western literature. He found himself drawn to philosophy, particularly to Kant, and by passing a number of comprehensive exams, he was able to earn his bachelor's degree in a single year. Friendships with other students and encouragement from professor Ulrich Middeldorf led him to apply for a graduate fellowship in the philosophy department. Meanwhile, Kahn continued to sketch, especially views of sailboats riding at anchor on Lake Michigan. He would return to these "visions of isolation and scale"[31] nearly twenty years later while summering on Martha's Vineyard.

Van Gogh was a great influence on Kahn at this time; much about van Gogh's life as well as his work appealed to Kahn's ideal of the artist as a romantic hero, which he applied to himself, despite his sedate academic existence. In New York, Meyer Schapiro had recently published his book on van Gogh; Kahn found the book appealing both for its formal analyses and its inspirational account of the artist's life. Excitement about van Gogh was further fueled by a show of ninety-five paintings and sixty-seven drawings at the Metropolitan Museum of Art in New York. Although Kahn never saw the exhibition, talk of van Gogh was very much in the air.

After finishing the academic year Kahn did not return to New York, but instead spent the summer traveling in the West. To a young man raised in Europe and New York, the Great Plains and Rocky Mountains were a revelation. Of stopping to work the pea harvest on a Shoshone Indian reservation between Oregon and Wyoming, Kahn recalls,

> It was one of the most beautiful experiences of my life. We were in an area of little hills covered with pea vines, and we'd work four men to a threshing machine. Three would work while the fourth slept, and we worked around the clock, so we saw all the hours in the day. My job was stacking boxes on pallets I really fell in love with America during that trip.[32]

Kahn's ultimate destination that summer was Deadwood, Oregon, a small

logging town in the Coastal Range. Kahn found work in a "Gyppo Mill," a small portable camp of ten men, where, due to a labor shortage, work as a lumberjack brought in $1.60 an hour (a good wage when compared, for instance, to the $1.25 an hour he would later earn as a social worker in New York).

Kahn quickly settled down to a routine of hard physical labor, a welcome relief from a number of issues—aesthetic, philosophical, and vocational—that he had left unresolved in Chicago. By the end of summer he had made his choice. As he wrote to his father, "I can't get excited over the idea of making a scholar of myself, whereas the idea of painting has lost none of its allure." In another letter, he recounted his pleasure at creating an agreeable pastel: "I think I 'have something to say'—that is, some things around me speak strongly enough to me, certain color harmonies, aspects of landscape, other artists' work, that I would feel justified in trying once more to make an energetic attempt at becoming a painter."[33] A typical quill-pen sketch by Kahn during the period, *Oregon Apple Tree* (1950; Fig. 6) shows an involved understanding of structure, a creative use of the medium (including a highly varied use of the nib as well as of wash) and the influence of van Gogh in the repeated staccato penstrokes establishing different areas of shadow and light.

As he worked, Kahn began to realize that while he had enjoyed studying philosophy, "once I got away from it I wasn't so enthusiastic to go back."[34] When he learned that the University had granted him a full graduate fellowship and living stipend for the following year, Kahn asked that the award be postponed. But by the time he left Oregon he knew that he would use the $1500 he had saved from five months of logging to set himself up in a New York loft. Inspired by the example of van Gogh, he was once again taking up the life of an artist.

Returning to New York in the fall of 1950, Kahn stayed with his father while he looked for a loft where he could both live and paint. He found what he wanted on the top floor of a walk-up at 813 Broadway, and he soon pursuaded the artist Felix Pasilis to share the space with him. The two set to work painting, renovating, and dividing up the loft. When they had finished, in February of 1951, the place looked so impressive that rather than move in, they decided to hold an exhibition, inviting Lester Johnson, John Grillo, Miles Forst, and Jan Muller to join them. The show, which was called "813 Broadway," drew a crowd of artists and art-lovers (including Thomas Hess, the influential editor of *Art News*), for whom the three long flights of stairs were no impediment whatever.

From this first exhibition evolved the Hansa Gallery Cooperative, whose members would eventually include Jane Wilson, Allan Kaprow, Richard Stankiewicz, and in later years, John Chamberlain, Lucas Samaras, George Segal and Robert Whitman. The name Hansa was intended to suggest both the Hanseatic League, a union of trading cities in medieval Northern Europe, and Hans Hofmann, who had taught many of the artists, but was selected mostly because the name had a pleasing euphony. As Hess would later report, "[Hofmann's] students have formed at least three co-operative galleries . . . in which the artists themselves join to pay rent, fix a show-room, handle the exhibitions."[35]

Kahn supported himself by working part-time at the Manhattanville Settlement House teaching arts and crafts to children and teenagers. While working there, he began again to look carefully at the work of European painters. Bonnard, whose retrospective exhibition in 1948 had caused a sensation among Hofmann's students, was a lingering influence, and so, too, was van Gogh.

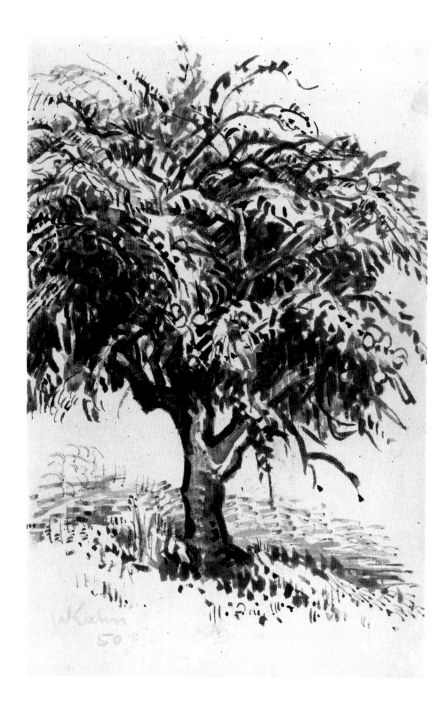

But it was Soutine (through his retrospective at the Museum of Modern Art) whose work brought a new look to Kahn's painting in 1951. The Russian artist's violent impasto, daring liberties with form, and rhythmical use of color and texture suggested new ways of incorporating gestural techniques into work that was otherwise representational. Kahn recalls, "Soutine was really in the air. . . . Everybody— de Kooning, Robert De Niro, Joan Mitchell—was interested in him."[36] True to his Hofmann training, Kahn set about exploring this new vision by way of a still life.

Soutine's Influence (1951; Pl. 2) is a much more painterly, sensual painting than *Still Life in the Style of Braque* (Pl. 1), though its colors, apart from an occasional assertive flash of red, are relatively subdued. The image is drawn from a still life that features two red peppers, three jugs, a crumpled cloth and a flower pot. The moodily tactile brushstrokes make a rapid progress downwards across the canvas, as if in the current of a stream (in fact, the heavy impasto was the result of three months'

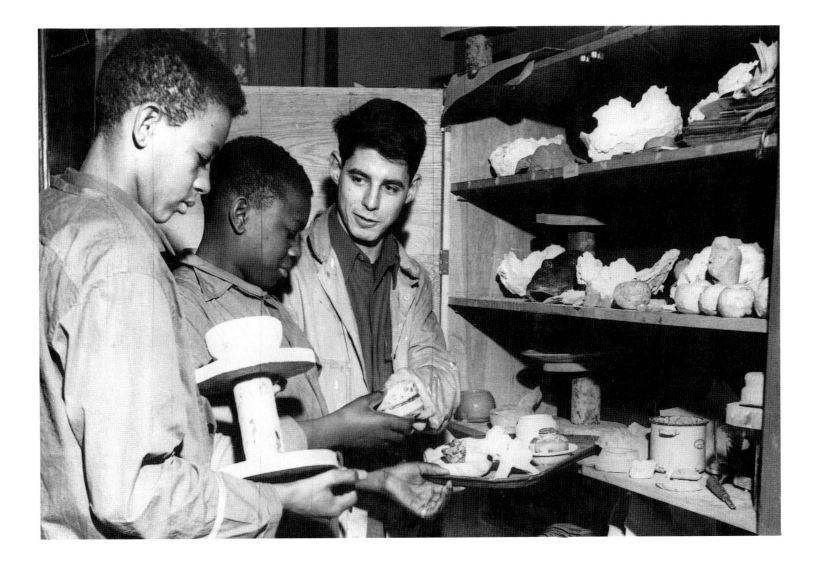

constant application of paint). The passages of yellow ocher reflect Kahn's ongoing fascination with van Gogh, while the strange aquamarine blue threaded with green, black, and red are more clearly Soutine. This is a passionate work, full of *Sturm und Drang* despite its small size; one senses youthful ambition and raw energy here as the twenty-three-year-old artist seeks a style and vision of his own.

The extent to which Kahn actually identified either with van Gogh or Soutine during this period is a complex question. In later years, Kahn would recall, "I thought I was van Gogh. I even picked up a bum and tried to sober him up in my apartment in an attempt to get as close to van Gogh as possible. . . . And then I found out I wasn't really van Gogh, so I decided maybe I should try to be Soutine, because at least he was Jewish."[37] The joke is somewhat misleading; van Gogh's real inspiration for Kahn lay in his struggles as an artist; and Soutine's tragic life had little in common with either Kahn's temperament or his background. As Kahn recalls, "Somebody—I think it was Jan Muller—once pointed out the irony of my painting like Soutine by observing, 'Soutine lies in the gutter, rolling in his vomit; Wolf Kahn teaches arts and crafts to children.' "[38] It was with this balanced awareness, both romantically inspired and dryly self-conscious, that Kahn went about the serious business of learning how to paint.

While working at the Manhattanville Neighborhood Center, Kahn met Sara Penn, a black woman originally from Pittsburgh with a degree in social work. Their

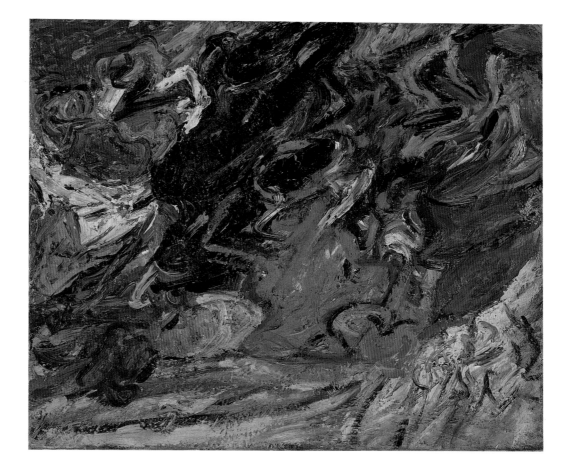

Pl. 2
Soutine's Influence
1951. Oil on canvas, 16 x 20″
Collection of the Artist
Photo: Peter Muscato

romance would last for the next four years, a very happy and social time in Kahn's life. Through Sarah, Kahn developed an interest in jazz (they once took a passed-out Charlie Parker back to his home on Edgecombe Avenue), and became an expert dancer of the jitterbug. Kahn had met few black people before coming to America, and New York's African-American culture fascinated him. Moreover, his experiences both as an art teacher and as a counselor to youth gangs had made him aware of the prejudice facing blacks in America, and sympathetic to their problems. Later in the Fifties, he would help Sarah and several other black friends "blockbust" their way into Greenwich Village apartments.

In the fall of 1952, the Hansa Gallery Cooperative opened at 70 East 12th Street. On Saturday, December 6, 1952, the *New York Times* noted:

> Space in an old building has been resourcefully converted, and the initial offerings are paintings by four artists and sculpture by Richard Stankiewicz. . . . least abstract are Wolf Kahn's landscapes, dark and glowing affairs that suggest Soutine. That Kahn is a good draughtsman is more evident in his watercolors. . . .[39]

Kahn did not, in fact exhibit any watercolors—the works were wash drawings—but he was happy enough for the publicity. The other artists featured in the exhibition were Jan Muller, Jane Wilson, and Barbara Forst.

Shortly thereafter Kahn unexpectedly inherited $1,080 from an uncle, which he used to travel to Baton Rouge, Louisiana, to visit his brother Peter, now an art professor at Louisiana State University. As a result, he missed a lecture at the Hansa Gallery that would be discussed and debated for years after, in which the theorist Clement Greenberg made his famous pronouncement that "Abstraction is the major mode of expression in our time; any other mode is necessarily minor."[40]

A statement of this sort begged a rejoinder. Indeed, in Kahn's circle, Abstract

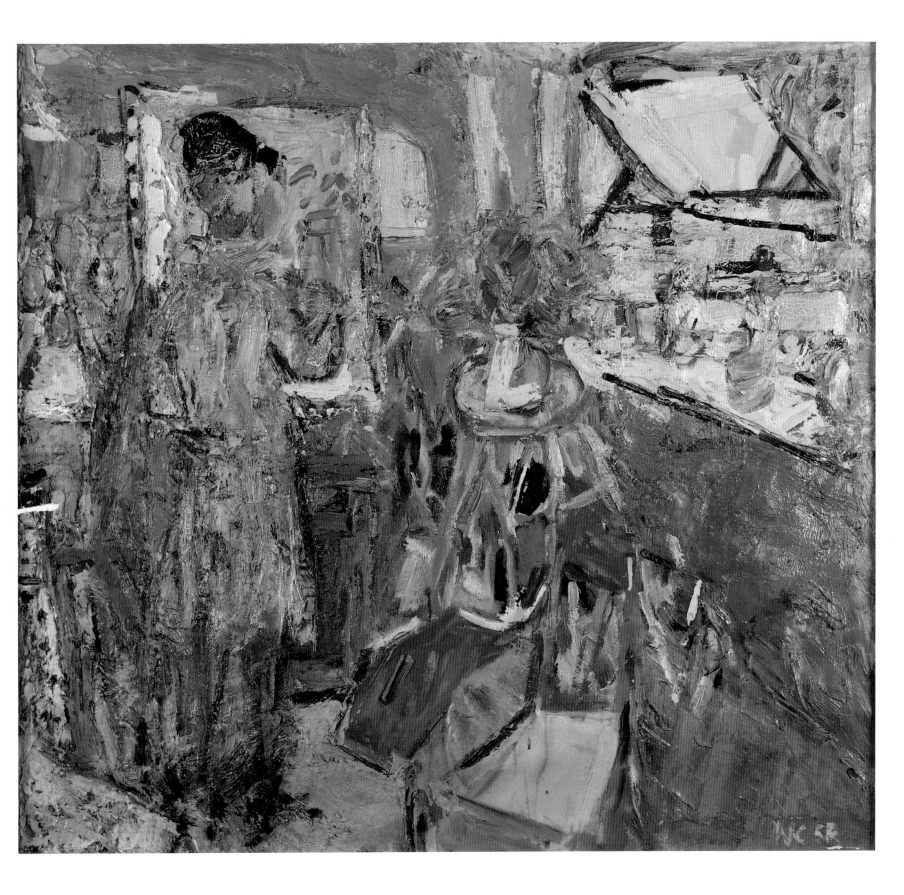

Pl. 3
My Louisiana Studio
1952. Oil on canvas, 32 x 36″
Collection of the Artist
Photo: Peter Muscato

Fig. 8. Wolf Kahn with self-portrait, New York, 1953. Photo: Rudy Burckhardt

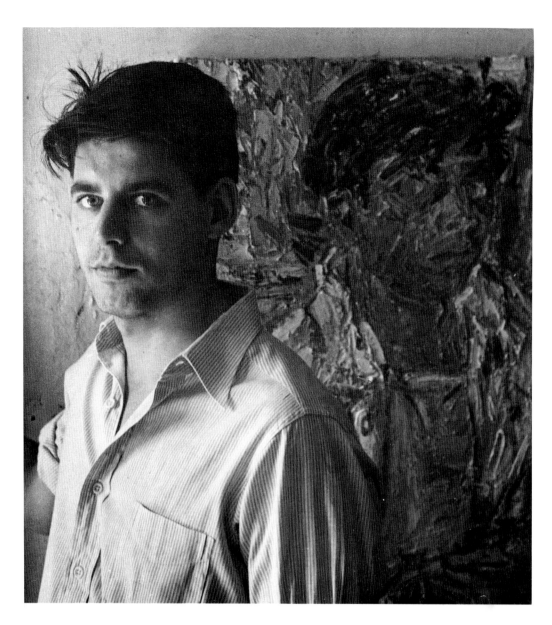

Expressionism was already giving way to a new style of painting which, influenced by European artists such as Bonnard, Soutine, van Gogh, Rouault, Matisse and Monet, sought to re-integrate figurative representation into the dialogue of contemporary art. In Louisiana, Kahn sorted through the ideas and influences he had encountered in New York. His first step towards the new, synthetic style was "to paint the world around me."[41]

A typical work of this period, *My Louisiana Studio* (1952; Pl. 3), pictures the artist at work—in this case in an unused classroom at LSU—de-emphasizing the artist's own presence (which is simplified almost to a cartoon) in favor of the overall space, a device Kahn had borrowed from Matisse. The artist stands, back to the viewer, in a machinist's smock, framed by a canvas behind him, facing (and upstaged by) a still life in vibrant thalo blue-green, which in turn sits before an open window. Outside, a different kind of light and space await. In the lower right hand corner sits a classroom chair.

While this work seems concerned primarily with paint, it contrasts an interior with an exterior, and the competing spatial awarenesses and the physical sensations that follow from them. While the figure and certain less focused areas of the interior are thick, sticky, and heavily worked, the still life attracts the eye, promising a cool

focus almost entirely through color. Outside, through the open transom window, is the diffuse glare of open day, a daring passage of bare canvas showing through this lightly worked area of the painting.

When not at work in the studio, Kahn entertained himself, as always, with sketching *en plein air*; the levees of bayou country provided him with a sub-tropical American analogue to the flat Dutch landscapes he had long admired by Rembrandt, Vermeer, and Ruisdael. He also sketched a rodeo encampment in the nearby fairground, and during the State Fair supplemented his income by painting portraits of prizewinning livestock. Later he would recall this period as "a carefree, adventurous time."[42]

In 1953, after returning from Louisiana, Kahn spent the summer on Cape Cod, not to study with Hofmann but simply to live near his artist friends. He rented a back-beach shack that was forty-five minutes by foot across the sand dunes from Provincetown and painted outdoors, often tacking his canvases to the side of his cabin to work on them.

Back in New York that October, Kahn held a one-man exhibition at the Hansa Gallery. The painter and critic Fairfield Porter reviewed the exhibition favorably for *Art News* (November 1953) remarking,

> Because of the high quality of his landscapes, imitative of the manner but not the feeling of Soutine, previously seen in group shows, the excellence of this first exhibition of energetic, sometimes wild and always genial [works] comes as no surprise. Everything is first-rate. The Soutine manner is giving way to a more generalized French manner. . . . Probably Kahn started with the same happy pleasure in color and light that delighted the Post-Impressionists, and so he studied these things very hard, with an unusually successful result. His pink, violet, orange and green paintings made in various parts of the country do not indicate that he pursues picturesqueness. He was in these places for other than painting reasons, and painted what there was. And being the sort of man he is, the deadness of his dead birds and fishes is an entirely unimportant fact about them.[43]

Some time after this review appeared, Kahn, thanks to an introduction by Larry Rivers, met Porter for the first time at Porter's Southampton home. This was the beginning of a friendship that continued until Porter's death in 1975.

Perhaps the most noteworthy development in Kahn's new paintings was the affirmation of the importance of color, both to the structure of the composition and for its sensual effect upon the viewer. To some critics, including Stuart Preston of the *New York Times*, the imagery and technique seemed in conflict:

> A torrent of thick strokes of blazing color crashes and splashes onto the canvases. When its shock effect abates one begins to discern the subject [which] is at odds with the frenzied style, the figures being too stolid and unemotional to be introduced in this fashion.[44]

Still, with this first series of images Kahn had established a style, and for the next few years he would continue in a similar vein. Two good examples of this style as it developed are *Portrait of Frank O'Hara* (Pl. 4) and *Portrait of Robin Jackson* (Pl. 5), both of 1953–4.

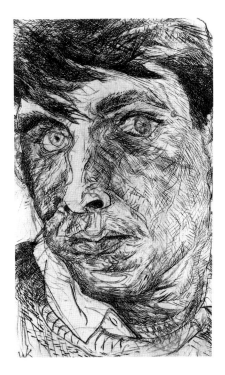

Fig. 9. Wolf Kahn, *Portrait of the Artist*. 1954. Drypoint etching (Atelier 17), 7 x 4½"

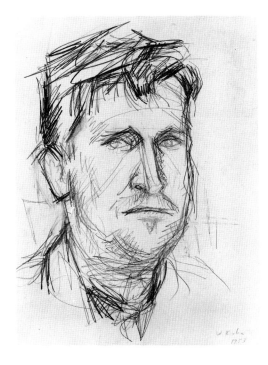

Fig. 10. Wolf Kahn, *Portrait of Fairfield Porter*. 1953. Graphite pencil on paper, 18 x 14". Collection of the artist. Photo: John D. Schiff

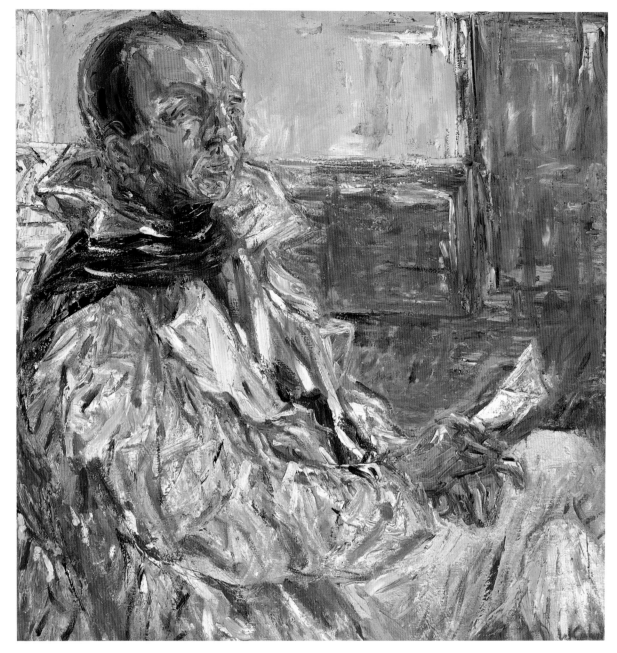

A poet and art critic, the urbane and somewhat elfin O'Hara would eventually hold a curatorship at the Museum of Modern Art. In Kahn's portrait, he sits in the loft at 813 Broadway, where both Kahn and his friend Elaine de Kooning painted him simultaneously. The woolen scarf wrapped artistically around O'Hara's neck suggests a reference to Toulouse-Lautrec's *Aristide Bruant*, although it was probably worn simply as a protection from the draught. O'Hara's folded hands, one of them holding a sheet of paper, are delicately modeled, and his face seems caught between two expressions, alternately gazing off into the distance and facing the artist in three-quarter profile. This "time lapse" technique suggests the sitter's nervous, birdlike temperament—and, less directly, the artist's freedom from more conventional modes of representation. Though psychologically acute, the work suggests that figuration is somehow at odds with Kahn's interest in color and brushstroke. The simple background features an area of van Gogh yellow ocher; in the foreground, the coat dissolves into ecstatic color and texture, suggesting something of pointillist technique.

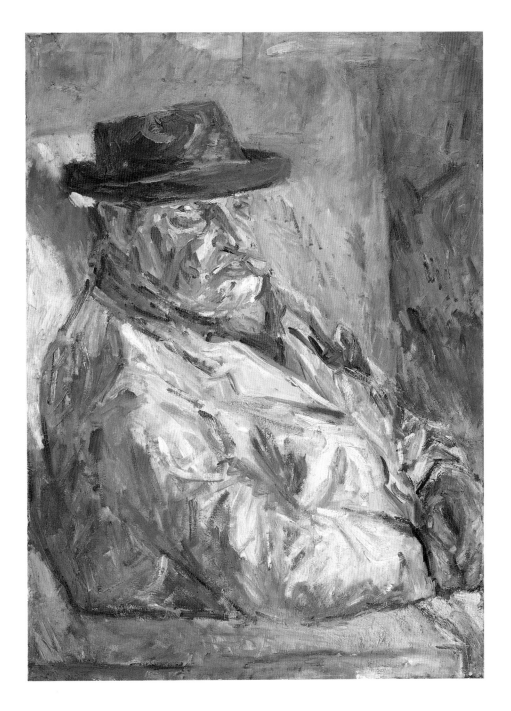

Pl. 5
Portrait of Robin Jackson
c. 1953–54. Oil on canvas, 40 x 30″
Collection of the Artist
Photo: Peter Muscato

Portrait of Robin Jackson (Pl. 5) is a similar experiment with figuration and color. Jackson, once the companion of Marsden Hartley, was a well known artist-about-town at the time he sat for Kahn in a tweed jacket, ascot tie, and borsalino hat. The pose is reminiscent of the formal and psychological ideas of Kokoschka's early portraits, as well as of Cézanne; but again, the color and texture of the paint are the artist's primary interest. The subject seems almost engulfed in the brushstrokes from which he is composed. The jacket is a particularly exciting tour-de-force that breaks down into passages of purple, blue, and green, which Kahn integrated with Jackson's beard with strokes of white. Kahn worked steadily on the portrait for three months, painting every second day, while the patient Mr. Jackson sat repeatedly for him until Kahn had achieved exactly the effect he wanted.

During the summer of 1954 Kahn returned to his back-beach shack in the dunes outside Provincetown. He worked in quiet isolation all summer, thereby formulating a sense of just how his art would break with the past. In his own words,

I realized I was painting my lifestyle. In doing so I was doing something that wasn't allowed—painting everyday life. Figurative work wasn't supposed to be art, but we were breaking those rules. You know what Clem Greenberg said about not doing figurative painting in an age of abstraction. Well, I was doing it anyway.[45]

Other artists and critics were beginning to move in a similar direction. In an insightful *Art News* essay of 1954 entitled "Subject: What, How, or Who?" Elaine de Kooning asserted that abstraction was no longer a revolutionary idea, and that realism was just as valid a way of seeing, since "docile art students can take up the Non-Objective art in as conventional a spirit as their predecessors turned to Realism. The 'taste bureaucracy' . . . all freely accept abstraction."[46] Artists, too, saw the opportunity. Larry Rivers, Jane Freilicher, Fairfield Porter, and Nell Blaine were each cautiously asserting a style which, having learned from Abstract Expressionism, also sought inspiration in nature and everyday life.

Ironically, Kahn's intense devotion to his nature-inspired work during this period in Provincetown—where he lived without even a radio to interrupt his concentration—placed him in a situation where nature itself very nearly cost him his life. In Kahn's words,

I hadn't been into town for some time, and when it started to rain I didn't think anything of it. But the sand started blowing against the windows, and I realized I'd have to go out and secure the battens because I didn't want the glass to become frosted and dull. By the time I'd finished, the sand in the wind had taken the skin off the back of my hands.[47]

The artist wrapped himself in a blanket for protection and spent hours with "hammer in one hand and nails in the other"[48] securing the cabin's floorboards as they were torn loose by the high wind. In the end, Kahn escaped injury from what turned out to have been one of the most destructive storms ever to hit New England, Hurricane Carol.

Returning to Manhattan that fall, Kahn exhibited his latest work, and its reception was favorable. Kahn was included in the *Second Annual Exhibition of Painting and Sculpture* at the Stable Gallery, juried by several senior members of the art community, including Franz Kline and Philip Pavia. Shortly thereafter he held a second one-man show at the Hansa Gallery (which by January of 1955 had moved uptown, to Central Park South). After seeing the work, de Kooning went so far as to recommend Kahn to Andrew Carduff Ritchie of the Museum of Modern Art.

The show was an important statement of Kahn's evolving style. *Portrait of the Artist* (1954; Pl. 6), its centerpiece, was, in the artist's words, "an artistic credo,"[49] an emblem of his painterly preoccupations and beliefs. The loft interior in the painting seems to revolve around the artist's right eye; as in Bonnard's work, different objects, including parts of the artist himself, are created in varied color and texture (here, with both brush and palette knife), suggesting independent moments of focus and meaning. A group of painting implements resting atop a sculpture stand; in the background, paintings stacked against the wall. Areas of heavy impasto give way to lighter, impressionistic patterning at top and bottom. True to Hofmann's precepts, the space alternates between two and three dimensions, energized by the "push and

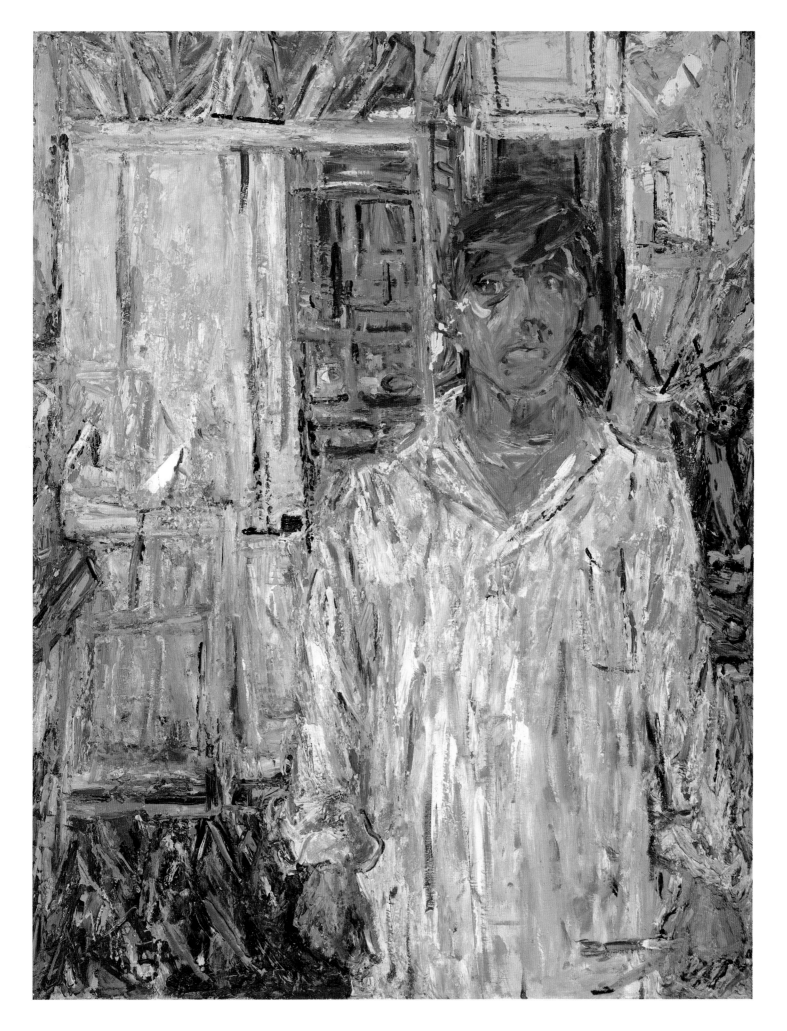

pull" between areas of paint; the rough, dry, complicated brushstrokes of the machinist's smock contrast strongly with the smoother, more liquid (but equally colorful) areas of the face and the head. Though not an "easy" painting—Kahn himself would later feel it showed "too much labor"—many of his later, more mature paintings would evolve directly from this heavily worked fusion of Impressionist, Post-Impressionist, and Abstract-Expressionist techniques.

Sara (1955; Pl. 7) presents an image at once more highly charged with pleasurable sensations and less fraught with meaning. Yet it, too, is heavily worked; created with a fully loaded palette knife and brush, the canvas is so thickly encrusted with paint that it weighs nearly twenty pounds, a by-product of Kahn's habit of "taking leads directly from the paint."[50] Sara Penn sits with her back to the viewer, before an open window, apparently reading a book. The mirror propped on the table beside her gives the image a complex spatial awareness, and the purple-orange-magenta floor grounds the space, whose energy of color and brushwork might otherwise cause it to appear to lift off and fly away. Again, there is a play of rhythm across the canvas: as areas of yellow dance toward the open window, the green of the table, easel, dress, and flowers form a lyrical counterpoint. Color creates the mood; as before, the figure seems important as a reference rather than presence.

Fairfield Porter's enthusiastic response to the new work appeared as the lead review in *Art News* that February, its prominent position suggesting that Kahn had "arrived":

> Wolf Kahn's second show of drawings, pastels and oils has more evenness than his first show of a year ago. He exhibits portraits, larger than life, with arbitrary color to accompany the interpretation of character and with some of the distortion of Soutine, for whom a portrait, even more than nature, was like the sitter with his psychological impact. But Kahn's passion is not tactile like Soutine's, and his restlessness is in the craft, unlike Soutine's, which was not assuaged by the most direct violence possible to painting. In short, Kahn's passion is not sadistic, and his pleasure is Impressionistic. When he relaxes into the skill he knows, he produces a *plein air* pastel or a gentle and lovely landscape on the spot. The most studied and successful paintings like the large interior with a girl, or those of the artist in his studio, have a solid weight of color and light in the right place and proportion, making them both heavy and sparkling, miraculously not paradoxical, and more French than Expressionistic, with qualities few painters today seem to understand as well as he does.[51]

Frank O'Hara shared Porter's enthusiasm in an extended essay entitled "Nature and New Painting," which described Kahn as part of a new generation of artists who drew on representations of nature for their vision.

> Wolf Kahn enjoys the wide frame of reference which painting nature enjoins. . . . [he] has the sensibility of the Impressionists—not just their vision, their design, their science; he sees Impressionistically, especially in his earlier work. He sees millions of colors on each leaf, he sees light breaking over a face like foam, he sees an eye rolling in an abyss of pearly hues, he sees the sun shedding its gold over the landscape like blood. It is the measure of his strength that this seeing finds its structure, too, in nature, pressing as Soutine and van Gogh did, the intelligibility of appearance no matter how rigorous the price.

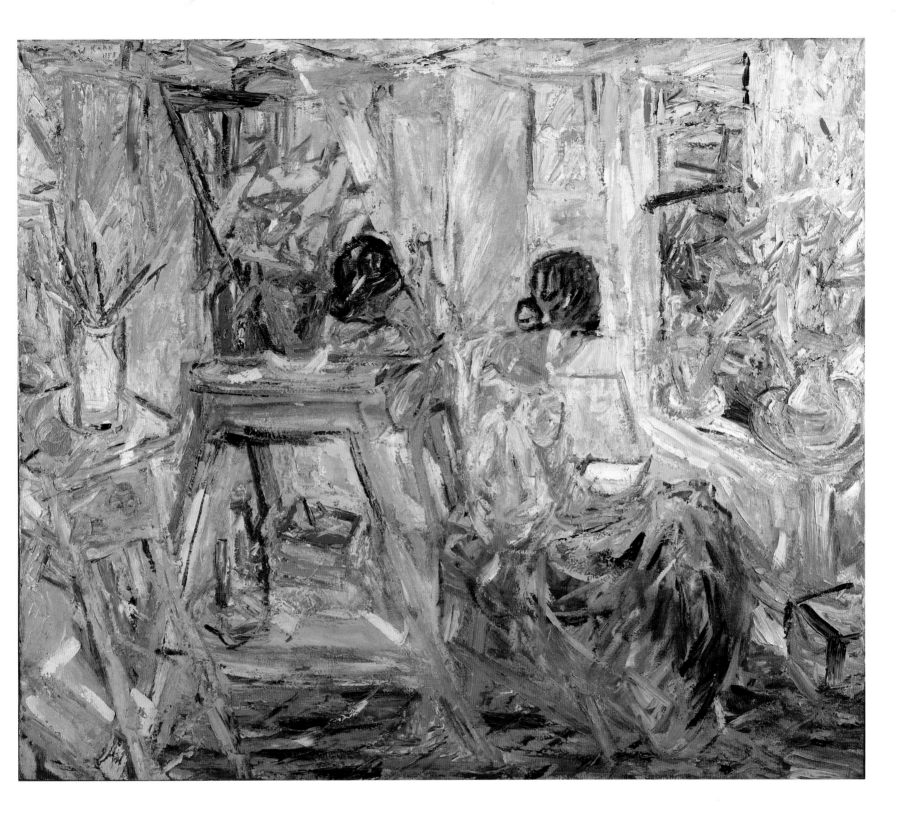

Pl. 7
Sara
1955. Oil on canvas, 51 x 60″
Richter Collection, Charlotte, NC
Courtesy: Jerald Melberg Gallery, Inc.
Photo: Rudolph Burckhardt

His paintings are very beautiful and very serious; very rich and very sad; very bright and very heavy. Like the passion of a Svengali for a Trilby, he seems to brood over nature at the same time as he presents its exquisite moments. The structure of the picture takes on a personal strength and openness, as if an intimate secret were being divulged, with a warning. His self-portraits of a year ago make this quality quite apparent: the artist is depicted in a bold emotional state, beset on every side by cutting colors, some sweeping into his form, others approaching and passing with the speed of arrows, and his eyes are everywhere upon them. . . . at the same time they have an objectivity of emotional statement within the stance which is like a date under a romantic poem: you read a fervent farewell, and the footnote tells you the poet died the next

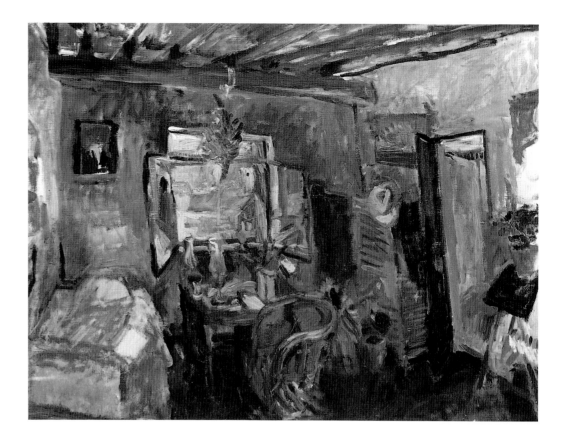

morning at Missolonghi. The "genuineness" of the paintings, their forms and details, no matter what the influence, has [a] kind of extraneous, compelling conviction. . . . In front of one of Mr. Kahn's paintings one is not always in command of oneself or of the experience, and as one sees longer it becomes apparent that an unknown quantity of perception is available to one's flagging powers, as in nature the hidden secret is partially revealed—or else this is the mysterious quality of painting itself.[52]

Only Hilton Kramer of *Art Digest* was nonplussed by this new synthesis of French painting and Abstract Expressionism, writing of Kahn's exhibition that

what used to be called subject matter is posed here, with the palette knife at its throat, facing that abyss where the subject of every painting is "painting" itself . . . the long arm of Hofmann's atelier makes itself emphatically visible. . . . The results are works in which more paint is plastered to the surface than there are formal ideas to accommodate it.[53]

Yet even Kramer's objections would eventually trail off into a grudging admiration of Kahn's less heavily worked paintings. With his second one-man exhibition, Kahn had formally entered the dialogue of contemporary art, and established himself as a painter of exciting new vision.

That spring, with his second exhibition behind him, Kahn felt it was time for a change of scene. His relationship with Sara Penn had ended, and he felt no need to remain in New York; in fact, it oppressed him. A wealthy acquaintance, Mrs. Libby Norman, had offered him the use of her home in Tepoztlán, Mexico. Kahn's finances were precarious; despite the positive critical response to his show, few paintings had sold, and he had resigned from the Hansa co-operative

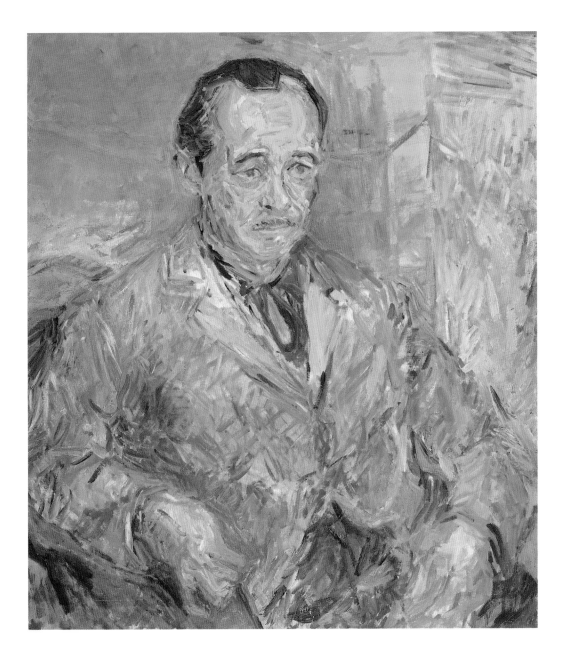

Pl. 8
Portrait of Baron W. W. von Schöler,
Tepoztlán
1955. Oil on canvas, 36 x 32"
Collection of the Artist
Photo: Peter Muscato

because he could not pay the $15 monthly membership. So he eagerly accepted Mrs. Norman's offer, sublet his section of the loft, and packed his art supplies. Mexico promised free rent and a favorable exchange rate of pesos to dollars, which meant he could live on practically nothing.

The villa in Tepoztlán was a comfortable one. Kahn was given the guest cottage by the pool, and when not painting he made a point of meeting local society, giving native children swimming lessons and painting portraits of his neighbors. Noting that the servants seemed bored and depressed, he began hosting parties, inviting the four maids to amaze him with their *mole poblano* and other regional delicacies. The local expatriate community in nearby Cuernavaca came to call, and sometimes Kahn painted their portraits to make extra money.

A typical painting of this period is *Portrait of Baron W. W. von Schöler, Tepoztlán* (1955; Pl. 8), painted in a manner combining aspects of van Gogh and Kokoschka. Von Schöler, another guest of Kahn's absentee hostess, spent three weeks at the villa; an antiquities smuggler whose passport had just been revoked, von Schöler was in the midst of an alcoholic collapse. He would pace around the pool clinking the ice

in his highball glass, distracting the artist from his work. To quiet him, Kahn suggested he sit for a portrait.

The bright light and wide-open spaces of Mexico seem to have encouraged Kahn to play with color: the wall behind the subject is a rich, earthy orange, the chair crimson; the lower left foreground features an area of thalo green corresponding to the more diffuse greens beyond the open door. The most painterly passages are laid in with subdued, almost systematic brushwork. The sitter's air of resignation, perhaps quiet despair, seems reflected in this methodic paint handling; if Kahn personally found his subject irritating, the work itself shows only empathy.

As September 1955 approached, Kahn began to tire of Mexico; he had contracted dysentery, and was finding the bright sun, heavy drinking, and earthy peasant foods of Tepoztlán less appealing by the day. Moreover, the news that von Schöler had committed suicide in Mexico City cast enough of a shadow over the villa that when Kahn packed up his canvases and returned to New York, he did so with little regret.

When he returned to New York, Kahn set about finding a gallery to represent his new work, a challenge compounded by the fact that his apartment had neither a telephone nor a doorbell. "I was living very simply at this period," he later recalled; "I only had a single change of clothes."[54] When Grace Borgenicht formally invited him to join her gallery, she had to do so through a Western Union telegram.

That winter Kahn was included in "U.S. Painting: Some Recent Directions," an article by Thomas Hess, editor of *Art News*, in the *25th Art News Annual*. As editor of the leading magazine of contemporary art in New York, Hess's opinion was highly respected, and inclusion on his list meant that Kahn now stood a chance of selling his work to collectors, as well as being talked about by *cognoscenti*. The article, published in conjunction with the *Fifth Annual Exhibition of Painting and Sculpture* at the Stable Gallery, which featured Hess's 21 artists, remains an important document of the New York art world during this period. In it Hess attempted to assess the extent to which the next generation of painters had been affected by Thirties public art projects, the collapse of American Communism, the rise of a New York artists' community, and the pervading atmosphere of post-War complacency (which Hess termed "GI-ism"). Hess noted Meyer Schapiro and Clement Greenberg as significant critical influences to the dialogue of contemporary painting, but gave top honors to Hofmann, whose philosophy and teaching method (fifteen of the 21 painters had studied with him) he discussed in detail.

Not only did the article position Kahn at the very center of the art world at that particular moment; it named a large number of his close friends and acquaintances as representative of the *Zeitgeist*, and thus was cause for even more celebration: Kahn's loft-mate Felix Pasilis was there, along with Miles Forst, Joan Mitchell, Nell Blaine, Robert Goodnough, Fairfield Porter, Larry Rivers, Robert De Niro, and Elaine de Kooning. The other artists named included Helen Frankenthaler, Robert Rauschenberg, and Milton Resnick. For the first time, Kahn and his generation were being celebrated as central to the New York art world, so long the domain of the Abstract Expressionist old guard.

It has been incompletely documented by art historians that the second generation of the New York School, especially those painting in representational styles during the 1950s, formed the transitional thread between Abstract Expressionism

Fig. 12. Wolf Kahn and Emily Mason in Provincetown, summer, 1956
Photo: Leonard Slonevsky

and Pop art. Thus, Elaine de Kooning's use of sport imagery, Robert De Niro's painted variations from movie still photographs, Larry Rivers's cigarette box covers, playing cards, and trademarks, and Grace Hartigan's paintings of Lower East Side shop windows all provided a climate for the growth of the Pop sensibility. Of this general movement toward the representation of American everyday imagery, Wolf Kahn's paintings of his studio surroundings were an important part. De Kooning, meeting Kahn on the street one evening in 1956, said, much to Kahn's surprise, that he envied the younger artist's way of painting, because "you are able to paint everyday life."[55]

1956 was a good year for another reason. At a meeting of The Artists' Club, Kahn, 28, met and was instantly attracted to a beautiful young artist named Emily Mason.

> Her mother was an artist, so Emily had grown up knowing all the Abstractionists. They were like family. I remember Mark Rothko looking at her and saying to me, "Emily used to sit on my lap," and he said it as if to say he wouldn't mind if she were to come back and sit on his lap some more.[56]

Two weeks later Mason was at the Artists' Club again, this time with her mother, whom Kahn recalls as "aristocratic, but not at all intimidating, in fact, very shy."[57] Luckily, her daughter was not. Shortly thereafter, Kahn and Mason began planning to spend the summer together in Provincetown.

Emily Mason's mother, Alice Trumbull Mason, was the daughter of an old New England family and a founding member of the American Abstract Artists Group, formed in 1936. Her feelings regarding Abstraction were so strong that, Kahn recalled, "If Alice had a problem with me, it wasn't because I was an artist—it was because I was a representationalist!"[58]

Emily Mason was also an abstract artist; she had attended Bennington College, earned a certificate at Cooper Union, and shortly before she and Kahn met, had been awarded a Fulbright fellowship to paint in Italy, where she planned to enroll at the Accademia delle Belle Arti in Venice. Kahn would join her there for the winter.

But first the two went to Provincetown, forgoing Kahn's shack in the dunes for a more civilized second-floor sail-loft in town. Kahn would later recall the summer of 1956 as one of the happiest of his life. He and Mason were absorbed in their work and each other; when not painting, they gardened and read Proust.

Amidst this state of contentment, Kahn's painting began to metamorphose. "Almost all of [my paintings that summer] were of Emily and our house,"[59] Kahn later recalled. Not surprisingly, he drew once again from the example of Bonnard, sharing that artist's taste for joyous color and airy light.

Late Afternoon (1956; Pl. 9) is a good example of what Kahn would come to know as "my love affair with Bonnard."[60] Painted from sketches made that summer, the picture shows Emily drawing. Beyond her are the flowers she and Kahn had planted, and beyond those lie the beach and Provincetown Bay. With its interest in contrasted interior and exterior, this radiant work owes a great deal to Bonnard's *The Breakfast Room*. Kahn's heightened foreground and raised horizon (a strategy he would later use with great effect in his landscape paintings) create a somewhat ver-

Pl. 9
Late Afternoon
1956. Oil on canvas, 50 x 42"
Collection of the Artist
Photo: Peter Muscato

Pl. 10
On the Deck
1956. Oil on canvas, 30 x 24″
Collection of the Artist
Photo: Peter Muscato

tiginous effect, but his central focus is the action of light falling across the table during late day. Here a strong sense of interior space and light takes precedence over virtuosic brushstroke; the artist seems intent on capturing a "real" and extraordinary moment of daylight, in which the sunshine is reflected from the tabletop to illuminate Emily's face. In contrast to *Sara* (Pl. 7), painted only a year earlier, *Late Afternoon* is less concerned with creating a striking painting surface, and is instead dedicated to the pictorial illusion of radiant interior light. Clay brown, mauve, and a calm china blue are new, more tranquil additions to Kahn's palette.

In *On the Deck* (1956; Pl. 10), Kahn's movement towards simplicity continues, as the energetic force of his earlier paintings gives way to a more reflective appreciation of tranquil space. The warm interior tones open into brighter, cooler exterior colors, with the seated figure serving as a focal point and transition between the two varieties of light. The door opening inward and the neat progression of spaces out-

Fig. 13. Wolf Kahn and Emily Mason on their wedding day, March 2, 1957. Photo: Tinto Brass

ward suggest Vermeer, as do the orderliness, quiet, and domesticity of the scene. The colors, meanwhile, suggest a dazzled happiness. Besides Bonnard, Kahn credits Vuillard and Edward Hopper as influences on his work during this period, but clearly he is also responding directly to the specifics of place.

During this summer, Mason introduced Kahn to Milton and Sally Avery, who were also in Provincetown. Avery enjoyed the younger artist's company, and invited him to paint with him. During this crucial period, Kahn may have been influenced by Avery's daring use of simplified imagery, calm brushwork, and open color surfaces to transmit feeling. The emotional tone of Avery's work was unusual for the period, for his paintings celebrated optimism, wonder, and happiness. Although Kahn had been, up to this point, too ambitious to direct his efforts to the expression of simple feeling, Avery's work demonstrated that such direct and joyful emotions were important enough to merit serious exploration. Moreover, Kahn was impressed by the dignity and self-assurance with which Avery went about his work. "There was an over-all absence of pressure or anxiety in the way he lived his life," Kahn would later write in a commemorative article for the *Art Journal*. "If Avery was ambitious, and he must have been at some deeper level, it never showed except in his commitment to the act of painting."[61]

Avery was also unusually prolific. Kahn habitually put in up to 100 hours' work on a single canvas; Avery, by comparison, might begin and finish two paintings in a single day. Though Kahn's own deliberate work habits would not change significantly for another twelve years, he was nevertheless impressed by an artist for whom a new painting was rarely a battle.

Another artist whom Kahn knew both in Provincetown and New York who also influenced his work during this period was Jan Muller. One of the original members of the Hansa Gallery, Muller had met Kahn at the Hofmann school; they shared a German background (Muller's parents had been left-wing radicals opposed to Hitler), and, more importantly, a love of color. "I remember sitting in his studio as he showed me canvas after canvas, each one more beautiful than the last," Kahn would later recall. "His color sense continues to resonate in the back of my mind."[62] With Muller's early death in 1958, Kahn lost a valuable and inspiring friend.

At the end of summer, Kahn returned to New York; his first show at Borgenicht would take place that December. Mason, meanwhile, departed for Italy, sharing the trip with another Fulbright fellow, the painter and critic Louis Finkelstein, and his wife, the painter Gretna Campbell. A warm friendship developed almost immediately; when, after an orientation meeting in Perugia, Mason departed for Venice, she promised to come visit the Finkelsteins in Spoleto.

Kahn planned to join Mason in Venice, where they could live frugally on Emily's Fulbright stipend, sharing a studio and living space. As it happened, the only passage Kahn was able to book departed two days before the opening of his first show at Borgenicht that December. Kahn and Borgenicht threw an opening party the day before his departure. In Kahn's memory,

> It was a tremendously successful show, sold out before it opened—paintings of Emily in Provincetown, mostly—and it was a great party too, one of the few that crossed the generations. Fairfield Porter was there, and David Amram, de Kooning, Franz Kline, and Adolph Gottlieb, whom I'd known in Provincetown though we weren't great friends. I remember de Kooning saying to me, "Now

you bring that girl back. She's a great girl; don't you let her get away!"[63]

Arriving in Venice in December, Kahn and Mason selected a studio on the Giudecca. It was the former ballroom of a palazzo, the Ca' dei Tre Oci, next door to the Casa Frollo, an artists' *pensione*. Though only two stops away by *vaporetto* from the Piazza San Marco, the living conditions at the palazzo were primitive. Mold grew on the damp floors, and draughts pervaded the rooms. Still, even their discomfort had an element of humor. As Kahn recalls,

> Taking a bath was nearly impossible. It took a long time to heat the water in the *termosifone*. Then you had to get into the bath before the water got cold. I remember one day Emily and I had spent nearly a whole day going through all of this and we were both just settling into the tub when somebody knocked on the door. Emily went to the door and told the person to go away. A few moments later the telephone rang, and it was the man who had been at the door—a reporter from *Time* magazine.[64]

When, a few weeks later, Kahn and Mason were married, the reporter attended as a guest and news of their marriage was featured in a magazine article. Not a single family member was present, but there was a dinner at a local artist's restaurant, Locanda Montin. Since they were living in one of the most beautiful cities in the world, the newlyweds spent their honeymoon at home.

Back in New York, Kahn's reputation continued to grow. Shortly after his marriage, he was included in a definitive exhibition of contemporary painting curated by Meyer Schapiro. *The New York School: Second Generation* at the Jewish Museum would eventually give a name to the painters in Kahn's circle: the "Second Generation" New York School.

Meanwhile, Kahn was responding to his environment in Venice. After first painting the garden of Casa Frollo in the warm tones he had used in Provincetown, he observed the beauty of Venice's shimmering, silvery winter haze, and accordingly his painting began to change. Over the next two years, Kahn worked in a nature-inspired minimalist vocabulary, in which the hazes of Venice—neither fog nor glare, but a cool, velvet shimmer—would move him away from chromatic pyrotechnics and thick impasto toward an exceptionally subtle rendering of nearly monochromatic tonal landscapes rendered in a smooth, dry stroke.

Of course, not all Kahn's inspiration came directly from the landscape. Venice was, after all, the center of a great painting tradition; aside from the Venetian colorists, Kahn could reconsider the Venetian work of Turner, Whistler, and Monet first-hand. As critics have pointed out, Kahn learned much from Monet's richly interwoven surfaces, from Whister's taste for silvery gray and the dissolution of his forms into the intervening atmosphere, and from Turner's ecstatic Venetian views.

But of course, Kahn continued to do most of his learning at the easel, following, as always, Corot's dictum that "the artist thinks with the brush in his hand." When poet Allen Ginsberg came to call during the summer of 1957, a recollected exchange between the two provides a valuable insight into Kahn's thoughts on his painting at the time.

> Allen said he didn't like my new work, that my old work was better and I was

Fig. 14. The artists in their studio in Venice, summer, 1958. Photo: Tinto Brass

Fig. 15. Wolf Kahn and Louis Finkelstein in Spoleto with the painters Piero Raspi and Filippo Marignoli, 1958

getting too complacent. I told him my work was following the course of my life, and that I didn't think it worthwhile to force myself to paint any more strenuously or intellectually, because my motto had always been "follow the brush"—which is to say, let the work develop its own way, without too much intellectual scrutiny or control.[65]

Another influence at this time was Giorgio Morandi, whose subtle, loosely painted landscapes and precise still lifes convinced Kahn of the potential beauty of nearly monochromatic tonal studies. Yet the two never met. Kahn's admiration for the artist was so great that, when invited to visit Morandi at home in Bologna,

> I had an attack of self-consciousness. I knew he had chosen to live a quiet life, and I couldn't think why he could possibly want a young American artist to come visit him. I've always regretted canceling that trip. Of all the contemporary Italian artists, Morandi was most important to me, the only one who convinced me he knew the Italy I loved.[66]

That fall, faced with another damp Venetian winter, Kahn and Mason decided to relocate. Mason, remembering her promise to Louis Finkelstein and Gretna Campbell, suggested a visit to Spoleto, and upon arriving the couple realized it would be a good place to settle. "Spoleto at the time was really a provincial backwater,"[67] Kahn recalled. Arriving the fall before Giancarlo Menotti started the Festival of Two Worlds that led to the revival of the town, Kahn and Mason found Spoleto run-down,

though beautiful. "*I Americani,*" as the two young couples were soon known, were welcomed into the community as visiting artists; but Kahn's prolonged exposure to the cold while painting out-of-doors led him to develop chilblains on his feet. "That was how I devised 'Wolf's First Law of Painting,'" he recalled afterwards. "Namely, 'When it's summer, you paint in the breeze and out of the sun, and in winter, you paint in the sun and out of the breeze.'"[68]

Finkelstein proved an admirable companion. His theoretical orientation towards painting provided stimulating conversation, and helped Kahn think through the new and very different style of painting he had adopted in the course of a year.

Pl. 11
Large Olive Grove
1957–58. Oil on canvas, 47½ x 54¾"
Whitney Museum of American Art,
New York, NY
Photo: Robert E. Mates Studio, N.J.

Pl. 12
Umbrian Hilltown #2
1958. Oil on canvas, 35½ x 49″
Collection of the Artist
Photo: Peter Muscato

Pl. 13
View Across the Plain
1958. Oil on canvas, 60 x 72″
Collection of the Artist
Photo: Peter Muscato

But here, too, landscape was the primary inspiration, for the limited tonal range of hazy Venice was now matched by the silvery winter landscape of Umbria, where a bleaching winter sun played over the flickering olive groves and pale, exposed soil.

Large Olive Grove (1957–8; Pl. 11) was painted just outside of Spoleto. Having moved away from figuration into landscape, Kahn was free to explore a new series of painterly effects; the brushwork is open and energetic, reminiscent of de Kooning, while the strong textural quality of the paint suggests the play of wind and light over the rough Umbrian fields. The colors are light, dry and wintry, with grays predominating.

Winter painting *en plein air* posed a number of unexpected challenges. In painting *Large Olive Grove*, Kahn needed to lay the canvas out flat on the ground, Pollock-style, in order to work; meanwhile the cool temperatures meant that the paint was thicker and more difficult to spread.

In *Umbrian Hilltown #2* (1958; Pl. 12), Kahn once again uses a silver-gray haze to capture the Umbrian landscape as it stretches away in the distance to the far-off town, which is touched, in the manner of Ruisdael, by a fleeting patch of sunlight. The opalescent quality of his mother-of-pearl whites touched with green, blue, and mauve is the result of a heavily worked surface.

A similar painting, *View Across the Plain* (1958; Pl. 13) dates from a car trip taken by Kahn through Tuscany in the company of Walter Barker, a painter from St. Louis. Kahn, who did not know how to drive, was somewhat at the mercy of his friend, who preferred to spend the hours toward sunset with a drink in his hand rather than a paintbrush. As a result, this large (60″ x 72″) painting was composed only afterwards, in the studio, from Kahn's hurried roadside sketches.

In this very nearly abstract painting, the gently rolling Tuscan wine country gives way on the horizon to the town of Pienza. The transitions between foreground, middle ground, and distance are accomplished through alternating looseness and crispness of gesture. The foreground features loose, open brushwork on a white surface; the middle ground, denser, more saturated colors, suggesting the ground first falls away, then rises again on a gently rolling plain. The middle distance, meanwhile, grows indistinct with the haze of day, and in the far distance, the town rises on the horizon, its ramparts struck with distant sunshine. This work, while never letting go of abstract painterliness or two-dimensionality, nevertheless evokes an exact, atmospheric moment of time and place.

The following spring, Kahn focused on the effects of Venetian light to create a number of exceptionally subtle white paintings (which are unfortunately nearly impossible to reproduce). His intention was to paint works in which the light is so pervasive that one does not see the color. The paintings lack almost any tonal contrast, relying instead on textured surfaces and loose brushwork for their effects. In these shadowy paintings, the subject alternates between objects dimly perceived in an opalescent haze—ripples in the water, a distant building—and the haze itself.

Kahn and Mason returned to America in late 1958. In September of 1959, their first child, Cecily, was born. Resuming life in the walk-up on lower Broadway after working in Venice and Tuscany required some adjustment, particularly since the presence of a newborn infant in the studio made concentration difficult.

Kahn had charted a new course for his painting in Venice: to capture the extreme optical effects of light (on water or through hazy air) in the paradoxical medium of thick, heavy paint. His commitment to this near-impossible task put him

through a very difficult period. The gray-light Venetian paintings that he exhibited that year at Borgenicht Gallery did not sell well, nor were they reviewed as enthusiastically as his previous work. The lack of critical support was especially hard for Kahn to bear after his earlier success.

But the return to New York was an important move for Kahn, since his renewed contact with the art world enabled him to become familiar with the work of other artists. Kahn was particularly interested in the paintings of Ad Reinhardt and Agnes Martin, the sculpture of Ronald Bladen, and the new work of Philip Guston and Milton Resnick. The ideas about painting light that he had been working through on his own in Venice were now proving to have much in common with the new movement of Minimalism.

In the summer of 1959, Kahn and Mason traveled to Martha's Vineyard, where they took a house on Lambert's Cove. Here Kahn began *The Further Shore* (1960; Pl.14), a painting of water featuring a high horizon line, which allowed him to think of his painting as one continuous surface rather than as two disjunctive ones. High horizons, and the towering heights required to find them in nature, eventually led Kahn to abandon the relative flatness of Martha's Vineyard for the coasts of Maine and, later, Vermont.

Kahn's object in this painting was to depict the action of light on water, seen as one travels across it toward a fixed point, in this case a house on the far shore of the cove. His method was to build up tone to achieve spatial density and weight on the surface of the canvas, while at the same time allowing the play of the brushstroke to articulate the movement of the light over the water. He restricted the chromatic range to the actual colors of the water, from blue-gray to yellow-gray, with some white added in. The paradox set by this painting—the use of heavy paint to capture the texture and appearance of light—was in many ways an extension of the visual investigations Kahn had been conducting in Venice.

While on Martha's Vineyard, Kahn also returned to the image of sailboats at anchor that had interested him while he was a student at the University of Chicago. These "visions of isolation and scale"[69] explored the nature of glaring sunlight, while the form of the sailboat provided a representational point of reference for the natural phenomenon.

In 1960, Kahn accepted a position as visiting professor at the University of California at Berkeley. Teaching at Berkeley came easily, for he already had much experience in his early years in New York, at the Manhattanville Neighborhood House, the Downtown Community School, and elsewhere. At Berkeley he was specifically invited to share his knowlege and love of painting, which helped him to solidify his own sense of aesthetics through discussing art with others. "The artist and the art teacher," he would later note, ". . . are [alike in that both are] nothing unless [they] present a point of view, and present it as clearly as we can, and with intensity and passion."[70]

Having studied with Hofmann, Kahn had a very solid sense of the importance of art school "not to develop or encourage personality . . . [but] rather to expose the student to art's mainstream . . . indicat[ing], in the broadest terms, what is worth doing, stressing the intellectual kernel of art and separating that from the purely hedonistic, the simply descriptive, and the merely autobiographical."[71] In many respects his classes were similar to Hofmann's, featuring group critiques, infrequent teacher appearances, and classes held in a single open studio ("What kind of learn-

Fig. 16. Wolf Kahn and Emily Mason with their daughter Cecily, 1960. Photo: Emily Nelligan

Pl. 14
The Further Shore
1960. Oil on canvas, 40 x 50″
Collection of the Artist
Photo: Peter Muscato

Opposite:
Pl. 15
Untitled Landscape (Martha's Vineyard)
1960. Oil on canvas, 33 x 53″
Collection of the Artist
Photo: Peter Muscato

50 *Wolf Kahn*

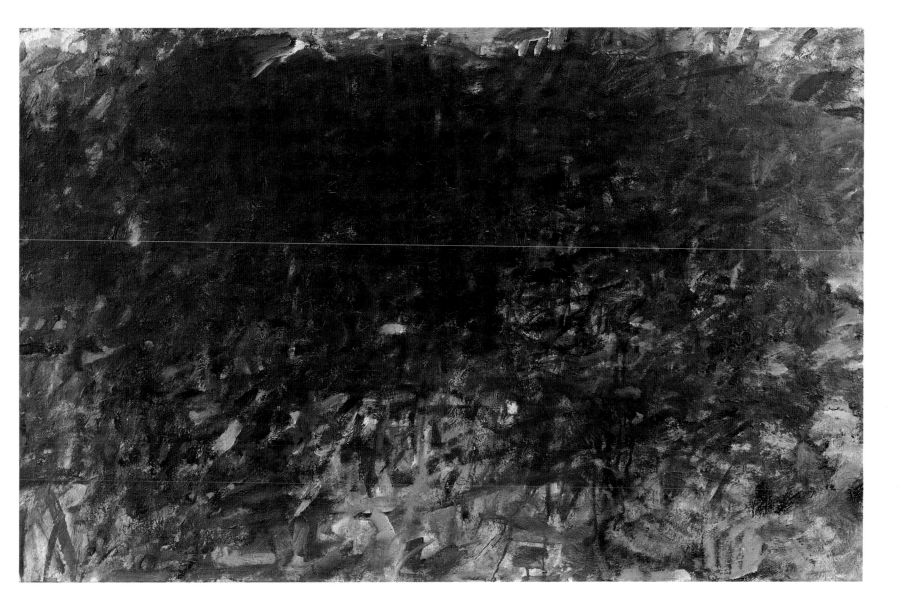

ing experience is it," he would later exclaim, "where no one follows the history of anyone else's work, where there is no kibitzing, where students are not constantly feeding off each other?")[72] Besides teaching his own courses, Kahn enjoyed taking part in group critiques with other painters, including Richard Diebenkorn, Elmer Bischoff, and Nathan Oliveira.

That year, Kahn's work was featured in a one-man show in Berkeley, and he was also included in a major exhibition at the Whitney Museum of American Art in New York entitled *Young America 1960: 30 Painters under 36.* When his visiting year at Berkeley ended, the University offered him a full-time position with housing and benefits. For a young man with a family the offer was tempting, but Kahn balked at the idea of a life so firmly predetermined. Preferring his more unpredictable existence in New York, he declined the offer and returned to the loft at 813 Broadway.

In the summer of 1961, Kahn took a house in Stonington, Maine. In *Between Two Islands* (1962; Pl. 16), which he began that summer, he used a large, heavy brush and a palette knife, working and reworking the image for almost a year, first in Maine and then later in his New York loft. This extended working method was typical for him during the period; averaging only ten "starts" per summer, he would "take down a set of relationships from nature, then back in New York, in my studio, I would

Fig. 17. Emily Mason in Rome, 1964
Photo: Wolf Kahn

Pl. 16
Between Two Islands
1962. Oil on canvas, 52 x 78"
Collection of the Artist
Photo: Peter Muscato

Pl. 17
View to Eagle Island, Deer Isle, Maine, I
1963. Oil on canvas, 50 x 44"
Collection of the Artist
Photo: Peter Muscato

develop and clarify these formal relationships."[73] Aware of the contradiction posed by a landscapist who does his best work in the studio, Kahn would later observe, "The environment in which my paintings grow best is at Broadway and 12th Street. I can see nature most clearly in my studio, undistracted by trees and skies. Art being emotion recollected in tranquility, I constantly find Nature too emotional, and Broadway very tranquil."[74]

Kahn had lived by this tongue-in-cheek paraphrase of Wordsworth for most of his career; historically, however, the practice can be traced back to his hero Bonnard, whose re-interpretation of imagery through the imagination had also demanded a two-part process of transcription and transformation.

Between Two Islands describes two pine islands and the merged image of white light and still water lying between. The paradox of this painting lies in the thick white paint at its center, which becomes (in Kahn's words) the "internal light source,"[75]

Pl. 18
Edge of the Woods
1964. Oil on canvas, 30 x 39″
Collection of the Artist
Photo: Peter Muscato

thereby challenging the convention that thick paint should describe darkness and opacity, while thin paint should represent light.

After a long winter's struggle with this and other images, which Kahn supported by working part-time as an adjunct professor of art at the Cooper Union (where he would continue to teach until 1977), Kahn returned to Maine, this time taking a house on Deer Isle Village.

In *View to Eagle Island, Deer Isle, Maine, I* (1963; Pl. 17), Kahn tried to find "a new way of dealing with near-monotone."[76] The image features a dark green area of pine trees and a grayed-down blue for water, two colors that are distinctly different, although their tonalities are nearly equal. This "same-but-different" quality teases the eye, challenging the viewer to understand why the two areas of different color should seem to have so much in common. The composition is also exciting for its use, once again, of the high horizon line, as if it were a view from an osprey's perch, looking down a precipitous pine slope to Penobscot Bay. This perspective energizes the otherwise tranquil image, creating a dynamic tension between what is seen in, and what is felt through, the painted surface.

In the fall of 1962, Kahn in turn was awarded a Fulbright fellowship to Italy,

which allowed him both to observe contemporary Italian painting and to continue with his own work. To be close to the center of contemporary Italian art, Kahn stayed in Milan, where he found an intellectual climate sympathetic to his own cerebral works of this period. In the late spring the family lived briefly near the town of Viterbo before moving to Rome for the winter. During their stay in Rome, Mason gave birth to their second child, Melany.

In *Edge of the Woods* (1964; Pl. 18) Kahn is working in a manner suggestive of Guston and Bischoff; indeed, writers on Kahn's work have noted that during the sixties, while teaching and living once again in New York, Kahn became much more open to the influence of his contemporaries. But Kahn's own recollection of the period is that "I was using the language of abstract painting to play my own games."[77] In *Edge of the Woods*, Kahn's game was "to go from dark to light."[78] Once again, as with *Between Two Islands*, he plays with the paradox of thick, heavily worked white paint as a light source, with the darker areas inside the woods described with thinner layers of dark paint.

Edge of the Woods is perhaps the most disturbing (as well as the most simple) of Kahn's many paintings of forest and field. While he chose this motif for the formal challenge presented by the optical effects, it may well carry a psychological implication. Like the fairy-tale forests of the Brothers Grimm, this woodland suggests a dreamlike area, apart from the known world, where elemental conflicts find expression. The tension created by light fading into darkness seems to suggest psychic tur-

Pl. 19
Imaginary Landscape
1964. Oil on canvas, 18 x 30″
Collection of the Artist
Photo: Peter Muscato

Pl. 20
First Barn Painting
1966. Oil on canvas, 43 x 50"
Collection of the Artist
Photo: Sarah Wells

moil. Kahn, moving away from the known and familiar territory in which representation balances on the verge of abstraction (and in which the primary focus is the act of perception), here creates a painting that explores the potential for communicating in a different manner, perhaps with a different set of priorities—a painting in which, in his own words, "personality is manifested in spite of your intentions, not because of them."[79]

Whatever the implications of *Edge of the Woods*, 1965 was without doubt one

of the most difficult of Kahn's life. Upon returning to New York in February, he faced indifferent reviews for his paintings of Rome and the nearby Italian countryside, not because of their quality, but because Pop art was taking the gallery and museum worlds by storm, leaving critics little time to spare for a landscapist working in the Hofmann tradition.

Moreover, in Kahn's absence the city had outlawed living in loft space, except for artists who had submitted Artist-In-Residence exemption forms. Since Kahn had missed the deadline while he was in Italy, he was facing eviction. Shortly after the family's return, the landlord broke into Kahn's loft and carried away the family's bedding and cookstove. Faced with so many problems, Kahn, who had experienced stomach trouble since his bout with dysentery in Mexico, developed a full-fledged ulcer.

Fig. 18. Barn on Martha's Vineyard, 1965. Photo: Emily Mason

Housing help arrived, somewhat miraculously, in a phone call from Robin Jackson, the artist whose portrait Kahn had painted in 1953. Jackson had recently had a heart attack, and thus would have to move out of his third-floor walk-up. When he heard what had happened to Kahn, Jackson handed over his lease, glad to help out another artist in need.

The Kahns fled New York that summer for Martha's Vineyard, this time taking a house inland, not far from the town of Oak Bluffs. The farmhouse and barn, set among eighteen acres of pine trees, bramble, and scrub oak, had belonged to the Philadelphia painter William Henry Miller, one of Eakins's colleagues at the Pennsylvania Academy of Fine Arts. While Mason used the dilapidated barn as a studio, Kahn found it menacing and confrontational. After making numerous sketches, he began to think about painting it.

Due to the nearly abstract nature of his work at the time, Kahn found the idea of making a painting of a barn problematic. Up to now, his imagery had been drawn from landscape, but he had concentrated on the optical effects of light rather than form, and had only rarely included any reference to humanity. Of all his work since the later Fifties, only the sailboat series suggested a human presence at all, and even they did so obliquely, the boats shimmering in the distance or in silhouette. Barns, by comparison, suggested meaning and purpose. To place a barn at the center of a minimalist abstraction would therefore be transgressive indeed.

But Kahn's intention was sincere, not ironic. Kahn later described the effect he was trying to capture in a chance encounter he had made, several years before in Maine. After working for some time on a pastel of a pond viewed through fog,

> I got up and turned around, [and] I saw the silhouette of a town hall looming up in front of me, filling nearly my whole field of vision. I found the confrontation exciting and sat down again to make a pastel, using what for me was a whole new scale. In the process of working I thought of a large, black sculpture by the minimalist artist Ronald Bladen I had recently seen. His work seemed much like that ungainly wooden building with its mansard roof that I was trying to put down on paper. Since then I've been on the lookout for similar moments of confrontation with barns, large boulders standing by themselves in the woods—anything that could be seen as a large volume in a simple surrounding. And once I have found it, my drive is to express the kind of space which will explain its importance.[80]

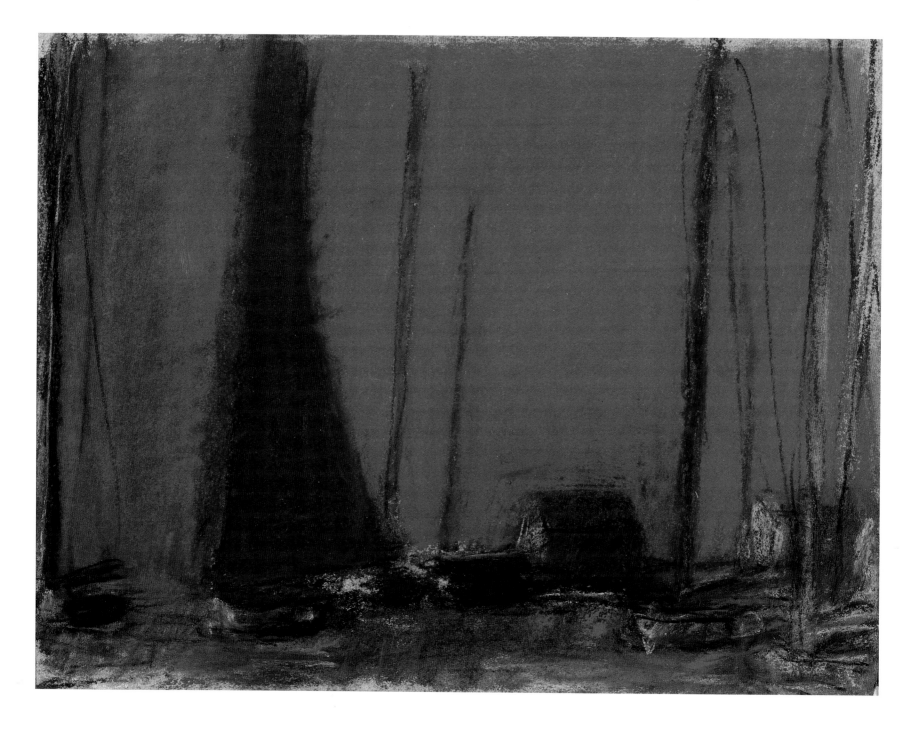

Pl. 21
Evening on Menemsha Pond
1967. Pastel, 9 x 12"
Collection of the Artist
Photo: Scott Hyde

Just as ten years earlier Kahn had challenged the idea that anything other than Abstraction was a "necessarily minor" art form, now he tried to confound the notion that there could be no such thing as a minimalist landscape. The barn offered an ideal opportunity to work with a large, simple shape.

The result, finished the following winter, was *First Barn Painting* (1966; Pl. 20) an eerie encounter with a looming presence that happens to be a barn, but is almost indistinguishable from its forested setting. Experimenting again with dark greens and grayed-down blues (here to capture the nearly monotonal light of late dusk in a wooded area), Kahn allows himself a free hand with his brushwork, drawing the painting away from representation by calling attention to the low-keyed dribbles, scrawls, and tarry patches on the picture plane. With this image, where a nightmarish presence resolves itself into the familiar (an experience of the

"uncanny" explored both by Freud and the German Romantics), Kahn challenged the influences he had absorbed over the past few years, moving beyond them into unexplored territory.

That same summer, Kahn worked in a very different style in his pastels. *Evening on Menemsha Pond* (1967; Pl. 21) is a startling work, in which Kahn began what he later would describe as "my love affair with purple."[81] Unlike the misty sailboat paintings of the early Sixties, this pastel presents an unambiguous image of sailboats at anchor. The viewer's first impression is coloristic rather than tonal, of a play between purple and blue rather than light and dark. In its exuberant simplicity, the pastel suggests something of the work of Milton Avery, but the manner in which the colors play off one another embodies an optical subtlety unique to Kahn's work. Despite the resolute unnaturalness of the colors, the combination of their related tonalities suggests a sense of their having been, nevertheless, "drawn from life." It would be some time, however, before such a bold color statement would appear in Kahn's painting.

In 1967, after receiving a Guggenheim fellowship, Kahn and his family once again summered on Deer Isle, Maine. Although Kahn loved the visual effects of the Maine coastline, the location was also prompted by a need for an affordable summer home. Inexpensive summer rentals were becoming scarce, and as a result, Kahn began to consider buying a country place of his own. Deer Isle, an area long colonized by painters, seemed inviting, and soon after he arrived Kahn began to cast about for available farmsteads. He finally located a bargain, a run-down farmhouse on fifty acres.

Unfortunately, the house and barn were separated by a road that led to the town dump. Worse, the roofs of both buildings were populated by sea gulls—thirty at any one time—"all of them facing in the direction of the dump," according to Emily Mason, who though normally easygoing, opposed the purchase. As she later recalled, "Wolf and I nearly came to blows about that house."[82]

The weather that year (in Mason's recollection "three months of solid fog"[83]) eventually turned Kahn against the idea of buying property on Deer Isle. The same foggy conditions, however, led to some serendipitous developments in his painting. As Kahn recalled later, "I began to let the color come through on my canvases. . . . my pastels were always intense, and finally my painting caught up with them."[84]

Sunset (1967; Pl. 23) marks a crucial transition in Kahn's painting. After years of nearly monochromatic work concentrating on varying tonalities, the artist found himself staring night after night at the sunset over Deer Isle's Southwest Harbor. Impressed by its color, he began an experiment. As he later described it, he wondered, "How far could I go towards color without giving up tonalism? . . . I wanted to have it both ways."[85] The immediate result was *Sunset*, which depicts the opalescent Maine haze lit by the setting sun. While the fog is drenched in color, the landscape remains grayish and austere, relieved only by an occasional splash of yellow or pink. While the dry, even surface of the painting might suggest Monet's *Nympheas* (an influence on many contemporary artists since its appearance at the Museum of Modern Art in the mid-1950s), Kahn remembers a more surprising inspiration: the "severe and velvety"[86] black paintings of Ad Reinhardt. The look of these black paintings so impressed Kahn that he deliberately shortened the amount of time he spent on each painting, realizing "if you work it too long, you lose the hazy velvet quality."[87] To achieve his austere textural effect, Kahn altered his brushwork, switching

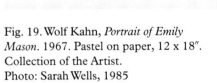

Fig. 19. Wolf Kahn, *Portrait of Emily Mason.* 1967. Pastel on paper, 12 x 18″. Collection of the Artist. Photo: Sarah Wells, 1985

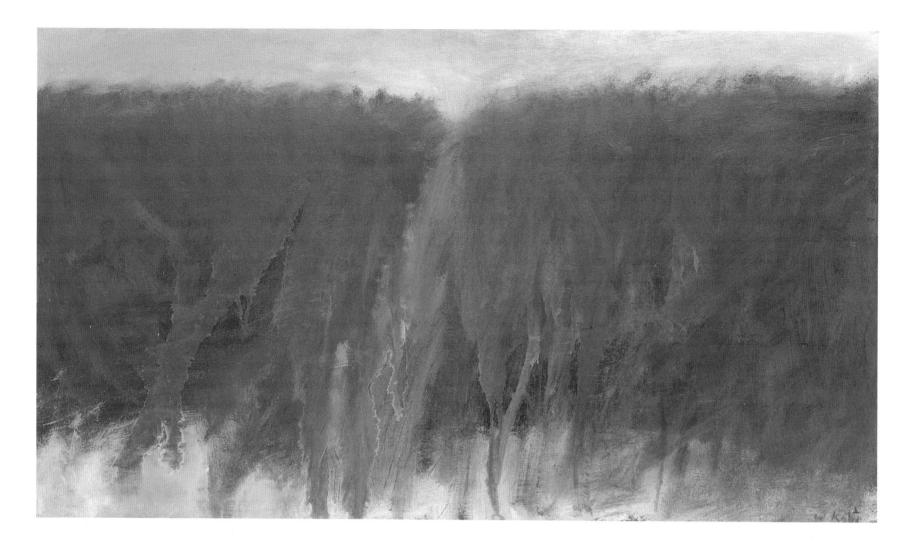

Pl. 22
Fire Path
1967. Oil on canvas, 20 x 36″
Collection of the Artist
Photo: Peter Muscato

to a long-bristled "decorator" brush, which he used to scrub unmixed colors into his canvas in thin transparent layers.

Yellow House, Maine (1968; Pl. 24) describes another step in Kahn's evolution that summer, although it was painted in his New York studio the following winter from a pastel study. The house belonged to neighbors, the Websters, whom Kahn often visited, walking down the road to sketch in their garden.

The lovely stillness and early-morning effect of this painting once again embodies the paradox of "same but different" colors—here pale yellow and lilac—that contrast chromatically, but not tonally. The carefully balanced tones suggest crepuscular or filtered light, an effect one can trace to Kahn's Venice paintings. The inspiration, however, is direct from the landscape; the colors and tones are not the milky, multicolored hues of Venice, but the gray-white fog of coastal New England, with its scent of sea salt, beach roses, and honeysuckle.

The paintings reflecting Kahn's experiments with color in the summer of 1967 appealed to a wider public than his earlier work had, and the resulting increase in sales at his next exhibition turned his thoughts again to buying a country house. As much as he had enjoyed his time in Italy, he had never cared much for travel, perhaps because of his early life as a refugee. Now forty, he wanted a more settled life.

The following summer, the Kahns bought a farm in Vermont. The house, a warren of cobbled-together rooms, had no electricity or gas. Water came from a hand pump in the kitchen; hot water, cooking, and heat from wood stoves, and the icebox

needed ice from town every second day. But the barn was large and roomy (Fig. 20), a perfect studio for Kahn, and the chicken coop could be converted to a studio for Mason. All they had to do was clear out the hay, farming equipment, and rusty scrap metal.

The farmhouse was perched on the side of a hill surrounded by pasture, from which the six-acre property dropped two hundred feet to the foot of the driveway.

Pl. 23
Sunset
1967. Oil on canvas, 44 x 48"
Collection of Judy Black Schlossburg,
New York, NY
Photo: Peter Muscato

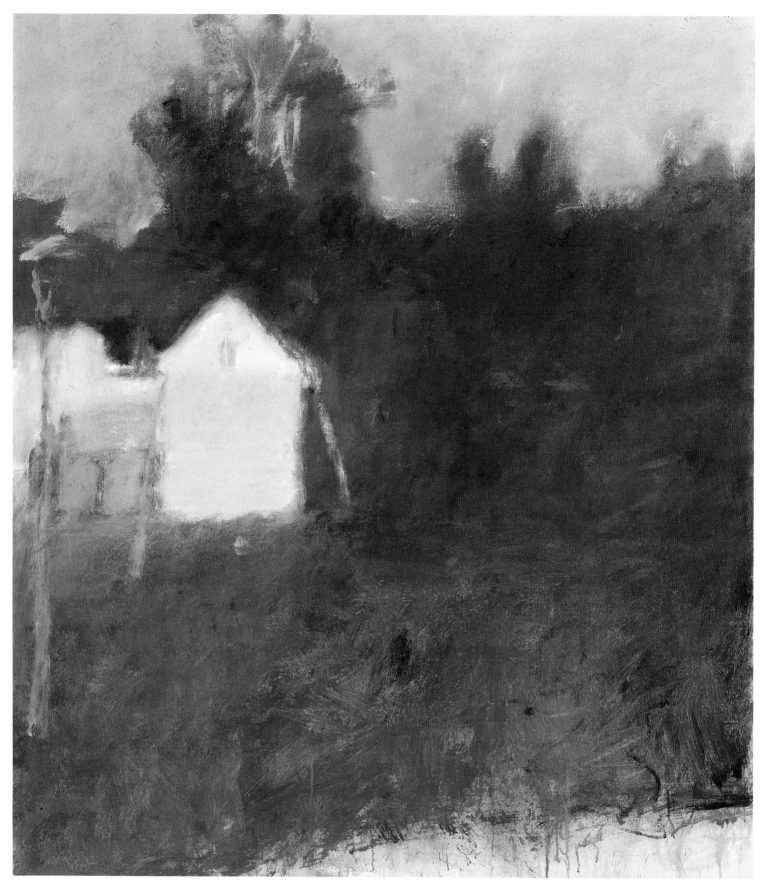

Pl. 24
Yellow House, Maine
1968. Oil on canvas, 50 x 40″
Collection of Roland and Kathleen
Stoughton, San Diego, CA
Photo: Malcolm Varon

Pl. 25
Barn Through the Trees
1969. Oil on canvas, 44 x 50″
Collection of Lola van Wagenen
Redford, New York, NY
Photo: Peter Muscato

Wolf Kahn 63

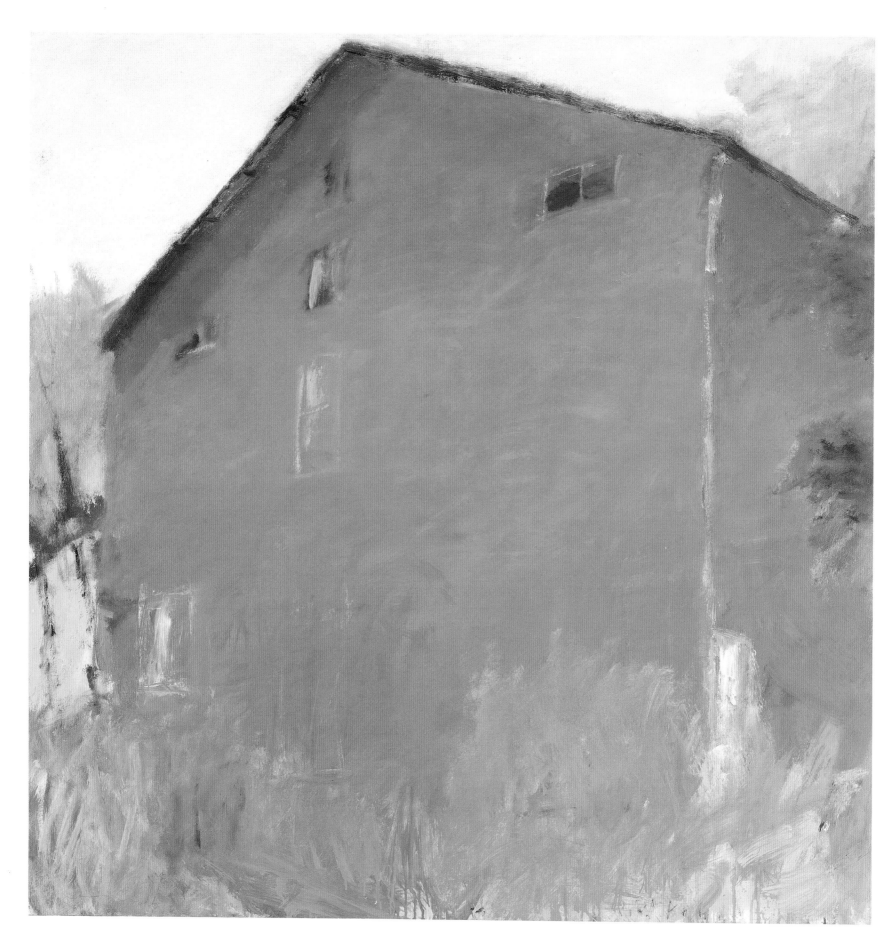

Pl. 26
The Red Barn
1970. Oil on canvas, 50¼ x 50⅛″
The Brooklyn Museum, Brooklyn, NY
Purchased with the aid of funds from
the National Endowment for the Arts

Fig. 20. The barn in Vermont, 1970.
Photo: Emily Mason

Thus the house had a splendid view of the surrounding countryside and an unexpected openness to air and weather. The east-facing slope also caught the morning light, a benefit to both painter and gardener.

In his studio in the late 19th-century barn, lit only by daylight coming in through the door, Kahn turned his attention toward this and similar structures as subjects worth painting. With its weathered, hand-hewn shingles, the great building supported Kahn's observation that "the barn invariably has a much greater presence than the farmer's dwelling . . . our utilitarian buildings, erected without a self-conscious aesthetic, are most often superior to our domestic architecture."[88] An unexpected bonus was that, due to northeastern weather, the barn was a soft blue-gray on the north and east faces, and a deep brown on the south and west, and thus provided Kahn with two differing coloristic visions.

During this period, Kahn created a number of exceptional barn paintings. In *The Red Barn* (1970; Pl. 26) he appears to have settled into a period of richer, darker colors—in part because of the difference of the light so far away from the ocean, and in part because his vision itself seems to have become more forthright. Instead of the tentative dawn and sunset paintings of Maine, *The Red Barn* seems to step out of a full-blown summer afternoon. The sheer volume of the building monopolizes the canvas, as if it were positioned to push the viewer aside. "I got very interested in the idea of confrontation around this time," Kahn recalls. "The barn in this painting is right up against you, right in your face."[89] As the sun blazes down on the barn, its worn red surface (which in places verges through orange into yellow) suggests an emblem of strength and endurance. Such unapologetically assertive colors may have corresponded to Kahn's feelings about himself at age 43: he was now a mature and well established artist, with a strong sense of his own vision. His new self-confidence made him less inclined toward tentative atmospheric effects, and more interested in exploring a new territory of powerful, even aggressive, masses of bright color.

Though its feeling of confrontation is exceptional, *The Red Barn* is only one of a series of barns, farmhouses, and outbuildings that Kahn would paint in the coming years. Unlike the earlier barn of *First Barn Painting* (Pl. 20), which is flattened almost to abstraction, these new buildings take their stand in the landscape, actively projecting their personalities, like country folk sitting for a portrait. Kahn has, in fact, stated that he sees in the American barn "a monument to the best American impulses: generosity, usefulness, permanency."[90] He has also noted that:

Nostalgia in the best sense, i.e., a yearning after a golden age, informs most of the best landscape painting . . . it's most clearly evident in Poussin and Lorrain, in Turner and Constable in a more homely key, and very strong in 19th-century American landscape painting—Ryder, Blakelock, Inness. . . .We in America don't have any antiquity, so for us there is only 18th and 19th century rural nostalgia. It was then we had our heroic age, and a New England

barn is to us as a Greek temple was to Poussin, a symbol of a whole tradition, laden with all kinds of good associations.[91]

Such buildings need not be sited like temples, however, to express those associations. *Through the Gap* (1976; Pl. 29) is a relatively modest painting of the space between the shed and barn on the Kahn farm, but its charm lies in the way the two buildings interrelate: as the land drops away between them, opening a distant view of the grayish-blue Brattleboro hills, the two buildings seem to gaze away from each other, distracted for a moment from some particularly intense spoken exchange. Kahn, in fact, calls this canvas "Question and Answer," for its uncanny conversational feeling.

The Yellow Square (1981; Pl. 30, on p. 6) is a much more ambitious work that slyly pays homage to the favored square color images of Kahn's teacher Hans Hofmann, while at the same time placing that influence in the context of Kahn's own painting.

Pl. 28
Barn Head On
1972. Oil on canvas, 53 x 60"
Mint Museum of Art, Charlotte, NC
Photo: Malcolm Varon

The heroic size of the work (six feet by four feet), made it necessary for Kahn to lay the canvas on the ground to paint, and in fact, much of the sky was painted in as the artist faced the image upside-down. The barn pictured is Kahn's own. In the darkened lower doorway, which formerly led to cattle stalls, a single yellow square of bright light—the window on the far wall—shines through the gloom. The lilac and yellow palette recalls an earlier painting, *Yellow House, Maine* (1968; Pl. 24), but the emphasis has shifted from a subtle balance of tonalities (which gave *Yellow House* an overall evenness and tranquility) to a more direct challenge: to devise a way to paint a block of bright yellow so that it seems to emanate from the depths of a purple-black interior without either "popping" forward from the darkness, or overwhelming the pale, sun-washed exterior represented by the rest of the painting. Kahn accomplished this by integrating a lighter purple into the darkened gloom from which the yellow square glows, thus allowing the eye to adjust from interior to exterior, which is to say from one sort of light to another. The dormer on the roof and the barn doorway form different perspectival axes, a phenomenon that surprised even the artist. "It's a will-

ful distortion that only happened in the finished painting, not in the preparatory sketches," Kahn later observed, "but until it happened, the painting didn't 'work.' It was a classic case of not knowing what the problem was until after I'd resolved it."[92]

Other challenges presented themselves in the joining of organic shapes into the rigorous geometry of farm buildings. *Barn and Apple Tree IV* (1977; Pl. 31) reconciles the two very different textures of a large, dark mass (the side of a barn) with a bright but insubstantial volume (the foliage of an apple tree). "The challenge I'd set myself in this one was to come up with some way in which I could keep the bright yellow of the apple tree from 'popping' or 'battling' the dark, velvety mass of the barn," Kahn observed. "I liked the challenge of it—dense versus feathery, dark ver-

Pl. 31
Barn and Apple Tree IV
1977. Oil on canvas, 52 x 60"
Collection of William Goldman,
New York, NY
Photo: Peter Muscato

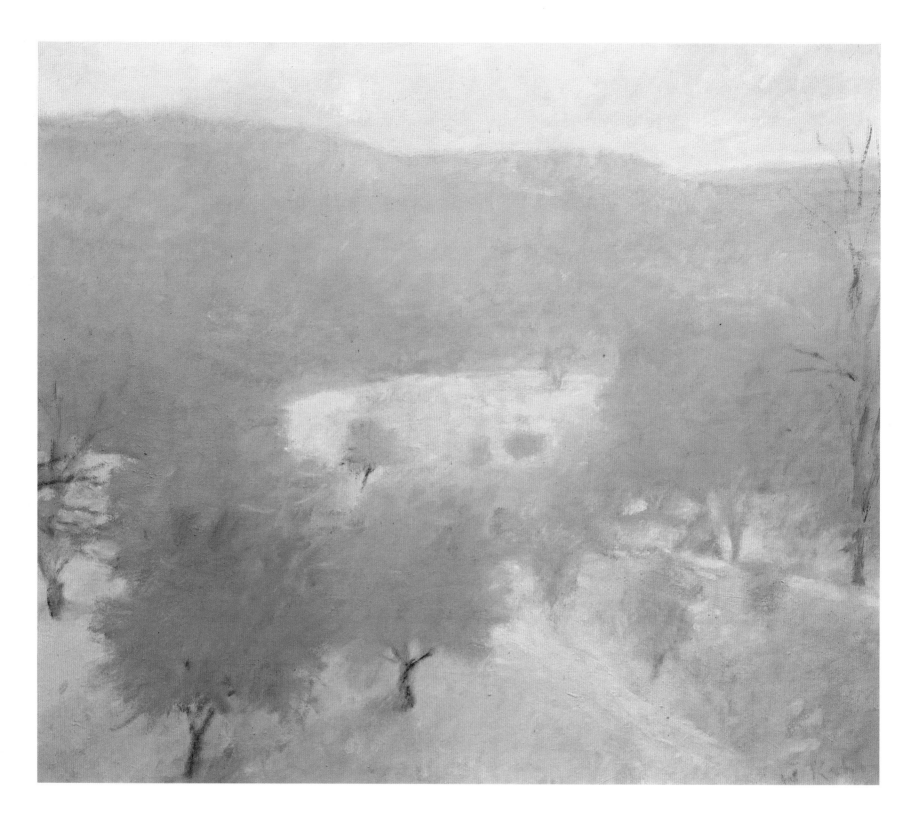

Pl. 32
Sfumatura
1978. Oil on canvas, 44 x 52″
Collection of Steven and Michelle
Manolis, New York, NY
Photo: Peter Muscato

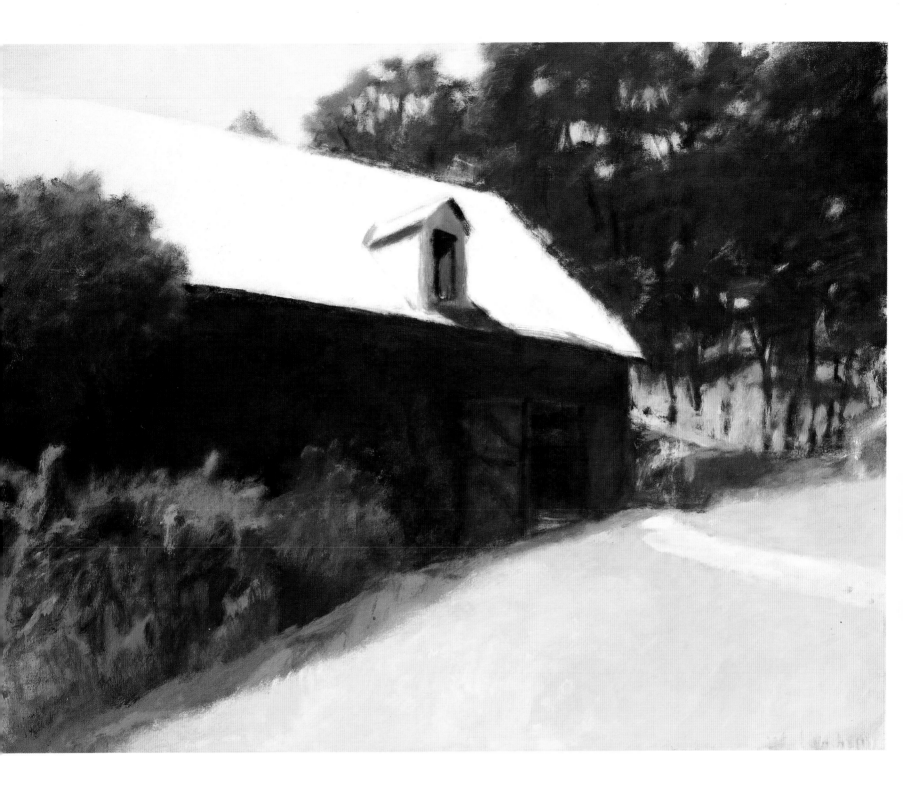

Pl. 33
Black Shadows of Summer
1978. Oil on canvas, 40 x 52″
Museum of Fine Arts, Springfield, MA
Gift of T. Marc Futter

Wolf Kahn 71

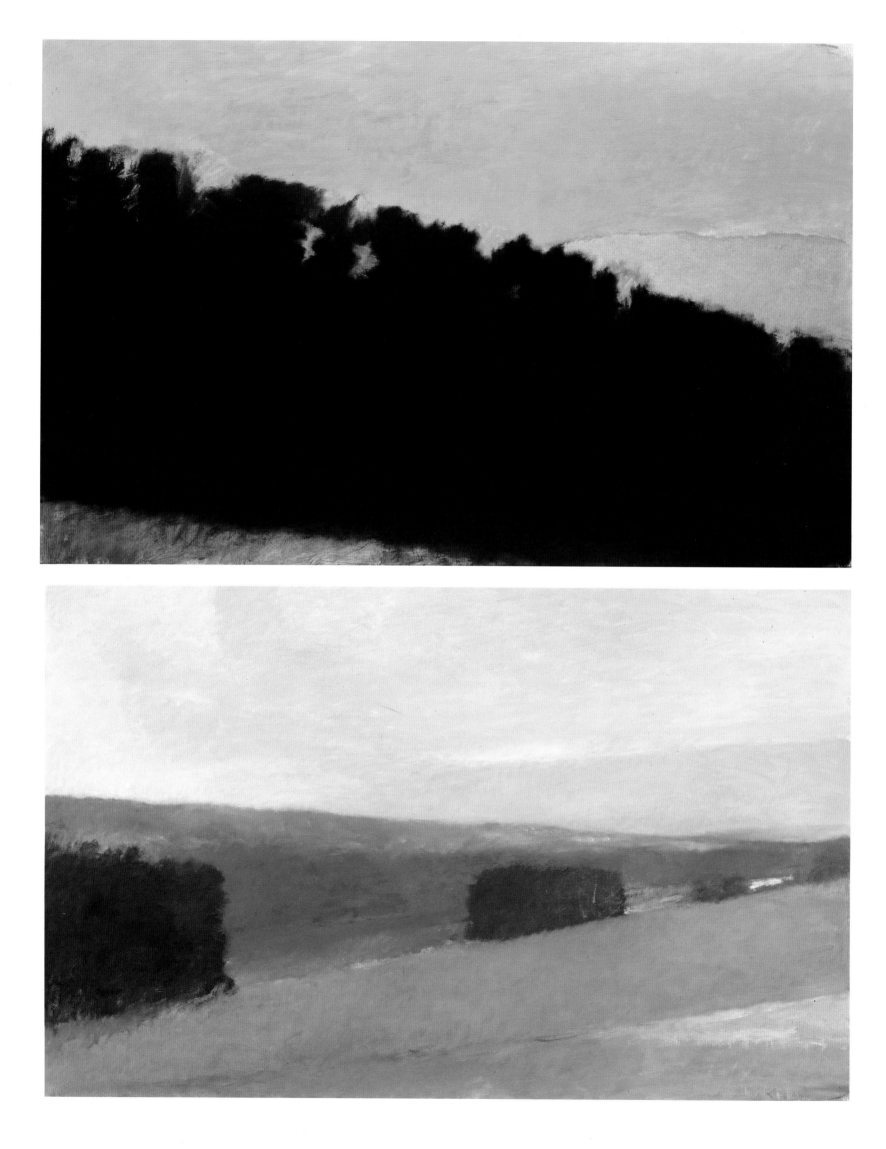

sus light."[93] He resolved the problem by introducing an even more striking chromatic contrast (the blazing white roof of the barn) and then settling both barn and tree into a shadow that integrates apple tree and wall into a conciliatory mix of purple, yellow, and blue. The blazing white roof is then wedded to the dark wall below it through the deftly modeled cupola, with its similar shadow tones of purple, blue, and black. Of these delicate relationships, Kahn has observed,

> All my paintings come down to a simple issue—in this case a seesaw balance between one thing and another. And as far as I'm concerned, the simpler the issue, the better. When a work becomes too descriptive, too much involved with what's actually out there, then there's nothing else going on in the painting, and it dies on you.[94]

Critics responded well to the new developments in Kahn's work. Reviewing the new Vermont paintings in the *New York Times*, Peter Schjeldahl traced Kahn's development:

> [A] painter with roots in Abstract Expressionism, Wolf Kahn long ago turned to a style of foggy, impressionistic landscape painting. The product of this curious choice, which hardly sounds promising on the face of it, has been a singularly rich body of work in a "minor" but intense key. His best, usually thickly painted, pictures have rendered dense atmospheric conditions—gray fogs and golden hazes—in which only the bare outlines of things are visible and local colors appear as fugitive glimmers. The more representational mode of his current show . . . is reportedly the effect not of more painting but of less; evidently Kahn's practically opaque former works all looked like this in their early stages.
>
> Brushy and pastel-bright, Kahn's glimpses of upstate farming country, without his wonted luminous overpainting, help make clear how little his art has ever been "realistic," even in the limited sense of Impressionism. Rather, he is an artist concerned primarily with the direct, sensual experience of color, in the tradition of Bonnard more than of Monet. His colors are brilliant and often searing—hot magenta shadows and grass of acidic yellow-green. These are not colors that sunlight finds in nature; they are colors that an aroused sensibility finds, with joy, in the act of painting. Though quirky, Kahn's commitment to a seemingly played-out style continues to yield delightful results.[95]

Two years later, critic Hilton Kramer, also writing in the *Times*, allowed a similar praise:

> [Kahn's] country landscapes are . . . pure constructions of color, and of color most often observed under the most intense light. There is an emphatic impressionist loyalty in all this that gives his work an immediate appeal.[96]

The only critical doubt about the work focused on the apparent ease with which Kahn arrived at a finished image, and on the fact that Kahn located his painterly investigations in a world of timeless bucolic beauty that could be perceived as comfortable, self-satisfied, or complacent. Art historian Martica Sawin, although generally appreciative of Kahn's work, suggested:

Opposite:

Pl. 34
Afterglow I
1974. Oil on canvas, 42 x 66"
Whitney Museum of American Art, New York, NY
Photo: Malcolm Varon

Pl. 35
The Connecticut River at Dusk
1977. Oil on canvas, 44 x 72"
Rahr-West Museum, Manitowoc, WI

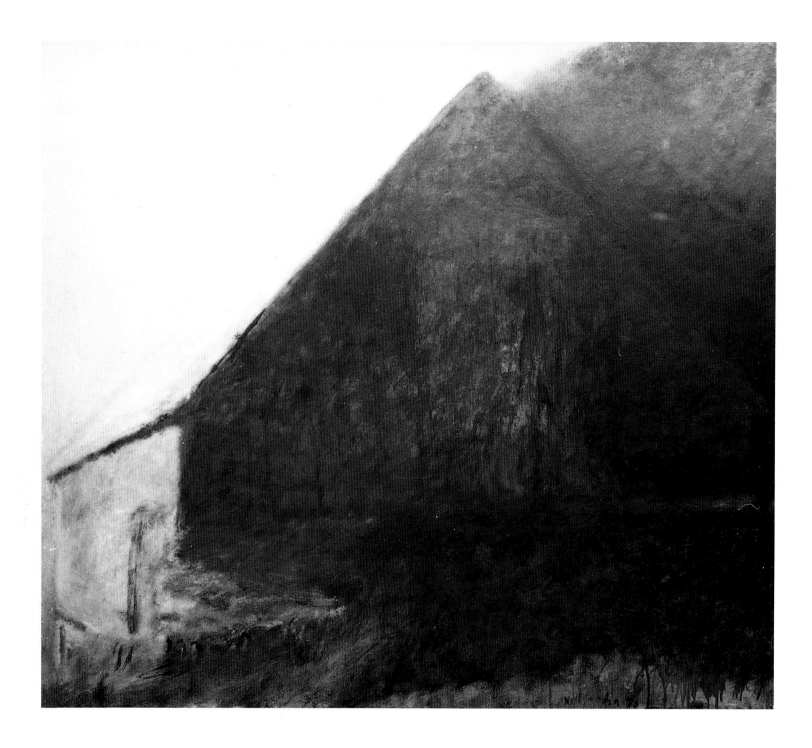

It is likely that his absorption with familiar surroundings is also an antidote for the displacements of his early years. . . . No wonder he repeatedly paints reassuring places, long-observed horizons, tended fields, houses and sturdy barns securely embedded among the hills, and a New England landscape of a comfortable scale. It follows naturally that these images should also have a slightly impalpable and mirage-like quality and that their tenuous presences appear to be on the verge of dissolving into patches of light. . . .[97]

Despite its convincing ring, this argument does not hold up: Kahn's interest in landscape predates "familiar surroundings," for it goes back at least to his days in Venice. And such paintings as *First Barn Painting* and *Edge of the Woods* are not entirely "reassuring." An alternative explanation for why Kahn should paint landscapes, familiar or not, is simply that he likes them. It may well be that Kahn's loving evo-

Fig. 21. Wolf Kahn, *Frontal Barn*. 1970. Oil on canvas, 42 x 52″. Collection of Michael and Julie Rubenstein, New York, NY. Photo: Emily Mason

cation of color and light, so long evident in his paintings, increased in the Vermont works because he took such delight in the view. And perhaps, too, just as in 1956 Kahn's work was transformed in his paintings of Emily Mason, his work of the early 1970s was transformed by the pleasures of his new home. Moreover, if Kahn seems to dwell over much on the beauty of his immediate surroundings, he is not alone. In the biographical sketch of Thoreau by Emerson that serves as a preface to *Walden*, Emerson remarked,

> [There] was a whim which grew upon [Thoreau] by indulgence, yet appeared
> in gravest statement, namely, of extolling his own town and neighborhood as
> the most favored center for natural observation. . . . I think his fancy for refer-
> ring everything to the meridian of [his home] did not grow out of any igno-
> rance or depreciation of other longitudes or latitudes, but was rather a playful
> expression of his conviction of the indifference of all places, and that the best
> place for each is where he stands.[98]

Emerson's words could be applied equally to Wolf Kahn, for whom the act of obser-vation, not the subject observed, has always been of primary importance.

Throughout the 1970s and 1980s, Kahn continued working in the mature style for which he is best known. With a vision firmly established in his own mind,

Fig. 22. Wolf Kahn, *Farm Pond on a Summer Evening*. 1974. Oil on canvas, 40 x 66". Collection of Richard and Liane Weintraub, Malibu, CA. Photo: Peter Muscato

he created paintings drawn from the Vermont landscape, with only an occasional foray elsewhere to paint commissioned works. The New York critical community gradually came to understand his objectives, and thus his shows during these years were well reviewed. Apart from a single negative appraisal from *Art Forum*'s Max Kozloff in 1974 ("A number of canvases are overly schematic or else they display a labored tentativeness"[99]), response was universally enthusiastic, raising some speculation on how Kahn's singular fusion of the traditional and the contemporary should have evolved. Examining the artist's development out of the near-minimalist stance of his gray paintings of the later Fifties and Sixties, Carter Ratcliff noted in 1981,

> It is only in the light of [Kahn's] most recent work, which gives each locale its own climate and time of day, that [his] allover landscapes [of the 1960s] look generalized. And yet the impression that Kahn nearly lost himself ten or twelve years ago is strong because he has so clearly found himself in the last few seasons—I mean, he has discovered a further aspect of his seeing. . . . For the last ten years, Kahn has worked toward those moments when pictorial complexity turns into a unified state of feeling. In abandoning allover form, he has deepened the intensity of his allover moods.[100]

While Ratcliff sought to determine the evolution of Kahn's vision, others began to consider its possible meaning. Seeking to understand the full range of possible interpretations for Kahn's landscapes, the poet and scholar David Shapiro observed,

> In Kahn's work we have a defiant turning away from the tradition of modernist naturalism. He has said that his art of "gentle ease" deliberately turns its back upon the city and its anxieties, but he believes that this deletion is a necessary one. He creates a sophisticated pastoral of ideals: "The artist has always had as part of his function to set up ideals—places where the mind can freely wander.". . . . [Kahn] is a sharp, penetrating observer whose healthy aggressivity could have led him to become a psychological master . . . but he is also attuned to light and repose. . . . If architecture is bound up with the theme of refuge, so is painting. A student of Claude Lorrain, Wolf Kahn yields us the melancholy humor of a "resistance" to everyday life. [Kahn's landscapes] speak of impermanence and of the value of the familiar . . . Day diaries that have the precision of dream diaries, [they] erase or avoid the figure but never the sense of human responsiveness to nature.[101]

Shapiro concludes by noting that however neutral or static Kahn's images may seem, "Landscape . . . is an active protest and has its own politics."[102]

During the early 1980s, Kahn's barn-painting phase came to an end. Although barns would occasionally appear in later paintings as elements of landscape, he no longer treated them as primary subjects, partly from impatience with people who regarded his work merely as barn painting, and (more importantly) because he simply grew tired of painting barns. "I like to say I painted barns in preparation for owning one," he observed recently. "The truth is, once I knew how to do it, I wasn't interested in repeating the performance. I don't like to do performances, I like to do research."[103]

His next area of investigation was the Connecticut River, which Kahn began to explore on a pontoon boat owned by a friend, sketching ideas in pastel that he would later turn into paintings. Riverscapes had always interested Kahn; from childhood, when he had taken walks with his grandmother along the Main River, he had responded to rivers as places of beauty and adventure. And of course, water had always been an important source of optical inspiration—in Chicago, in Venice, on Martha's Vineyard, and finally in Maine. Kahn had necessarily shifted focus after moving inland to Vermont, but even during his barn-painting period he had often

Pl. 36
River Bend I
1978. Oil on canvas, 38 x 41"
Collection of Judith Ehrlich,
New York, NY
Photo: Peter Muscato

included ponds and water elements in his farm paintings. By 1978 he was ready to return to a more substantial body of water, the Connecticut River, which he would continue to paint in the 1990s. But he has been quick to point out that his interest in the river is hardly sentimental: "I picked it formalistically. A river divides the world up right away into four parts—sky, water, left bank, and right bank. From there, you can immediately start playing."[104]

River Bend I (1978; Pl. 36) is a distinctly complicated and dynamic image. As the Connecticut River recedes around a bend, its organic curve contrasts with the recession into space made by the train track at its side. The trees along the near bank almost obscure the river, while the far bank and its reflected image create two matching and nearly indistinguishable areas in the middle left. After the stately and somewhat static portraits of barns, *River Bend I* seems almost chaotic, full of an excitement that spills into the crackling painted trees separating river and railway.

Another source of inspiration during the late 1970s was the art supply store.

For as, in the mid-1950s, Kahn's world had seemed held together by van Gogh's yellow ocher, so in the late 1970s Kahn became obsessed with purple alizarin madder, the results of which can be seen most specifically in *Adams Farm, Evening IV* (1976; Pl.37), *The White Roof* (1976; Pl. 38), *Barn and Apple Tree IV* (1977; Pl. 31), and *Black Shadows of Summer* (1978–9; Pl. 33). Purple alizarin madder would in later years give way to Gamblin transparent orange, along with brief infatuations with other colors, including pink, magenta, and perelyne red.

Discussing his work with critic Dore Ashton, Kahn spoke of his interest in new color:

> I'm always trying to get to a danger point in color, where color either becomes too sweet or it becomes too harsh, it becomes too noisy or too quiet, and at that point I still want the picture to be strong, forceful, and the carrier of everything that a painting has to have: contrast, drama, austerity.[105]

Pl. 38
The White Roof
1976. Oil on canvas, 32 x 44″
Private Collection
Photo: Malcolm Varon

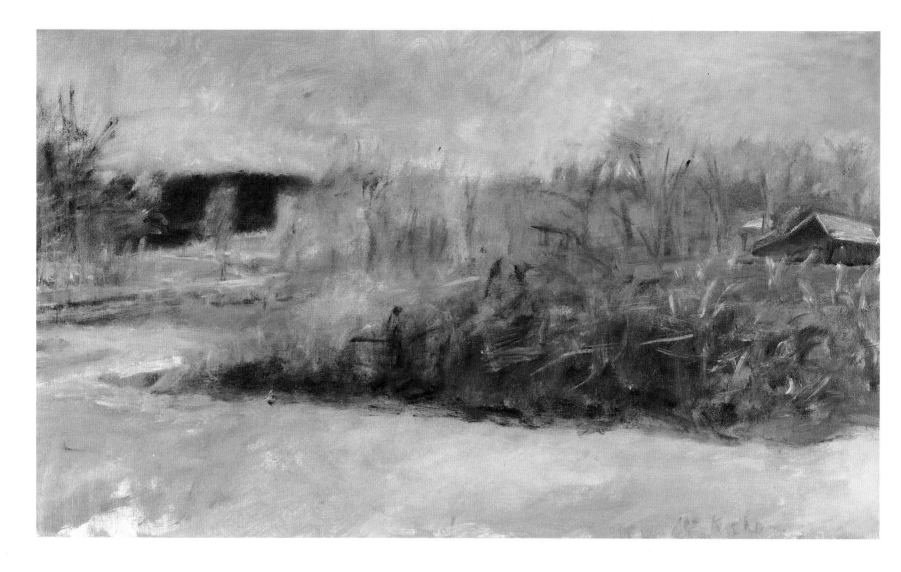

Pl. 39
Brush Pile in Early Spring
1980. Oil on canvas, 22 x 38"
Worcester Art Museum, Worcester, MA
Gift of the American Academy of Arts
and Letters, New York, Hassam and
Speicher Purchase Fund, 1981

Though Kahn had abandoned the barn as a subject, he had not abandoned farm imagery. Along with the river paintings of this period, he continued to paint farm landscapes, including *Brush Pile in Early Spring* (1980; Pl. 39), which renders a very different image of tree branches than *River Bend I*. In this painting, branches are not crackling and energetic but smoky and vague. "I love painting heaps, dumps, and brush piles for the same reason I loved painting olive groves—because they flicker,"[106] Kahn has noted. The brush pile, a mass of pale purplish red-brown, is a good example of such flickering, at once both a solid mass and an open volume in which air and light circulate and play. How to capture this simultaneous weightiness and open quality was the specific formal problem Kahn tackled in this work. The pale foreground adds weight to the pile at the center, while the dark shadow that describes the meeting of brush pile and ground extends the gentle slope of the hill as it falls away from the farmhouse. The tree line in the middle distance, like the brush pile, is rendered as a smoky, purple-brown haze.

During this relatively stable period in Kahn's painting career, his financial situation took a distinct turn for the better. In 1979, advised by the art collector Martin Ackerman, Kahn revised the pricing of his paintings and developed a strategy to sell more of them to museums. As a result, his income tripled during the next few years with no significant change in his artistic output or in his relationship to his longtime dealer, Grace Borgenicht. So it was that, for the first time in his life, Kahn found himself in possession of a steady income.

The change in his financial situation made little difference in Kahn's day-to-

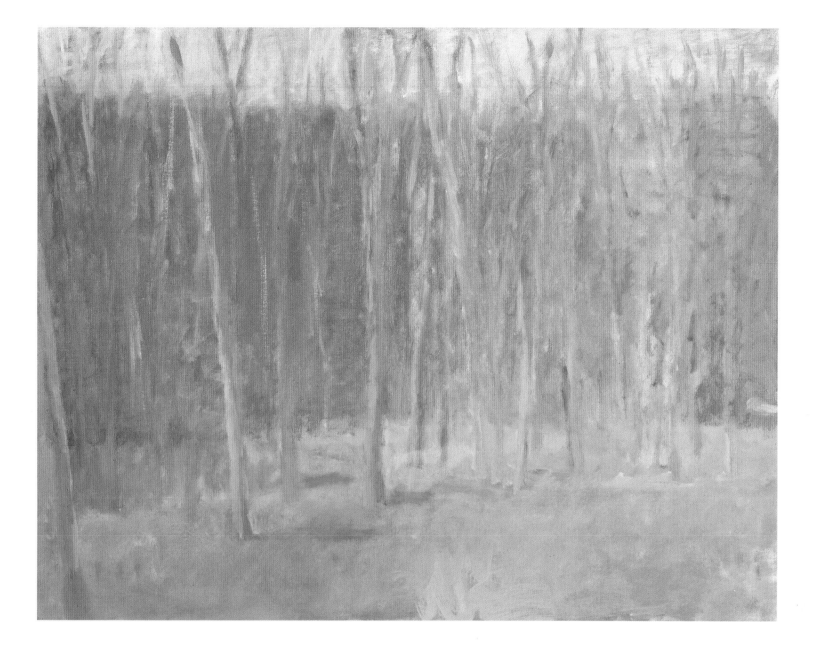

day life. In New York, he continued to live in a third-floor walk-up and work in a fifth-floor studio, and his country house remained modest. But his new-found stability and growing self-assurance allowed him an extended period of artistic concentration in which he could focus intently on color.

The metamorphosis of Kahn's color sense has been perhaps the great development in his painting over the past decade. His relentless pursuit of new color ideas and new ways of portraying landscape through color is apparent in an experience he had while working on a painting of autumn trees:

> I was intent on expressing the fall foliage with the setting sun on it against the cold blue of the evening sky. First I painted the trees a pale alizarin crimson against a cobalt blue wash and something too warm and tropical resulted. I decided to turn each color as cool as I was able, and painted thalo red-rose against a thalo blue and white mixture. The blue came out too dense, too pastel, and I finally tried manganese blue. Voilà! I had it, and in the next few days I built my paintings on this central color relation with interesting results, while that relation was fresh in my consciousness. . . . Today I would have to find a new one, because the old one is stale and I need to start fresh.[107]

Pl. 40
The First Greens of Spring
1984. Oil on canvas, 34 x 44"
Collection of Mr. and Mrs. James R. Palmer, State College, PA
Photo: Peter Muscato

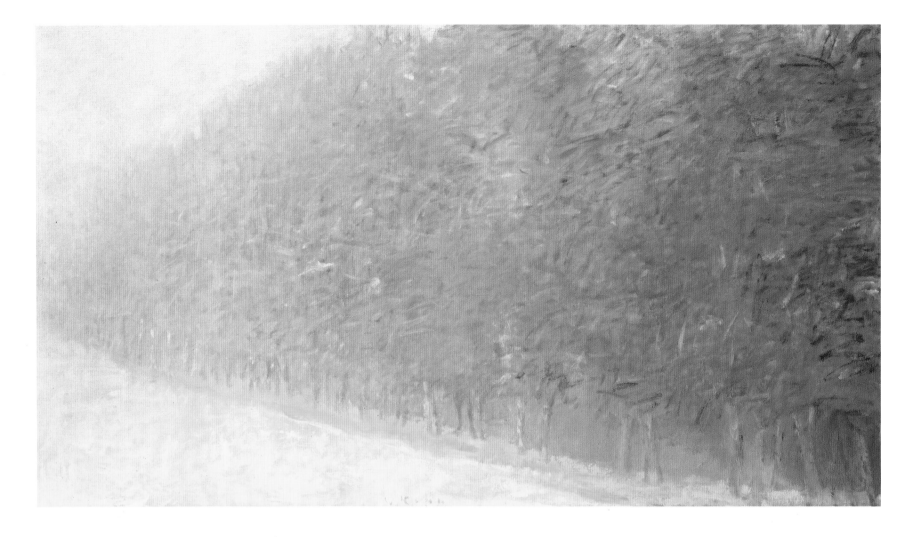

Noting Kahn's restless, ever-evolving color sense, critic Lawrence Campbell wrote:

> Color relationships are abstractions, and all genuine art has always been abstract. There are numerous painters who, like Kahn, paint pictures of "simple nature"—but how many are interested in a color relationship which approaches disharmony and is only made harmonious by the presence of other colors acting as a go-between? Such relationships may be new and unseen by anybody before, and therefore . . . create a new *frisson* of originality. In these color relationships, Kahn merits a direct confrontation with Rothko, but since Kahn is labelled a realist or an impressionist by museum curators, it is unlikely that such a meeting will ever take place—at least not in his lifetime.[108]

In *First Greens of Spring* (1984; Pl. 40), Kahn addresses a subject that will come to preoccupy him in the years to follow, as he moves away from farms and buildings and returns to the world of natural landscape—trees, meadows, and woods unencumbered by the distracting geometry of man-made structures. In this painting, Kahn's pleasure comes from playing with the light greens of early spring—colors whose integration into the landscape takes place in spite of their chromatic intensity, thanks to Kahn's understanding of tonal compatibilities. Despite his commitment to bold new colors, Kahn is careful not to bring too sharp a contrast into

Pl. 41
Yellow Trees Along a River
1985. Oil on canvas, 44 x 80″
Collection of the Artist
Photo: Peter Muscato

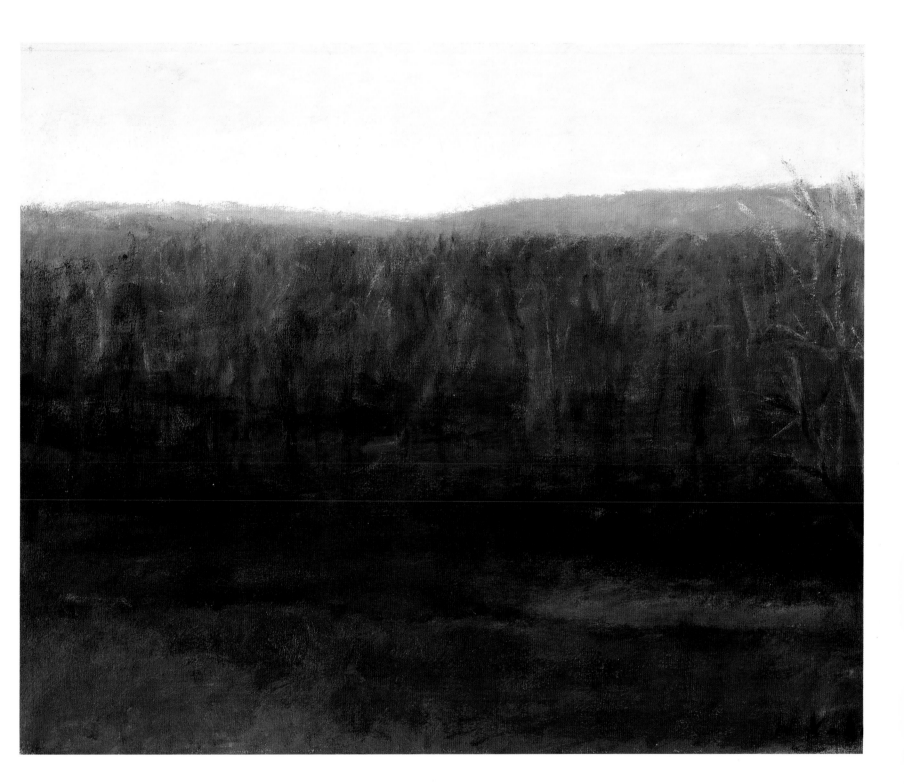

his tonal range. "My knowledge of tonality keeps even the wilder colors from going off into Never-Never Land," he once observed. "I don't want circus colors. There's got to be a certain austerity."[109] In *First Greens of Spring*, Kahn's startlingly artificial greens—which run from Kelly green in the immediate shadows of the saplings towards a milky thalo blue-green—is the subject and the challenge of the painting. The grayed-down blue of the distant woods, the opaque white of the sky, and the streaky green-yellow-brown-violet of the tree trunks is so tonally compatible with this

Pl. 42
Pond in November
1977. Oil on canvas, 29 x 36″
National Academy of Design,
New York, NY
Photo: Peter Muscato

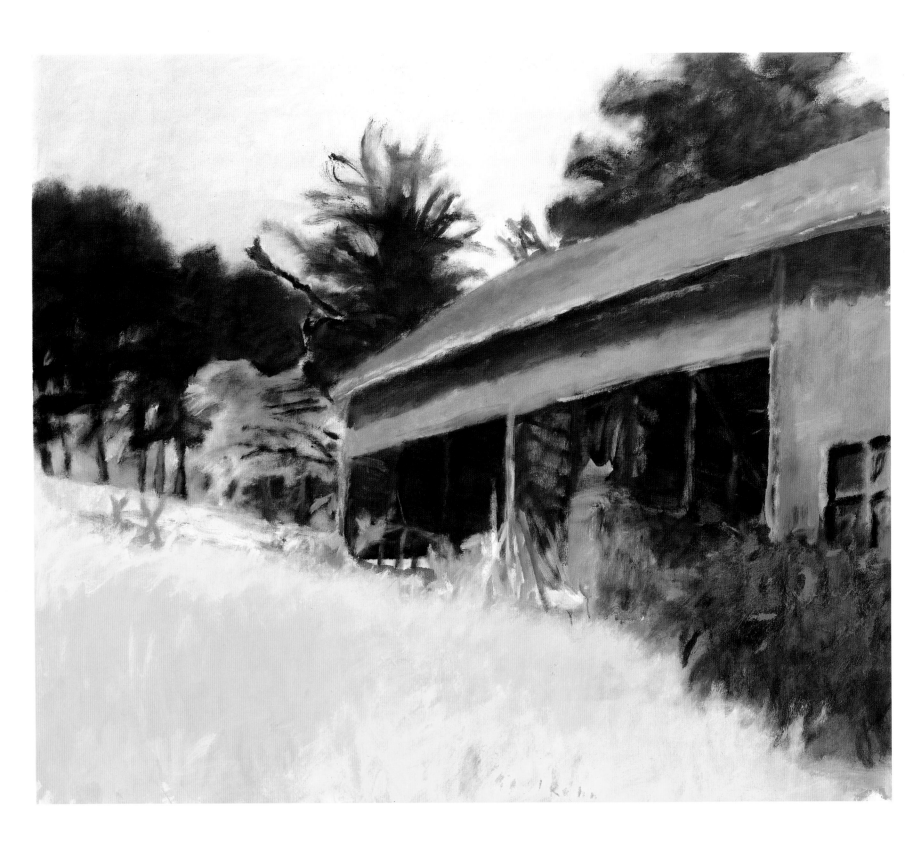

Pl. 43
High Summer
1972. Oil on canvas, 50 x 58¾"
National Museum of American Art
Smithsonian Institution,
Washington, DC
Gift of the X. Sara Roby Foundation
Photo: Art Resource, NYC

strange green that it seems not at all out of place; the young trees seem in fact to bask in its reflected light.

In 1986, Kahn traveled to Washington, D.C. to paint the cherry blossoms along the Tidal Basin as a commission for businessman Bradford Cook. "I was in a pink phase," Kahn later explained. "I thought nothing could be pinker than cherry blossoms—but it turned out they were mostly just white."[110] Kahn's disappointment vanished, however, when his Washington dealers Chris Addison and Sylvia Ripley

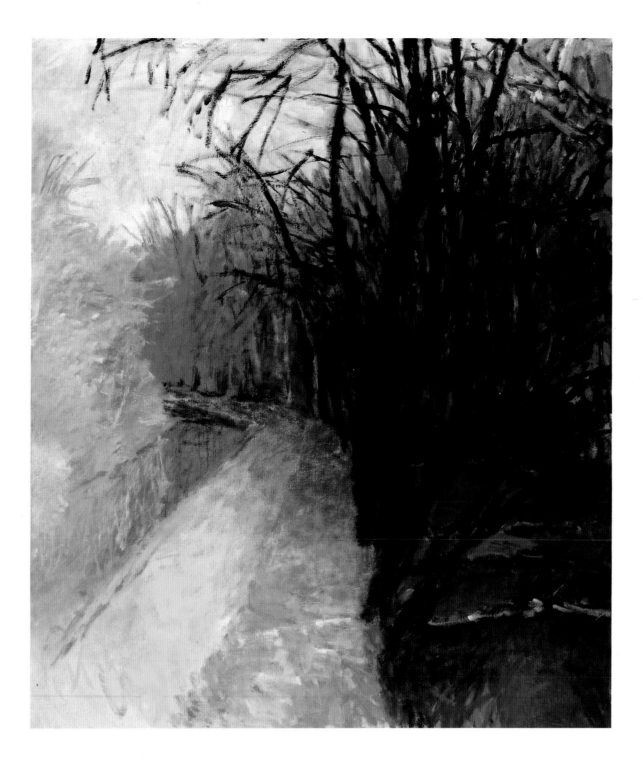

Pl. 44
The Towpath
1986. Oil on canvas, 60 x 52"
Collection of T. Tuft, New York, NY
Photo: Peter Muscato

Fig. 23. Peter and Wolf Kahn,
Trumansburg, NY, 1980s.
Photo: Charlotte Kahn

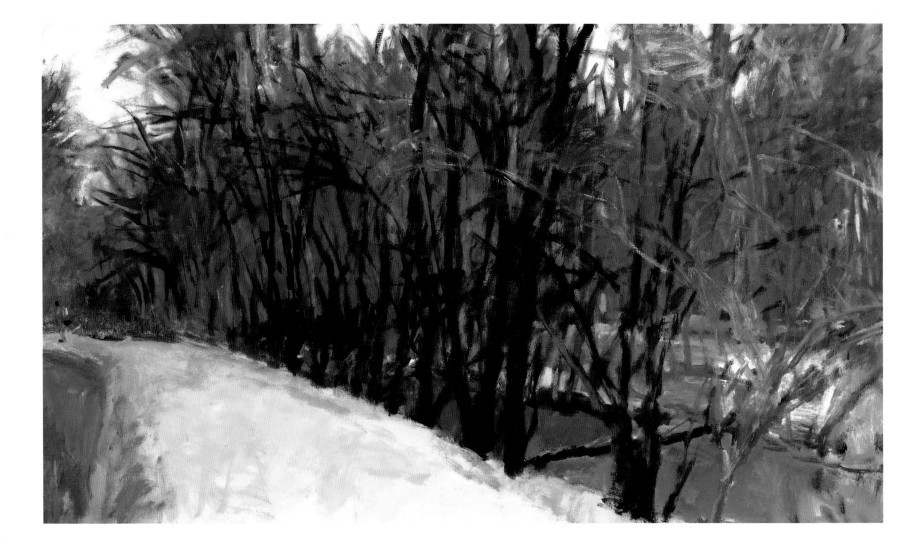

Pl. 45
Runner
1986. Oil on canvas, 30 x 52"
Collection of Ryder Truck Executive
Offices, Miami, FL
Photo: Peter Muscato

pointed him in the direction of the old Chesapeake and Ohio Canal, between Georgetown and the Potomac marshes.

The result was a series of paintings and pastels typified by *The Towpath* (1986; Pl. 44). Though in some ways reminiscent of *River Bend I*, the composition is additionally complicated by the sheer improbability of the landscape itself: an elevated canal in the midst of a swamp. Moreover, the scene features a number of other complexities: severe geometry (in this case, the man-made waterway); tangles of wood and swamp bracken; contrasting perspectival elements (thanks to the differing water levels of canal and swamp); and finally the brilliant, unexpected color combination created by the red clay soil of the old canal towpath. "I loved painting there," Kahn recalled. "It was so visually interesting that I could have stayed forever."[111] Kahn completed nearly fifty pastels and paintings in this series before returning home to New York.

In *Evening Meadow* (1987; Pl. 46), Kahn returns to a more elemental landscape, in which the three areas—field, woods, sky—give a perfect example of Kahn's ambition of "Doing Rothko over from Nature."

"When I started this painting, it was complicated," Kahn recalled. "Eventually, I simplified it down to almost nothing."[112] Kahn had been toying with the idea of re-integrating color field abstraction into representational painting since his days in Venice. Now his statement became more assertive, due to his use of vivid chromatic values. No sky was ever so blue, no field so gold, no line of trees so richly green-

ish black; together the colors powerfully describe a particular quality of light and mood.

Returning to riverscapes, in 1989 Kahn created *Imaginary Shore Line III* (Pl. 47) as an homage to one of his favorite painters, Jacob van Ruisdael. Ruisdael's extraordinarily dramatic feeling for light had long inspired Kahn to play with the dramatic effect of light across fields or reflected in ponds. By the late Eighties, however, Kahn found himself increasingly drawn toward improbable colors and imaginary landscapes for the freedom they offered his vision. With *Imaginary Shore Line III*, Kahn pushes his chromatic values and idealized river landscapes to a new extreme, the dramatic light enhanced by a heightened vision of New England fall foliage and looming, shadowed mountains. Kahn's move toward exaggerated effects of light and landscape can to some degree be traced to his lifelong fascination with Claude Lorraine, although his most immediate inspiration seems to come from innovations in paint manufacture. Of his new, riskier colors Kahn has observed:

> I'm toying with the idea of taking colors that everyone hates, and seeing whether I can give them a respectability, an austerity, and believability, because I love to use these colors—like that pink. Some people like my color

Pl. 46
Evening Meadow
1987. Oil on canvas, 18 x 26″
Collection of Mr. and Mrs.
Allan Kurtzman
Courtesy: Gerald Peters Gallery,
Santa Fe, NM
Photo: Peter Muscato

Fig. 24. Wolf Kahn and Emily Mason with their daughter Melany, New York, mid-1980s

Fig. 25. A visit with Meyer Schapiro in Rawlingsville, VT, ca. 1989. Photo: Emily Mason

Fig. 26. Wolf Kahn and Emily Mason at the Stratton Arts Festival, Stratton, VT, 1990. Photo: Barbara Molloy

Fig. 27. Wolf Kahn visiting Nathan Oliveira at his Stanford University Studio, Palo Alto, CA, 1994. Photo: Ken Elliot

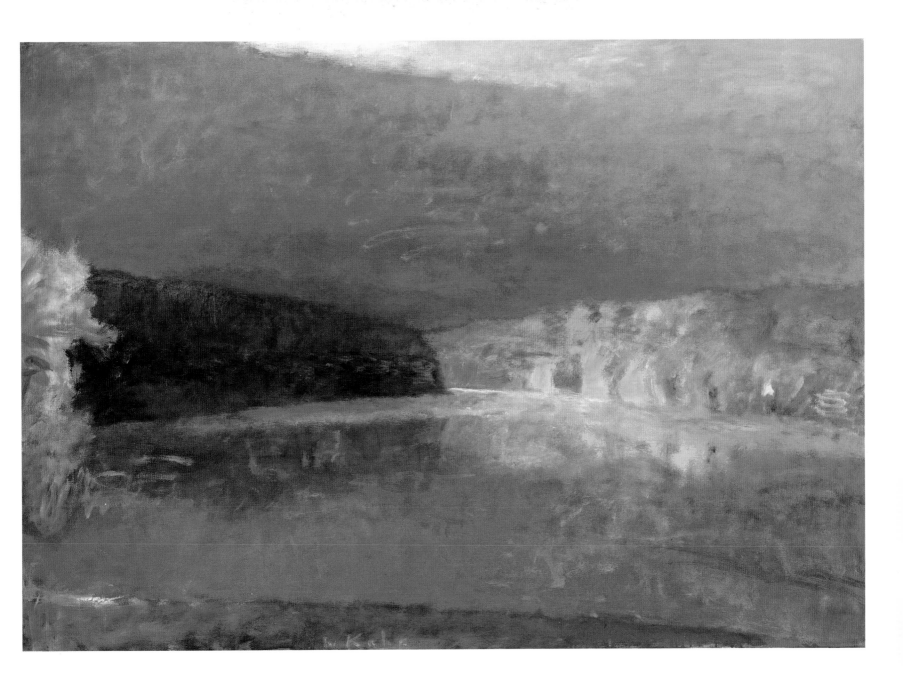

and understand what I'm trying to do, while others think I'm too soft. I don't think I'm soft. I'm trying to use ingratiating elements in an austere way.[113]

Hot Summer (1990; Pl. 48) plays with imaginary color in an otherwise commonplace landscape. The simple image of a river bend becomes a chromatic fantasy "so entirely about color that you don't even think about dark and light."[114] The burnt orange sky, lemon-yellow riverbank, and dusty rose river (which carries reflected orange on the lower right hand side, reflected green-yellow-purple on the left) have a strange effect which, while hardly taken from nature, is not far from it, either; staring into it, one senses a chemical heat that holds an intuitive relation to the physical sensation of warmth.

A Cold Sunset Over Santa Fe (1992; Pl. 49) takes the same issue of *Hot Summer*—using color statements to describe a palpable physical mood—but now the painting describes cold rather than warmth. The colors are equally improbable: cobalt blue and pumpkin orange predominate, with traces of purple alizarin crimson seeping through the complicated dark green-purples of the shadowy valley. The

Pl. 47
Imaginary Shore Line III
1989. Oil on canvas, 36 x 52″
Collection of Mr. and Mrs. Raymond
Friedman, Boynton Beach, FL
Courtesy: Carone Gallery,
Fort Lauderdale, FL
Photo: Peter Muscato

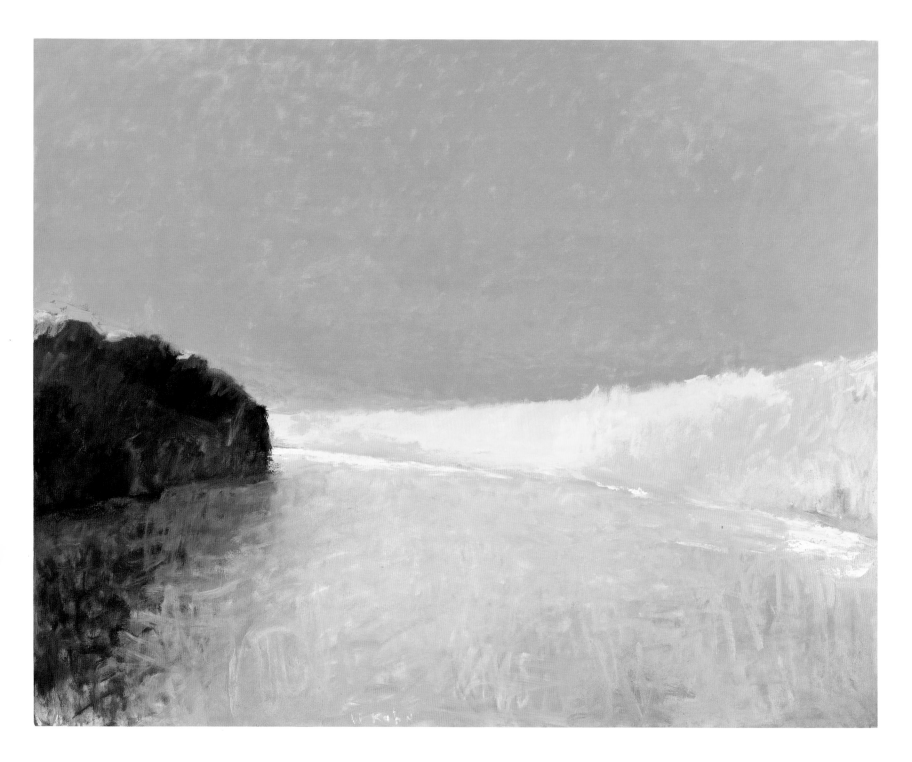

artist was inspired to create the image one evening while attending a rooftop party at a house above Santa Fe. Although the view was gorgeous, the weather was too cold for most of the guests to tolerate. In the quest to capture that physical sensation—the bright, bitter beauty of a frigid southwestern winter sunset—Kahn resorted, once again, to the metaphor provided by chemically brilliant colors.

Such wildly exuberant experimentation can also be found in *In a Red Space* (1993; Pl. 50). A number of compositional elements will seem familiar here: the high horizon line, the intermediate area of tall thin trees, the bright thalo green undergrowth so reminiscent of *First Greens of Spring* (1984; Pl. 40). Yet the real inspiration for this painting was a new tube of paint. "Gamblin, which is one of my favorite paint

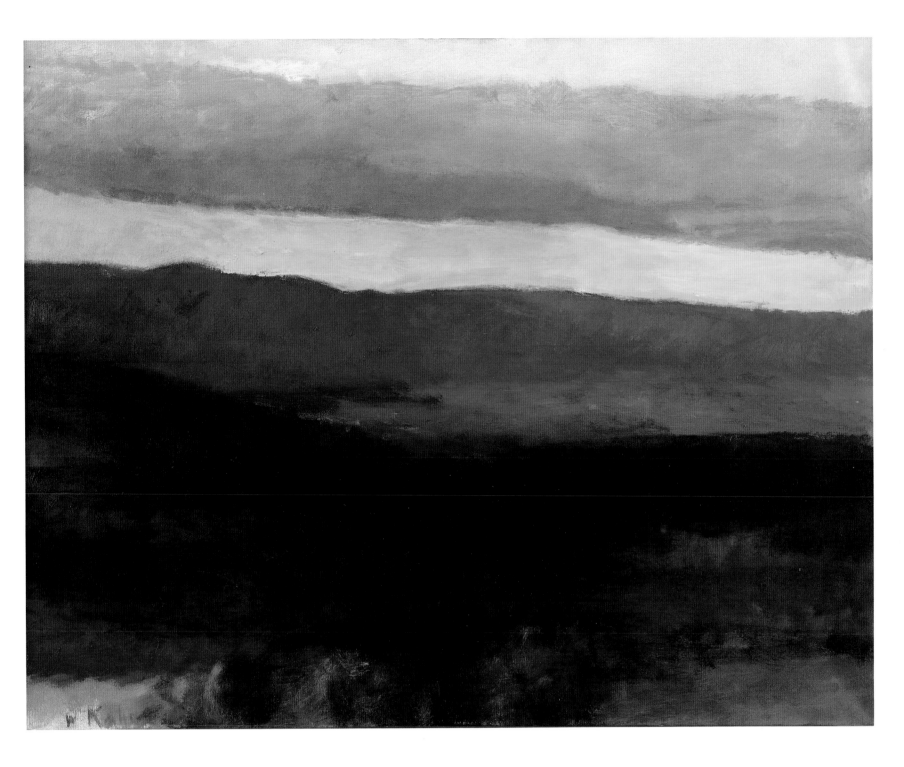

producers, came up with a new color called perelyne red," Kahn recalls. "I got so excited about the color, I had to make it the center of a painting."[115] As a result, the middle distance of the painting gradually moves from orange to perelyne red and through it to magenta. These complex transitions are unified by the trees, which capture both direct light from above and reflected light from below. The space is integrated and believable, despite the extreme improbability of these presumably discordant colors.

In *Orange Maples* (1994; Pl. 51), an equally improbable series of massed colors moves away from the more staid earlier arrangement of colors into simple chromatic bands brought together by trees. This time, an almost musical element is added

Pl. 49
A Cold Sunset Over Santa Fe
1992. Oil on canvas, 28 x 36"
Collection of Dr. Kirby Smith,
Memphis, TN
Photo: Peter Muscato

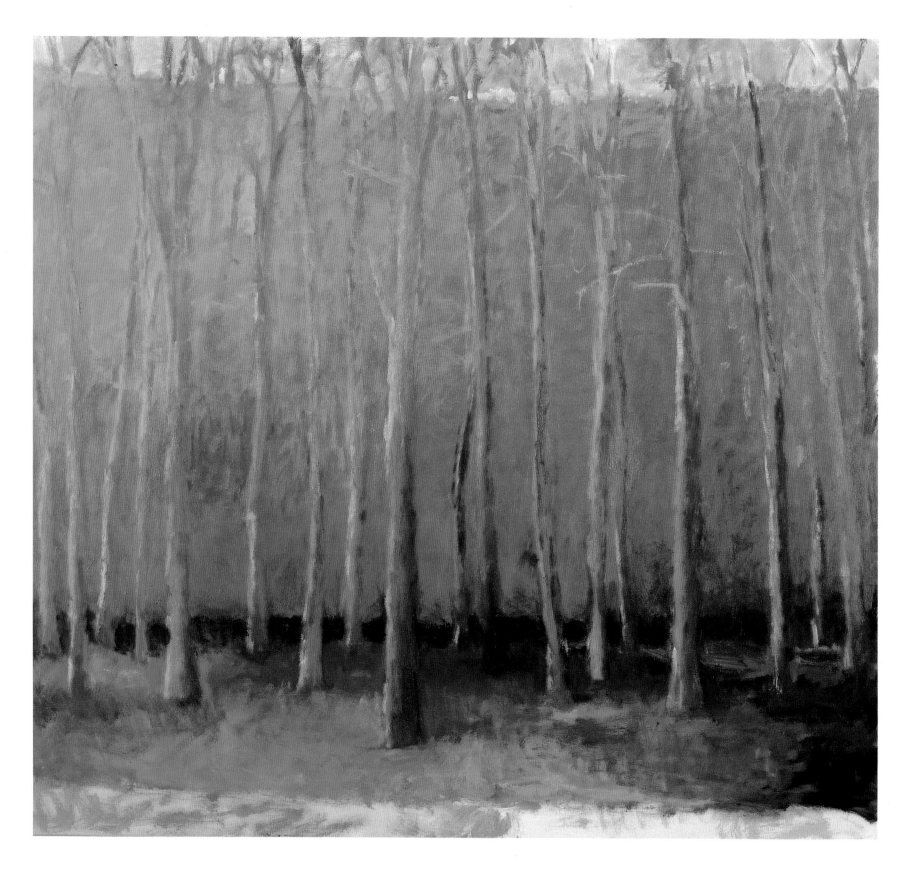

Pl. 50
In a Red Space
1993. Oil on canvas, 52 x 57″
Collection of Steven and Michelle
Manolis, New York, NY
Photo: Peter Muscato

to the picture by the foliage, which is intentionally flattened out into two-dimensional, abstract shapes. "I hate bands of color, but they're an organizing element," Kahn recently observed. "So you might say these orange maples are bands not wishing to be bands."[116] Again, one feels the influence of Rothko in the massing of color to make the principal statement; Kahn flaunts convention by attempting what one

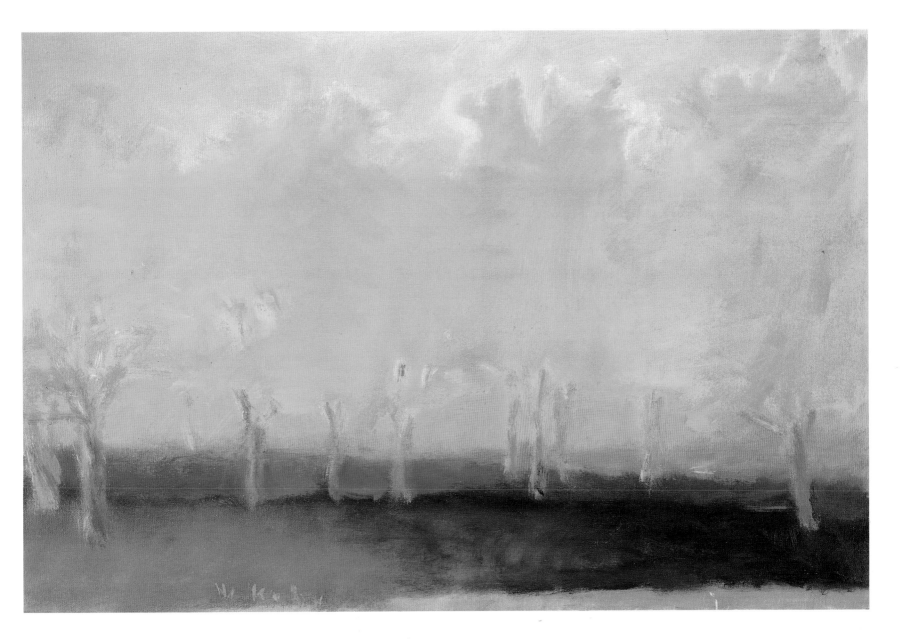

would assume to be impossible: namely, achieving the effect of color field painting with colors that describe a representational form.

While challenging, Kahn's outrageously artificial color schemes in the late paintings have appealed to critics, who understand his use of them as the continuing innovation of a restless spirit. Lawrence Campbell noted Kahn's development, writing in November 1989:

> . . . as [Kahn] gets older, he gets more and more daring—he risks more. He is trying to do things with color that have never been done before. . . . In the catalogue introduction Kahn [states]: "I am always on the hunt for very artificial, very chemical-looking colors, because using such colors initiates a complicated process until they are adjusted to create the feeling of natural harmony and austerity rather than noise". . . . The only painters to equal the intensity of the radiance to be found in a Wolf Kahn painting are Mark Rothko and possibly Matisse.[117]

Pl. 51
Orange Maples
1994. Oil on canvas, 16 x 24″
Private collection
Courtesy: Marianne Friedland Gallery,
Toronto, Canada
Photo: Peter Muscato

Wolf Kahn's career has progressed through several distinct stages. As a child,

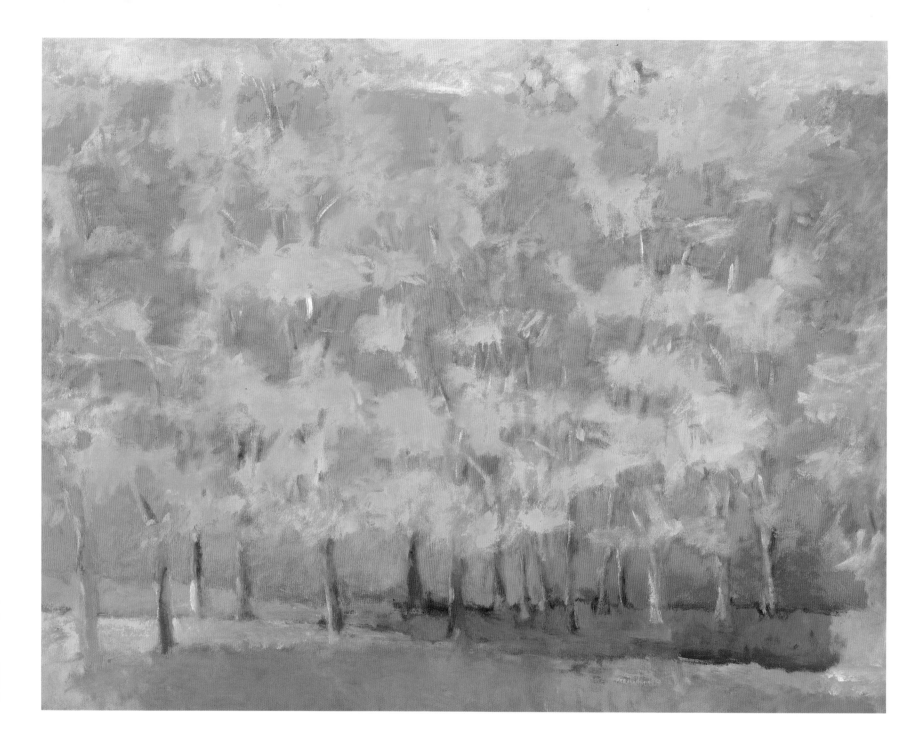

Pl. 52
Field of Trees
1993. Oil on canvas, 36 x 52"
Courtesy: Thomas Segal Gallery,
Boston
Photo: Peter Muscato

his family and early education imbued him with a respect for both tradition and thoughtful innovation. His unsettled late childhood and youth allowed him the freedom and solitude to follow his artistic inclinations, while the disastrous effects of World War II not only freed him from familial expectation, but enabled him to gain an extraordinary art education under the greatest teacher of his generation. During this period of apprenticeship, Kahn absorbed wisdom (and anxiety) from Hans Hofmann, and found inspiration in the works of such European artists as Braque, Bonnard, Soutine, and van Gogh. Like many artists of his moment, Kahn also responded to the work of the Abstract Expressionists, by seeking to synthesize their abstract ideas with aspects of traditional representation drawn from the Old Masters, as well as with various movements of late-19th and early-20th-century European painting, specifically Impressionism, Expressionism, and Post-Impressionism.

Kahn's intuitive sense of color and dedicated pursuit of a new synthetic vision led to a moment of youthful celebrity followed by over a decade of struggle in near-

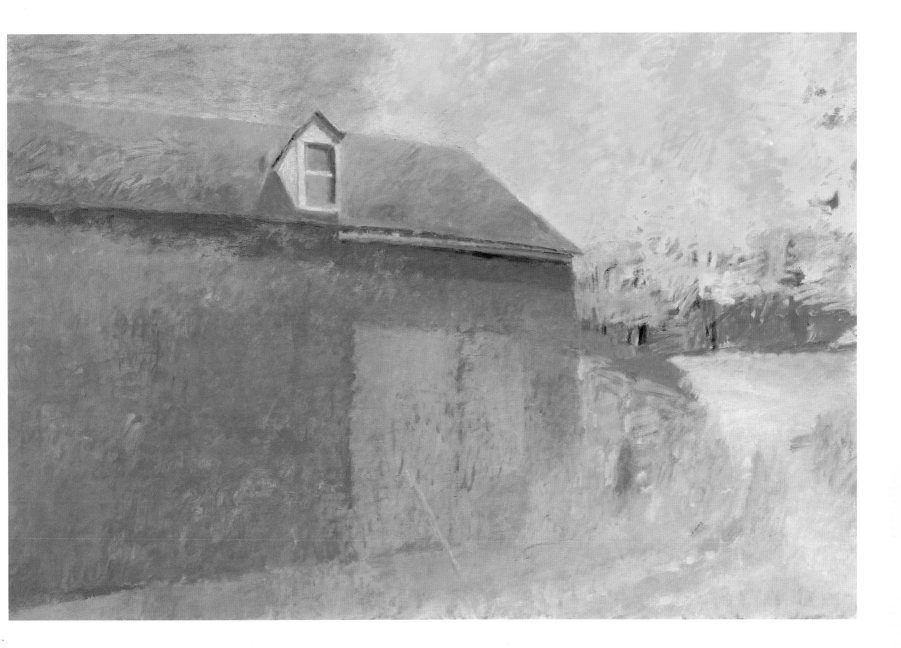

obscurity, during which his development continued unhindered. During this time, his style mellowed, its more virtuosic effects softening into a delicately nuanced sense of atmosphere. Always inspired by light in landscape, the mature Kahn worked first in Venice and then in the Italian countryside before returning to the United States to paint the coastal landscape of Massachusetts and Maine. With his return to the United States in the mid-1960s, Kahn was strongly influenced by Minimalism, but since that time his work has steadily evolved away from painterly abstraction toward a singular style of representation that strives to reconcile vibrant color through careful chromatic and tonal manipulation. He has been influenced, in some measure, by other artists who share his fascination with radiance and atmosphere; critics have noted a direct connection between his work and that of Mark Rothko and, to a lesser extent, Milton Avery. For the past twenty-five years he has charted his own course as a painter of landscape, drawing upon the techniques and concerns of Abstract Expressionism. By doing so he has remained true to an essential impulse: to create work that revitalizes the 500-year-old tradition of landscape painting, incorporating the artistic concerns, techniques, and materials of the immediate present.

A European-born painter with a love of the American countryside, a man dedicated to his craft, but possessing an essentially philosophical and intellectual nature,

Pl. 53
October Barn
1985. Oil on canvas, 53 x 80"
Collection of R. Aron, New York
Photo: Archival

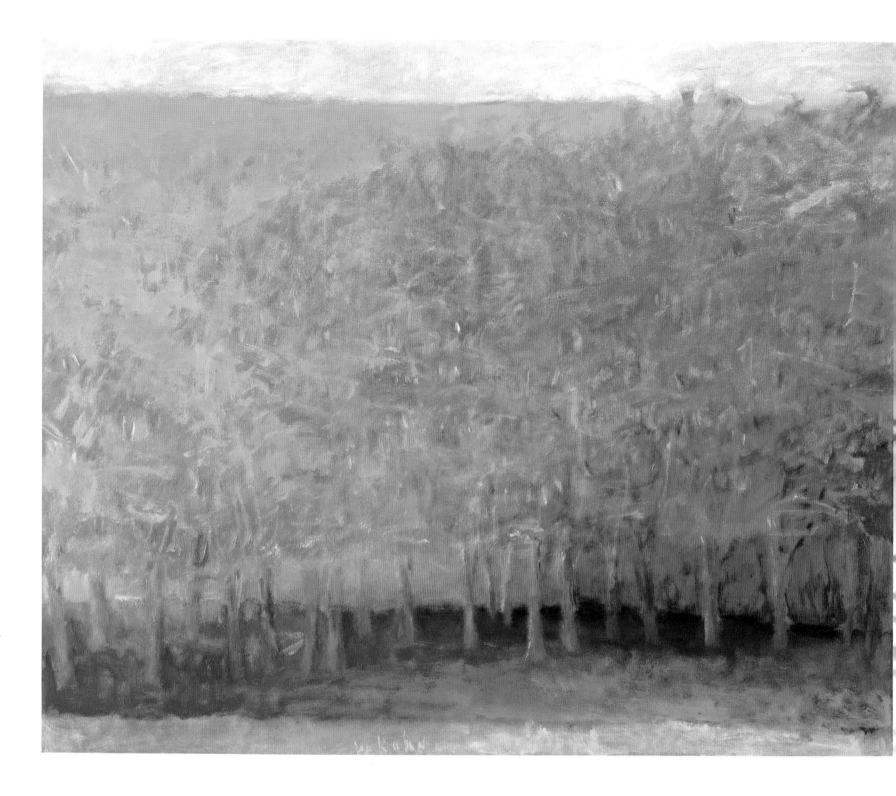

Kahn recently ventured that his art was less a political assertion than an opportunity for personal and spiritual revelation:

> Landscape, of all representational modes, seems to me to be the least affected by fashion, politics, trends. . . . through our investigation of landscape we can express our sense of the connectedness of things, where we stand in relation to them. Above all, we come in touch with those over-arching abstractions that govern our perceptions: the great and the small, near and far, up and down, sharp and soft, smooth and rough. None of this is likely to change soon. . . . People mistakenly think that art is about nature, or about an artist's feelings about nature. It is instead a path to enlightenment and pleasure, one of many paths, where nature and the artist's feelings are merely raw materials.[118]

Pl. 54
Slow Diagonal
1994. Oil on canvas, 42 x 52"
Courtesy: Morgan Gallery,
Kansas City, MO
Photo: Peter Muscato

Notes

1. Wolf Kahn, interview with the author, July 1995.
2. Ibid.
3. Ibid.
4. Ibid.
5. Report card in Wolf Kahn Archives.
6. Kahn interview, ibid.
7. Ibid.
8. Ibid.
9. "Young Grad Exhibits," *Overtone of Music and Art* (high school newspaper), 1953. Clipping in Wolf Kahn Archives, n.d., p. 4. (Author: Susan Stamberg as a high school student)
10. Kahn interview, ibid.
11. Ibid.
12. Ibid.
13. Ibid.
14. Wolf Kahn, "On the Hofmann School," unpublished paper delivered at the January, 1973 College Art Association annual conference, New York. Manuscript in Wolf Kahn Archives, n.p.
15. Wolf Kahn, "Hofmann's Mixed Messages," *Art in America* 78 (Nov. 1990): 189–191, 215.
16. Kahn interview, ibid.
17. Kahn, "Hofmann's Mixed Messages," 189–191.
18. Ibid.
19. Ibid.
20. Kahn interview, ibid.
21. Ibid.
22. Ibid.
23. Ibid.
24. Kahn, "On the Hofmann School," ibid.
25. Kahn interview, ibid.
26. Ibid.
27. Ibid.
28. Kahn, "On the Hofmann School," ibid.
29. Wolf Kahn, "Growing Up to Art in New York," unpublished address to the United Federation of Teachers convention, New York, 1981. Manuscript in Wolf Kahn Archives, p. 2.
30. Kahn, "On the Hofmann School," ibid.
31. Kahn interview, ibid.
32. Ibid.
33. Letters from Kahn to his father, Wolf Kahn Archives.
34. Kahn interview, ibid.
35. Hess, Thomas. "U.S. Painting: Some Recent Directions," *Art News Annual* 25 (1956): 75–76, 80.
36. Kahn interview, ibid.
37. Ibid.
38. Ibid.
39. "Gallery Opens in Village," *New York Times*, 6 December, 1952, p. 19 (no author). Clippping in Wolf Kahn Archives.
40. Clement Greenberg, as quoted in Elaine de Kooning, "Subject: What, How, or Who?," *Art News* 54 (April 1954), p. 26.
41. Kahn interview, ibid.
42. Ibid.
43. Fairfield Porter "Reviews and Previews" *Art News* 52 (Nov. 1953): p. 41.
44. Stuart Preston, "Diverse Gallery Shows: Novices," *New York Times*, Nov. 8, 1953, II, 11.
45. Kahn interview, ibid.
46. Elaine de Kooning, ibid.
47. Kahn interview, ibid.
48. Ibid.
49. Ibid.
50. Ibid.
51. Fairfield Porter, "Reviews and Previews," *Art News* 53 (February 1955): 56–57.
52. Frank O'Hara, "Nature and New Painting" Reprint from *Folder*, no. 3 (New York, The Tiber Press) 1954; n.p.
53. Hilton Kramer, "Exhibition of Paintings, Pastels and Drawings at Hansa gallery," *Art Digest* 29 (February 1955): 24.
54. Kahn interview, ibid.
55. Ibid.
56. Ibid.
57. Ibid.
58. Ibid.
59. Ibid.
60. Ibid.
61. Wolf Kahn, "Milton Avery's Good Example," *Art Journal* 43 (Spring 1983): 87–89.
62. Kahn interview, ibid.
63. Ibid.
64. Ibid.
65. Ibid.
66. Ibid.
67. Ibid.
68. Ibid.
69. Ibid.
70. Kahn, "Growing Up to Art in New York," ibid., p. 5.
71. Kahn, "Hofmann's Mixed Messages," ibid.
72. Ibid.
73. Kahn interview, ibid.
74. Ibid.
75. Ibid.
76. Ibid.
77. Ibid.
78. Ibid.
79. Ibid.
80. Ibid.
81. Kahn interview, ibid.
82. Emily Mason, interview with the author, July, 1995.
83. Ibid.
84. Kahn interview, ibid.
85. Ibid.
86. Ibid.
87. Ibid.
88. Wolf Kahn, "About Barns," unpublished statement, 1971. Manuscript in Wolf Kahn Archives. n.p.
89. Kahn interview, ibid.
90. Ibid.
91. Wolf Kahn, "The Subject Matter in New Realism," *American Artist* 40 (November 1979): 50–55.
92. Kahn interview, ibid.
93. Ibid.
94. Ibid.
95. Peter Schjeldahl, "Wolf Kahn," *New York Times* (Nov.19 1972): IV, 21.
96. Hilton Kramer, "Wolf Kahn" *New York Times* (March 16, 1974), p. 27.
97. Martica Sawin, *Wolf Kahn: Ten Years of Landscape Painting*, exhibition catalogue, Arts Club of Chicago and traveling (Chicago, 1981), n.p.
98. Ralph Waldo Emerson. Quoted in his preface to *Walden* by Henry David Thoreau (New York: Walter J. Black, 1942), p. 12
99. Max Kozloff, *Art Forum*, June, 1974, p. 66.
100. Carter Ratcliff, *Wolf Kahn: Paintings and Pastels* (New York, Grace Borgenicht Gallery, 1981), n.p.
101. David Shapiro, "The Art of Wolf Kahn: The Art of Resistance" in *Wolf Kahn: Pen, Pencil and Pastel* (New York, Grace Borgenicht Gallery, 1986), n.p.
102. Ibid.
103. Kahn interview, ibid.
104. Ibid.
105. Dore Ashton, "An Interview with Wolf Kahn," in *Wolf Kahn: Paintings and Pastels* (New York, Grace Borgenicht Gallery, NY, 1983), n.p.
106. Kahn interview, ibid.
107. Ibid.
108. Lawrence Campbell, "Wolf Kahn at Grace Borgenicht," *Art in America* 71 (October 1983): 185.
109. Kahn interview, ibid.
110. Ibid.
111. Ibid.
112. Ibid.
113. Ibid.
114. Ibid.
115. Ibid
116. Ibid.
117. Lawrence Campbell, "Wolf Kahn at Grace Borgenicht," *Art in America* 77 (Nov. 1989): 194–5.
118. Wolf Kahn, Catalogue statement for B.R. Kornblatt Gallery Exhibition, 1990.

Pl. 55
Landscape Sequence
1994. Oil on canvas, 24 x 32"
Collection of the Artist
Photo: Peter Muscato

98 *Wolf Kahn*

The Development of
Wolf Kahn's Painting Language

By Louis Finkelstein

Some years ago I encountered the noted art historian Meyer Schapiro at an exhibition of Wolf Kahn's paintings. Schapiro's broad smile signaled that he had a point to make. "Look!" he exclaimed, "He makes the abstraction and the representation at the same time." This essay will explore the coming together of these two aspects of painting: what it means, how it came about, and why it is of value.

The dialogue between the abstract and the representational in Kahn's work can be traced back to his study with Hans Hofmann, and particularly the method of drawing from the model that Hofmann imposed, and which was central to his teaching. Through it, he demonstrated the essential breakthrough of modern painting. Most drawing from the model teaches analysis of the human figure in terms of anatomy, pose, and the characteristics of both solid form and detail. Hofmann, however, insisted that the model be seen primarily in relation to its surrounding space. For the artist to concentrate on this, the drawing itself was kept summary, with a minimum of detail. But this was only part of Hofmann's message. For him, the major issue was the construction of all the formal relationships on the sheet of drawing paper, to make it function as a completely coordinated, self-defining whole. This requirement distinguishes modern formalist art as a self-conscious, self-articulating discipline.

A drawing on paper, like a canvas, proposes to represent space. Unlike Leonardo da Vinci's device of making a picture by tracing the outlines of an object seen through a sheet of glass, or the system of linear perspective for which this method was a model, Hofmann's exercise was active, personal, and immediately creative. Students in Hofmann's classes were directed to observe that the very first line drawn established a number of implied forms on the page, defining them as large, small, and placed here or there, and each oriented toward the others in a specific way. By itself, the marked page might be thought of simply as a flat design. Since, however, it presented an analysis of the appearance of a model in a particular spatial envi-

ronment, every line was an expression of an intention to describe space and volume. The act of reading into the flat markings the meanings of the observed spatial relationships creates an element of tension between them. Any new markings added to the paper must be consistent with the ongoing set of intentions.

By contrast, in the traditional academic approach to painting, objects were depicted by means of various conventions, which were regarded as "natural." The importance of Cézanne for Modernism was to show that all such systems are artificial, and that the truly creative artist deals with the tension between what is seen and the constructions made of it.

Neuroscientists tell us that consciousness changes incessantly, and need only be as consistent as is needed from one moment to the next to serve such specific functions as getting from here to there, recognizing someone, or doing a particular job. Consistency is imposed by the continuity of events. In drawing or painting, however, consistency in the real world has to be supplied by an understanding of the overall design as it emerges, and by adjusting and altering its intentions.

Hofmann often drew directly on his students' drawings, both to set a goal and to reveal his method of achieving it. The goal was a perfect, self-defining entity; his method was the careful placement of each new mark, noting its effect on the whole work. This, in short, is the artist's central task. The artist might have various goals and values, portray various subjects, employ various means, but the task remains the same. The great artists of the past—Giotto, Piero, El Greco, Rembrandt—all interpreted and modifed the conventions they received to the same effect. What distinguishes modern formalism is its self-consciousness, both in looking at the works of the past and in becoming aware of how artistic language, shared in various degrees but given pointedness and revelatory power by individuals, determines the felt values of experience.

Hofmann's teaching frequently included analyses of the works of old and modern masters, through which he showed that art was a serious humanistic enterprise, while at the same time giving to art-making a practical underpinning, relating the drawing exercise and the decisions it demanded to the highest achievements of art. Hofmann's drawing exercise is important to our understanding of Kahn's art, because Hofmann's precepts of the autonomy of the picture, and of the artist's need to discern the relationships of the parts to the whole, run through Kahn's work in an important way.

Kahn's continuing stylistic development has been focused on the depiction of nature and the use of color. The turn to nature by artists of his generation was partly a reaction against the extreme subjectiveness of Abstract Expressionism, but it was also inspired by that movement's opening up of the possibilities of an artistic language that moved beyond Cubism, which had been the authoritative model for serious formal painting throughout the Thirties and Forties. As Kahn and his colleagues looked for an art grounded in direct experience, landscape beckoned on two counts. First, it represented a common experience that needed no explanation, and secondly, it is inherently accommodating to a free, spontaneous development.

What Kahn's generation explicitly did not reject was Abstract Expressionism's standard of totally integrated form, although they did deny that this could only be achieved through abstraction. They also rejected the dogmatic insistence on the historical inevitability of abstraction, and its superiority to representation. At one point these issues were debated in an exchange between Kahn and Jack Tworkov. When

Tworkov asserted that there was little difference between painting an actual object and painting an abstraction, Kahn countered by saying that the fun was in taking an object in nature and trying to make a painting out of it. Thus he affirmed both the self-sufficiency of the work, and the fascination of transforming a vision of the world.

During the 1950s, Americans had the opportunity to see important exhibitions of the paintings of a number of modern European artists whose work embodied this position, including Monet, Matisse, Bonnard, Vuillard, Rouault, and Soutine. These exhibitions caused a reevaluation of the place of these artists in modern painting. Whereas previously their work had been seen as a finished chapter of the historic past, and even, by some artists, as an artistic backwater, now they were appreciated as a source of suggestions of what to do and how to do it.

Much of the new respect accorded these artists involved a revaluation of the sensuous, and especially, of color. Traditionally, color had been thought of as inferior, or at least subordinate, to drawing. It was considered not only less intellectual, but as merely charming or decorative. This prejudice derived from several sources, primarily from Plato's depreciation of sense experience, and it had led Renaissance Florentines to value *disegno* over *colorito*, in the belief that color appealed primarily to the baser human appetites. Michelangelo, among others, had reproached Titian's sensuous treatment of flesh surrounded by atmosphere as too infused with the character of the material world to attain true loftiness of expression. The same thinking was reflected later in the idea that the Impressionists had "no form." Similarly, Willem de Kooning remarked to me in 1950 that he avoided color because it was "a seducer." Indeed, when de Kooning first exhibited *Woman I*, what struck me as the most important change in his work was not his often-noted return to figuration, but rather the embrace of carnality through his use of color.

The movement toward color reflected a general change in feeling among artists about the kinds of experiences that painting might express. Arshile Gorky's late style of color veils was an early instance of this, and Philip Guston was certainly involved in the groundswell, as was Mark Rothko. Such coalescences of feeling are hard to explain, and are often only seen long after they occur, their aims and objectives only partly understood. In my own view the shift was an embrace of a belief that the deepest part of our humanity is rooted in the flesh.

Color functions in painting in a variety of interrelated ways. It segregates components of the picture into groups, and provides a means of plastic definition, complementing drawing in its expression of spatial tensions. In Hofmann's teaching, color could be used, not to copy nature literally, but to construct relationships of quantity, placement, and interval, to create the effects of volume and luminosity. Color intervals do not have the absolute character of pitch in a musical scale; rather, they are known comparatively within a particular context. The appearance of a color, and therefore, its plastic function, is affected by the color to which it is adjacent—an effect known as simultaneous contrast—and also by the color range of the entire painting. Colors also have different identities depending on whether the edges that define their territory are hard or soft, or whether transitions in their tonality are smooth or abrupt. Thus a change in one color within a painting will alter the appearance of all the others.

We interpret color intuitively in a painting, just as we apprehend the plastic intentions of a drawing. Thus, we see it as if we were seeing the facts of nature. Likewise, we see an artist's depiction of the effect of light, not as a system of calculated

highlights and shadows, but as a "natural" element pervading the entire picture.

I once saw a striking demonstration that this is the result of the intuitive understanding that I call "reading into." In the Detroit Institute of Fine Arts there is a small Cézanne painting of Mt. Ste.-Victoire seen through trees. A woman who had been looking at the painting for more than five minutes suddenly exclaimed to her companion, "Oh, it's full of sunshine!" in way that unmistakably showed that she had just come upon that interpretation. She was not simply seeing the appearance of the colors, but "reading into" them. One reason that the Impressionists were so poorly received at first was that it took some time for their audience to develop this new way of reading. Along with reading the effect of light, the viewer must construe properties of density, transparency, and translucency, which impart a new feeling of the existence of objects in an enveloping and luminous atmosphere. This is what is meant by the saying, "Turner invented the sunset."

The aspects of color that depend on the viewer's "reading into" them address the same underlying issue raised by Hofmann's drawing exercise of the autonomy of the work of art. If there is a law of color (and Hofmann said that there was, although he never defined it), it would work through our intuition of the interaction of the colors in a painting. Indeed, the achievement of a specific vision is too complex for it to happen any other way.

Color also expresses feelings. We have little vocabulary for feeling, nevertheless small changes of sensation evoke very different responses. One might feel, for example, that a certain red carries associations of royalty, and whatever that might suggest: dignity, elegance, opulence, or power. But change that red ever so slightly and the feeling changes, evoking associations of violence, exoticism, or sexuality. Naturally these responses are different for different individuals, but they are shared to a degree according to context and culture, and they are integral to painting. Colors, indeed, have an associative content that makes their experience an integral part of our internal lives, giving rise to color preferences and color symbolism. Such responses are inherently subjective. When colors are combined to conform to the needs of a particular painting, a new and distinctive phenomenon emerges. I call this (for lack of any other suitable term) "the color statement." By this I mean to point out the way in which color, intrinsically, combines its various aspects: simultaneous contrast, spatial tension, description of light and air and density, together with its emotional and associative content. Nothing but color in painting acts this way, and each painting is a special instance of it. Over time, Kahn's work as a whole is a striking example of this mode of synthesis.

The range of possibilities that opened up to painters in the Forties, Fifties, and even the Sixties, was shared by Wolf Kahn and his close acquaintances such as Lester Johnson, Gandy Brodie, Felix Pasilis, Joan Mitchell, Robert De Niro, Jane Freilicher, and Nell Blaine. This group particularly esteemed Bonnard, Soutine, Matisse, and Monet, because their work provided formal alternatives to Cubism, all closer to direct experience. Bonnard's use of color made him a particularly important figure. Previously, Bonnard, like Monet, had been viewed as having "no form," and indeed, as long as "form" was thought of as applying only to the tactile, sculptural aspects of painting, this was almost inevitable. When the idea of form is expanded to include the essential synthesizing of the work using all of its components, color and form were fused, and the dichotomy of "form and color" disappears.

At the same time, the handling of paint itself was revalued. "Paint quality" in

the Fifties suggested thick, irregular, churned-up, worked-over, drippy, or slashing strokes, and in short, emphasized the physical presence of the pigment. All this was reflected in Kahn's painting of the period, and in various ways has continued to the present.

Irregular paint-handling has a long history. We see it in the work of Hals, Rembrandt, Goya, and Delacroix, followed by the Impressionists, whose strokes seem to break up the object. In contrast to this, Seurat's regular system of dots, whatever its utility for color analysis and resynthesis, explicitly freed him from personalness of expression. Almost the opposite is true of the work of Seurat's contemporaries, Cézanne and van Gogh. Cézanne's discrete, squared-off brushstrokes of the 1870s and later blunted the role of descriptive detail in his painting, and simultaneously imposed an architectonic structure not inherent in the objects themselves, but stemming from the artist's contemplation of them, and from his urge to create an autonomous, self-sufficient entity parallel to nature. For van Gogh, and later for Soutine, visibility of brushstroke was intended to bring the elements of a painting together in unified movement.

Paint-handling confirmed the artist's connection with the meanings expressed by the painting itself. The physical accidents of the paint were left visible, heightening the viewer's empathy, that is, sharing the sense of the artist's physical involvement in the making of the work.

The tactile quality of the abstract painting of Philip Guston in the Fifties inspired many artists to explore the suggestive qualities of paint itself, which caused Clement Greenberg to complain, misplacedly, I thought, of "homeless realism." The interest in "paint quality" represented both a rejection of abstraction's earlier quest for the "pure" quality of flatness, and a search for "impure" ones, so that while flat, a painting could stand for anything else. The textures of "painterliness" serve in descriptive painting to differentiate focus. In both abstract and representational painting they shape—in an analogy to musical composition—a work's "inner voices." Finally, paint quality often signifies not only turmoil, but also its opposite: grace, fluency, closure, the completion of interweaving of all the constituent parts, a physical unity that stands for a felt unity of intentions.

Kahn's paintings in these years included portraits, interiors, and still lifes, as well as landscapes, which were to become virtually his exclusive concern some time later. In their overall look they resembled amalgams of Soutine and Bonnard. Their tactility and use of gesture recalled Soutine, although it was observed that Kahn's sympathies lay less with the subject depicted than with the play of brushstrokes. The pastels of the early Fifties also exhibit considerable choppy activity inside the forms. These describe surfaces tilted in different directions in space. From Bonnard comes the juiciness of the color (also reminiscent of Soutine) and the overall quality of radiance and airiness.

These qualities figure significantly in two paintings of 1956, *On The Deck* (Pl. 10) and *Late Afternoon* (Pl. 9). The subject and presentation of the former is reminiscent of two interdependent paintings of 1905 by Matisse, *Siesta* and *Open Window*. In the Matisses we see the separate elements, objects, or colors and the way they join into a whole. In the Kahn it is the other way around; we see the glow and its flavor overall and then from this we realize the precision and necessity of its parts. In the second, *Late Afternoon*, the specification of the whole is not accomplished by the sizes and placements of the separate color areas, but by the modulation of intensi-

ties, which can be seen particularly in the refinement of the grays, of which Bonnard is a great master. How far this moves from Expressionism can be seen by comparison with another painting, *Sara* (Pl. 7), painted in a similar environment in the preceding year.

Kahn's subject, scheme, description, color, and paint-handling were dramatically recast in the course of his first sojourn in Italy in 1957–58. The overall look of the paintings that came out of this period could be called "minimalist," but they have nothing to do with the later movement of that name. Rather, their apparent simplicity contains a host of motives and influences, as well as the complex way they were worked out. The beginnings of Kahn's "minimalism" can be seen in *Large Olive Grove* (Pl. 11), painted on a hillside outside Spoleto in the winter of 1957–58. Seeing its relation to the motif and to his earlier work, I could not, for some time, understand what he was up to. The painting retains some Expressionist tilts, zig-zags, and agitated brushwork, but the grays, which hitherto had mediated among the more saturated colors, took over the surface, giving it a different kind of, and indeed a different role for, atmosphere. The trees have lost their particular structure and identity, and have moved to the edges of the canvas, leaving a vague and expanding agitation overall. This sense of overall movement was to dominate Kahn's work for roughly the next decade. Following *Large Olive Grove*, are a number of horizontal, largely gray, atmospheric canvases, portraying open spaces: a view across a plain (Pl. 13), the Umbrian hills (Pl. 12), or fog in Venice. Recently I saw a painting from this period in Venice that I had not seen before. At first glance it looked simply like a surface that had been covered with several layers of medium light gray paint; but whether it was by the effect of the small differentiations or by my relating it to the rest of his body of work, it seemed filled with luminous atmosphere, and movements within the space. The element of "reading in" that was first implicit in the Hofmann drawing exercise has been displaced from particulars to the character of the canvas as a whole. Later, when Kahn returned to the U.S. he applied the pictorial language he had developed in response to the visual character of Venice to new subjects. This reversed the usual relation between subject matter and form, for instead of adapting his pictorial means to what he was looking at, he sought out subject matter as a pretext for using his new vocabulary. He painted light over water, curtains of trees, sailboats, land meeting water, the edge of forests, and densities of forests. Occasionally, almost as a concession to the world of local facts, he would paint a firebreak or power line going through a mass of woods.

In this same period he assimilated influences from the work of a number of other artists. The significance of influences is not, in the long run, where they have come from, but the uses to which they are put. Kahn has never disavowed the impact of other artists on his work; rather, he has shown a remarkable capacity to reshape them into his own distinctive vision. It was as if Venice, with its open skies, shimmering lights, sunsets, and fogs, had set new tasks for painting. These were only to be realized through the usages Kahn brought along with him and the accumulated and constantly revised subjective intentions he focused on them. An important part of his baggage was New York paint—that is, the idea of paint-handling that was current in the New York of Jackson Pollock, Franz Kline, Philip Guston, Willem de Kooning, Joan Mitchell, Gandy Brodie, and Lester Johnson. The reigning idea was clotted, smeary, drippy, cruddy, splattered, worked over, tortured, desperate, dismal, and voluptuous—garlic and sapphires in the mud—a testament to the autonomy of

painting over nature.

There were also the ghosts of earlier artists who had worked in Venice and whose language had been transformed by it: Turner, Whistler, and Monet. Each of these had a different impact on Kahn. Monet's was the most obvious, perhaps because his paint quality often has the same worked-over build-up as Abstract Expressionist paint. Kahn rapidly adapted these richly interwoven surfaces, as well as their distillation of air to the all-over flickering of light on water. At the same time, his silvery gray tonalities, and his feeling for form dissolved in atmosphere, are reminiscent of Whistler.

The impact of Turner was the most overarching and long-lived. In his watercolors made in Venice in 1819, Turner—in contrast to his later practice—shifted his task from the description of particular objects and local colors to the color of space itself. Indeed, he was the first artist to show that combinations of pure colors create, in their own way, the sensuous reality of light and space. When the luminosity and transparency of these watercolors are projected into oil paintings, we can see the congruence of the actual paint and the colored vapors of Venice. The principal issue was the transformation of the depictive aims of painting by the means of execution.

The first reaction of other painters to Turner is often to attempt to emulate his sensuous splendor. For the Impressionists, his inspiration was directed back to the analytical study of nature and its appearances. For Kahn it served instead to heighten the dialectical tension between the impression drawn from nature and the "power and practicability of art" (Turner's phrase).

Two exhibitions that Kahn saw while in Italy, one of the work of Jackson Pollock in Rome, and the other of Mark Rothko at the Venice *Biennale*, also had a far-reaching effect on his work. In Rome he saw that the space of Pollock's skeins of drippings had nothing to do with the analysis of internal relations, as in Chardin and Cézanne, but created "a non-hierarchical space." That is, no element or area assumed any greater importance than any other. This struck him as having an immediate emotional authenticity; and it became for him a means of observing and handling what went on in the painting. Eventually he was convinced that this was a necessary and distinctively modern way of experiencing in general.

The effect of seeing Rothko's paintings was even stronger. Kahn had certainly seen Rothko's work in New York, but in Venice it stood up in seriousness and impact, not only against an international array of contemporaries, but also against the glorious weight of the past. In this context, it asserted the legitimacy of an alternative way of seeing and expressing to that of the entire European pictorial tradition, through the openness and solidity of a few simple, very specific, completely frontal shapes, which took over the entire canvas. Later Kahn was gradually moved to incorporate the most expressive of Rothko's devices into his own work, including the worked-over but not piled-up extension of color over the surface. When I asked Kahn much later how he perceived Rothko's surfaces, he answered, "Dry and airy at the same time."

Of equal or perhaps greater importance was the use of color, specifically the radiance that emerges from the dramatic juxtaposition of color chords, together with a soft gradation of edges, which gives to all the shapes the quality of light. This emphasis on radiance, both in the treatment of detail, and in the all-over effect, led Kahn to state his aim as "Painting Rothko over again from Nature."

Kahn also came to esteem the work of Milton Avery, an early influence on

Rothko, as well as the paintings and etchings of Giorgio Morandi. He particularly admired the way every element—color, placement, shape, volume, and above all, touch—in Morandi's compositions were consolidated into the whole, so that the most simple ingredients could produce, by their subtle variations and adjustments, a profound and complex poetry. Not all of these influences were incorporated into Kahn's work immediately; they were sorted out and transformed gradually by his ongoing commitment to the depiction of the natural world.

Kahn's most significant break was with frontality, the presentation of forms parallel to the plane of the picture. The impulse toward planarity is powerful, and runs historically from Egyptian reliefs through Greek sculpture, Byzantine mosaics, Italian Renaissance painting, and the work of many later artists including Mondrian and Ellsworth Kelly. While penetration of the surface was already implicit in Kahn's curtains of trees and atmospheric effects, and in his extraordinary recapitulation of the late Monet in an untitled painting of 1960 from Martha's Vineyard (Pl. 15), when frontality as a governing scheme gave way, it had a profound significance for his entire painting language.

This occurred in *Glimpse of a House by the Beach* of 1965 (Pl. 56). The squarish shape, the misty atmosphere, and the edges of the major elements reiterating the edges of the canvas still assert the frontal character of the picture, with one dramatic difference: between the house at the upper left and the base of the tree trunk at the right margin, the picture incorporates a diagonal recession into deep space. The equilibrium of the work requires a new way of reading the role of air, weight, and position in his art, for the elements that are to be "read into" are no longer merely descriptive, but structural. This change in space composition brought with it a new role for color, in which the hazy sunset glow of soft-edged grayed pinks, golds, and blues transformed the silvery gray tonalities of previous years with a new radiance. Now the subtle modulations of loosely brushed passages that denote distance (or nearness) and mass (or translucence) regulate the viewer's reading of these interior modulations of space and volume. This new concern for spatial definition, which suggests the movement of the eye into depth, establishes an empathy between the viewer and the picture. This is something very few artists can control, and few viewers learn to appreciate, for every artist interprets the way forms recede into space in a different way. The recession of forms is a major expressive component of Rembrandt's drawing and etchings of farmhouses, for example, and one sees it also in the tilted ground plane of Monet's haystack paintings. Its regulation is a constant concern of Cézanne's landscapes after 1880, and Renoir, Soutine, and de Kooning all use it masterfully and idiosyncratically. Indeed, this intuitive interpenetration of forms and space is one of the most personal features of an artist's method of composition, standing in stark opposition to the mechanical and experientially false system of linear perspective, which both the Impressionists and Cézanne had rejected.

This new sense of spatial recession, achieved with color, became an indispensable part of Kahn's vocabulary. A comparison of *Glimpse of a House by the Beach* of 1965 (Pl. 56) with a painting of similar chromatic range of nine years earlier, *Late Afternoon* (Pl. 9) will show what a fundamental change Kahn's new usage was.

In 1966, Kahn's *First Barn Painting* (Pl. 20) signaled another new movement in his art. The subject of the painting was an abandoned structure he had found looming in the midst of the woods on Martha's Vineyard. The trees form an intervening medium analogous to the curtains of trees in his earlier landscapes, but set against

Pl. 56
Glimpse of a House by the Beach
1965. Oil on canvas, 42 x 48"
Collection of the Artist
Photo: Peter Muscato

Wolf Kahn 107

them now is the dense mass of the barn, which seems to encroach on the space of the observer. The contrast of this imposing bulk with its surrounding of air and trees is a restatement of Kahn's earlier device of organizing the space surrounding an object with the space actually occupied by it, but now there is also an added play of transparency and density.

First Barn Painting and *Glimpse of a House by the Beach* prefigure a widening development of references and resources. While Kahn's range and emphasis on color were expanding, so also were his devices for describing space. He painted with an immediate sensuousness the glow of sunsets and reflected light, the time of day and year, and the local colors of specific objects, but he also depicted the manner in which the masses and voids of specific structures interact with the edge of the picture.

The Red Barn (Pl. 26) of 1970, when compared with *First Barn Painting* of 1966 (Pl. 20), demonstrates how far Kahn had carried specific depiction while retaining the primacy of abstract relations. The cylindrical metal tank at the right corner of the building, reflecting the light of the sky, the window openings, and the eccentric slant of the gable define the tilt of the barn's front end; both jut forward against the background plane of the trees at the left, beyond the ocher yellow field. That patch of color is answered by the slightly more olive ocher at the upper right, and the pinkish buff of the ground in the lower right corner. Leading the eye into the space of the painting are various forms grouped around the edges of the frame: clumps of tall grass at the bottom and left, dark foliage at right, and the dark posts and tree trunks back at the left, all set at different depths. The artist is neither merely expressing the "personality" of the barn, nor articulating the purely technical problems of the abstract structure of the painting; one cannot exist without the other. (This is the basic claim of all formalism.) Between the first barn painting of 1966 and this example of 1970, Kahn had certainly developed his talent for convincing description, especially a care for the individual appearances of things and the means of translating this into paint (indeed, he once bragged, "I can paint the fuzz on a peach"). Henceforward, this convincingness was to be both at the service of, and precipitating agent for, new insights into pictorial form. Kahn was to employ all the freedom, rigor, self-awareness, and engagement with the means of painting that Greenberg claimed undergirded the historically necessary dominance of abstract painting, but in a way that stood the critic's complaint against Abstract Expressionism's "homeless realism" on its head.

"Realism" is a blunt and incautious word, suggesting a spirit of documenting and depending on particulars, a literalistic subservience to the world of facts. I prefer generally to use the word "representation," which is more neutral and denotes the interplay between motif and motive. This re-presenting works itself out in the double dimension of space and color, which in all of Kahn's subsequent paintings are complementary. Change the color, and the space reads differently; change the movement of the space and color has a different appearance and function.

Recently I had the opportunity to observe how this interaction works in Kahn's painting. He had in his studio a small painting, about thirty inches across, depicting a body of water, the near bank, the far bank, and the sky in four shallow wedges of color, fairly equal in size. The solid elements were a greenish orange, the sky and water cool grays. Shortly after I came in he put the painting on his easel and painted while we talked, brushing colors into the still wet paint, continuously but subtly changing what was already there, both in regard to the overall color relation-

Pl. 57
Height of Autumn
1973. Oil on canvas, 38 x 48″
San Diego Museum of Art
Gift of Mr. and Mrs. James Nathan
Photo: Philipp Sholz Rittermann

ships, and the articulation of each edge with its neighboring color. As he worked, making only the most delicate changes, I saw that the angle of tilt and relative weight of each area were altered with each modification. He remarked that at one point he had been attracted to the effect of minimally discernible contrasts in the 1960s paintings of Paul Brach, and that the effect of such decisions on his own work was critical. This statement, and its demonstration, echoed a phrase Cézanne wrote to his son, that, while painting on the banks of the Arc River, by bending his head this way or that, he could see a host of motifs.

A substantial part of Kahn's mature work after 1970, shortly after he found a permanent summer home in West Brattleboro, Vermont, explores the visual possibilities in nature that his working process generates. The house and its environs have provided a number of motifs that he has worked over many times. These come in groupings, some of the same place, others of the same formal schemes, to which he gave differing treatment in color, proportion, and position. They are not, however, series in the sense of Monet's haystacks or Rouen cathedral façades, because they are not, as Monet intended, interdependent, defining each other by showing the same subject under different conditions of weather and light. In Kahn's work the same formal idea may recur many years apart, sometimes as a close variation, sometimes in a completely new spirit.

Throughout, there runs the element of synthesis, of bringing the components of the picture together not simply as a copy of nature, but in terms of their interaction. This is nowhere more evident than in his use of color. The first intimations of this came one summer when we exchanged visits in Maine. While visiting on Deer Isle I saw Kahn paint a tree that was, to me, dark green in pure thalo blue, a very intense and acid color, right out of the tube. Later, while looking at a field behind my studio on Cranberry Island, which I again saw as green (although a different green from the previous one), he insisted that it was orange. On an even later visit to Vermont, I watched him make a pastel of the sun coming up through trees. None of the colors he used matched any of the colors that I actually saw there; but the effect of their relations admirably caught the radiance of that summer morning. In the intervening time I had seen a painting by Monet of a locomotive in the Gare St.-Lazare painted with a full Prussian blue, very close to Kahn's thalo. From such experiences I can discern something like a method. Often, when working from nature in pastels, which, of course, are separate sticks of color, one has the impression, no matter how many sticks there are, of lacking the proper color. There is nothing to be done but to use whatever is at hand, that is, propose a color hypothesis, and proceed by making whatever relations are necessary to make the whole scheme work. Indeed, Kahn has frequently said that he, too, is often involved in searching through his palette for just the one color that gets the others to coordinate. The artistry is not in matching a given color, but rather in matching its effect: its luminosity, its weight, its modification of the colors around it, its chromatic distance from them, and its plastic function. The matching is never a literal one, and the effects created are emotional and thematic. They eventuate, in Kahn's work, in convincing illusions of fidelity by means of colors that separately are astonishingly unlike the colors one finds in nature.

One can see this synthesis at work in the painting *Woodshed* of 1975 (Pl. 58). The roof of that shed is not the purple pink you see in the painting, nor is its local color "objectively" modified by the color of the light from the sky, nor was there ever a foreground of grass that lemon yellow or that lime-pale a tree. It is only the way

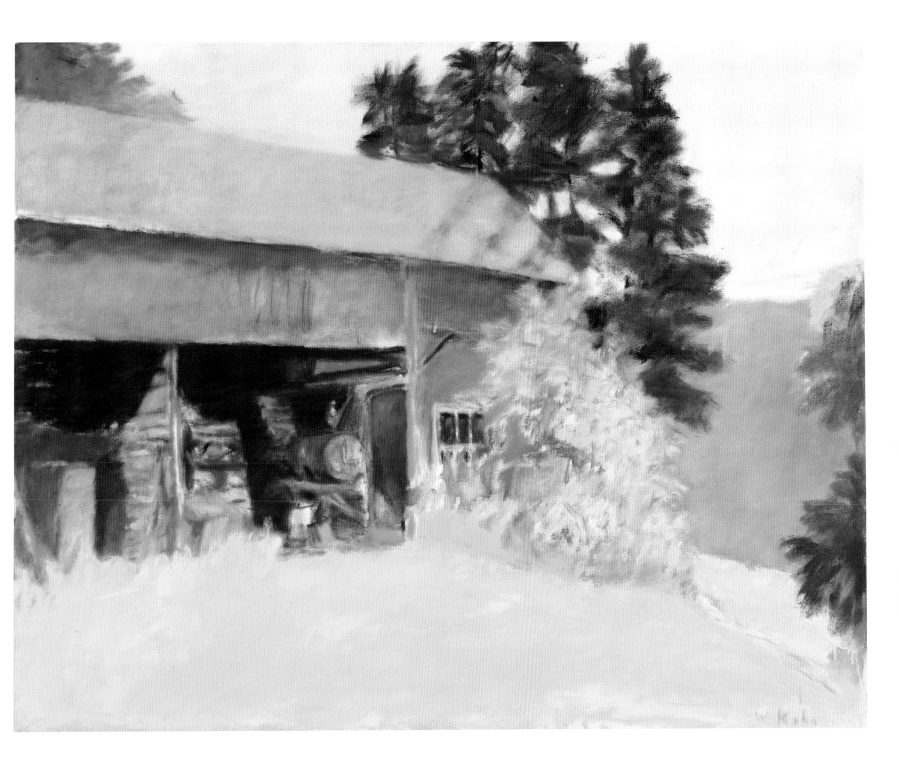

Pl. 58
The Woodshed
1975. Oil on canvas, 42 x 54"
Collection of Seth Paprin, New York,
NY
Photo: Peter Muscato

the colors on the surface of the canvas modify each other and the uses to which they are put within the ensemble that makes them seem true. Kahn has never needed a theory of color because his constant assessment of such effects while confronting nature, together with his ability to impose rigorous demands on the self-sufficiency of the canvas, has given him a much finer instrument of discernment.

The same consciousness of a synthetic construction of relationships informs the organization of space, which fact is often overlooked because the result seems so immediate. As we have seen from preceding discussions, the main means of describing and animating space is the diagonal, either a literal one, such as the edge of an object, or one created by lining up several objects. In the same woodshed painting both devices are at work. The contour of the ground starts from the bottom right and rises along the right edge of the trees to the slope of the gable edge of the roof. There is an implicit diagonal in the same direction between the brownish-green tree that frames the right edge of the picture in front and the very similar color that completes it at the upper left. What integrates this with the entire plane is the viewer's intuitive realization of the depth that separates the lemony-yellow in the foreground from the umber/ocher screen of trees, which leads up to the brief piece of the horizon at the right. Connecting the visual centers of these areas to the more overt diagonals, lower right to upper left, describes a huge "X" in space, which embraces all the picture elements. Contrasted with this is a more subtle tension connecting the center of the yellow foreground with the screen of tall trees rising almost in the center of the picture, which presses in at an angle slightly to the right from a perpendicular to the picture surface, and seems to stand for the observer's line of sight. Even the angle at which it accomplishes this is countered by the slight tilt inwards of the top of the door that leads from the hollowed space of the open section of the shed to the enclosed portion. One gets the impression that this is made by someone who listens to a lot of chamber music.

A completely different play of virtual diagonals animates *Brush Pile in Early Spring* of 1980 (Pl. 39). Here the foreground spills forward to a bare patch of canvas at bottom left, which is almost a hallmark of Kahn's paintings of this period. From here, the eye zooms back to the red barn which anchors the right edge. Counter to this is the airy tangle of the brush pile at the apex of a triangle, the right side of which slices steeply back across the stubbly field, while the left side, which goes farther back in the long run, is sedately punctuated by alternating bands of bare ground, grass, and trees just coming into leaf at various intervals in depth.

Although diagonals are not what Kahn's paintings are about, they are active building blocks, and he gets a lot of use out of them. Part of their presence is due to the fact that the Kahn property in Vermont is on the side of a mountain, with a zigzag drive from the public road up to the buildings, which are built into or thrust out from the slope at various angles. But it is also explained by the fact that, from Tintoretto through Claude to the Cubists, diagonals have provided a variety of ways to animate space, continually bringing in view the expressive potentials of new motifs.

In many paintings of Kahn's barn, a single diagonal dominates the entire canvas and its sharp angle makes for a dramatic dislocation in depth of different parts of the picture. A similarly oriented angle is softened into a curving plane in various bands and walls of trees at the edges of meadows. In paintings such as *Purple Edge of the Woods* of 1987 (Pl. 59), and *A Wall of Trees* of 1983 (Pl.60), the paling out of color at the receding side sets the luminosity of the intervening air against the nearer

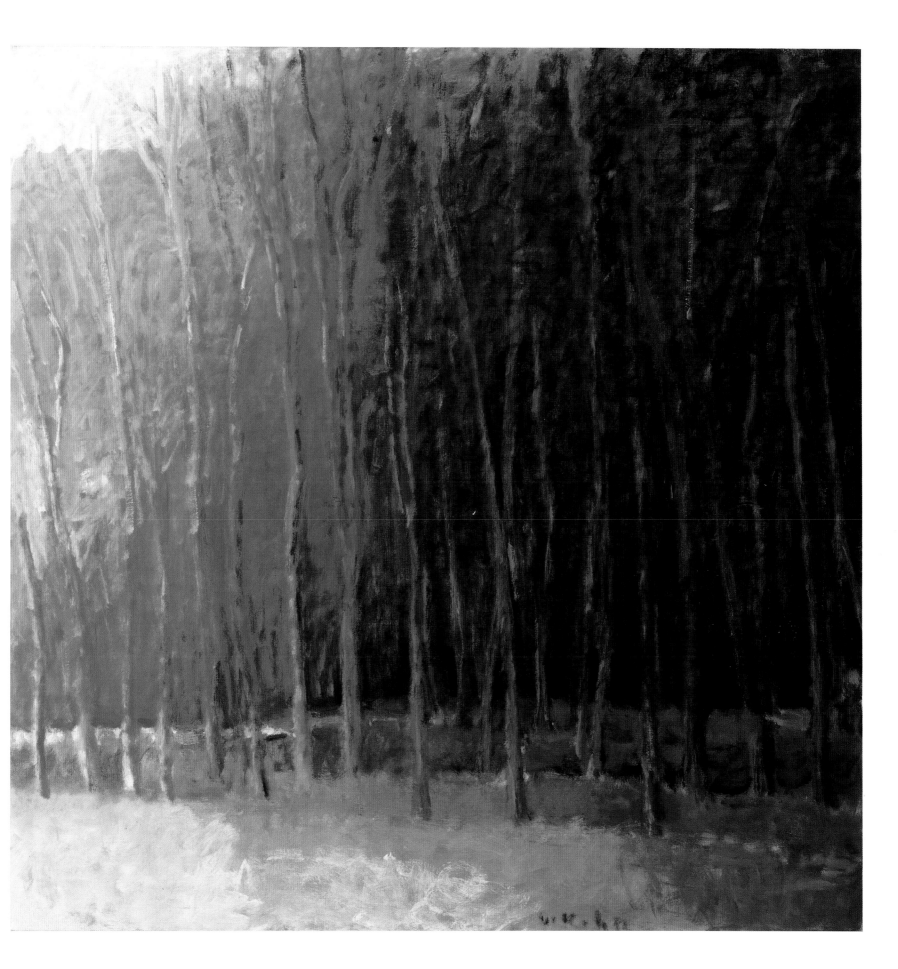

Pl. 59
Purple Edge of the Woods
1987. Oil on canvas, 53 x 53″
Collection of Mr. and Mrs. Donald
Cadle, Princeton, NJ
Photo: Peter Muscato

Wolf Kahn 113

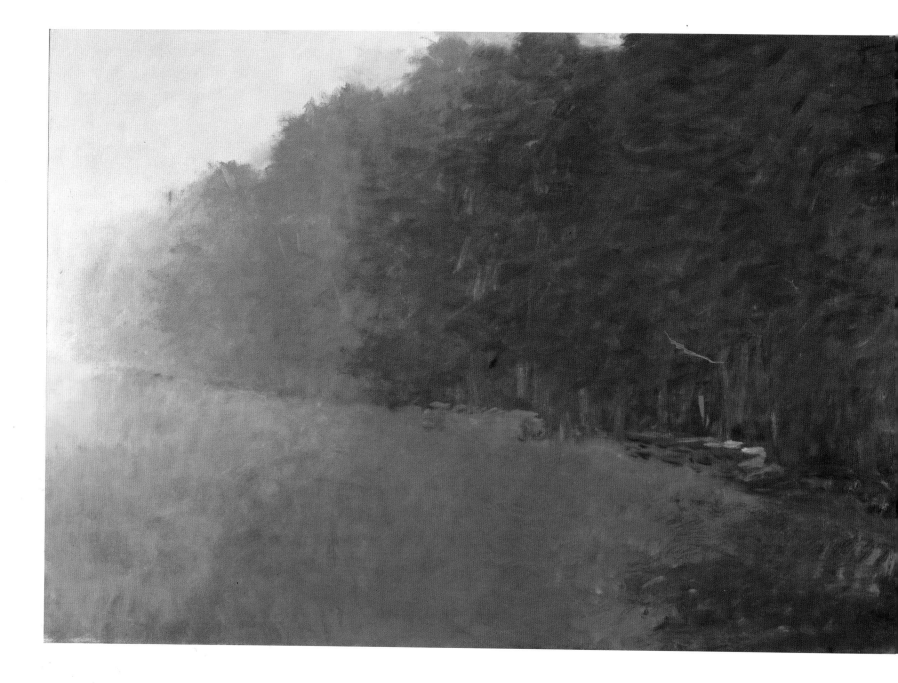

Pl. 60
A Wall of Trees
1983. Oil on canvas, 36 x 52″
Collection of Moody's Investors
Service, New York, NY
Photo: Peter Muscato

114 *Wolf Kahn*

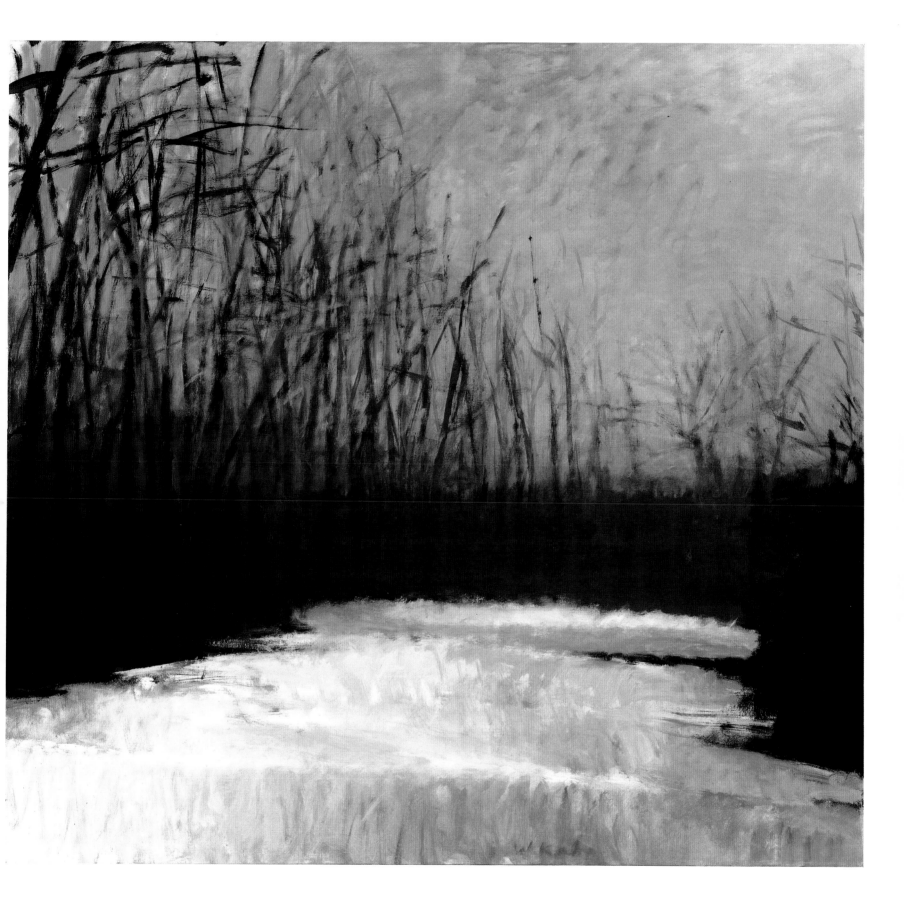

Pl. 61
In Westport, Connecticut (Winter)
1987. Oil on canvas, 48 x 52″
Private Collection
Photo: Peter Muscato

density dipping down at the right as a major subject for feeling. Another group of motifs from *River Bend I* of 1978 (Pl. 36), which was painted along the railroad tracks paralleling the Connecticut River, through *Runner* of 1986 (Pl. 45) and *In Westport, Connecticut (Winter)* (Pl. 61) involve a wholly different set of proportions and placements.

Because of the connections between such treatments and the contrasts between them, one might say that Kahn paints by formula, but this would be a complete misunderstanding of his development. Certainly his thinking is systematic, about the moves he can make, the opportunities various motifs may offer, but this approach is no more mechanical than it is in the work of Bach, Haydn, or Mondrian. Formulas—and Kahn makes use of many—are as good as the novel insights, extensions, and articulations of possibility they provoke. Kahn's are filled with sensuous particulars, which open out on new readings of nature. This is the case with the paintings involving open sloping fields, like *Sfumatura* of 1978 (Pl. 32), and *Uphill (Spring)* of 1983 (Pl. 62), among other examples. Similar are the many views of the Connecticut River, which range from overlooking views from a height, to the juxtaposing of shadowed and sunlit shores from the level of the water; these, in turn, are transfigured by different usages of light and color.

In some cases, the diagonals are somewhat concealed, but the interaction of the "mechanical" factors they involve produces a particular and (at least in me) deep feeling. In one subject, that of a barn seen from below, each of the several versions involves a large upward sloping foreground topped by the mass of the barn, which, by receding over the crest of the rise, also thrusts up forward against it and the sky. Each of these that I have seen is from a different sense of entry into the space or movement from the plane. In *Barn Atop a Ridge* of 1987 (Pl. 63) the left side of the barn is lit with a sunset glow of yellow orange; the gable end is blue. This color chord dominates the space that is defined at various stopping points and angles by dark browns, muted yellows, blue grays, and pale greens both warm and cool. The different relative weights and luminosities these produce provide various dimensions of sensation: heavy and light, warm and cool, soft and hard, moving up and in, and especially the sense of turning one's head in the space and thus being enveloped by it.

Alongside Kahn's diagonal compositions are an entirely different set of pictorial premises in which diagonals are suppressed or almost completely eliminated. These start with side views of his barn, culminating in *The Yellow Square* of 1981 (Pl. 30), which is one of the most insistently planar pictures he has painted. Most of the forms are lateral, but there is an in and out movement as well. There is a feeling of atmosphere between the viewer and the barn as he looks across the foreground grass to its gray purple surface. There is an even greater atmospheric feeling between the observer and the foliage at the side and the sky. A window lit by sunset glows from the dark interior depth. Against these penetrations is set the long horizontal of the building and of the picture itself. By suppressing the dynamic recessions provided by diagonals, Kahn shifts the emphasis to these other factors.

Kahn's color always works spatially, but at the same time we can see the relation of each color patch to the color adjacent, and to the whole, very much as we see the color areas in an abstract painting, as, for example, in a work by Josef Albers. The planar treatment of the barn is paralleled in many landscapes. His tendency to work in bands of color is seen as early as *Afterglow I* of 1974 (Pl. 34), and becomes increasingly evident throughout the Eighties. From this the paintings acquire a monolithic

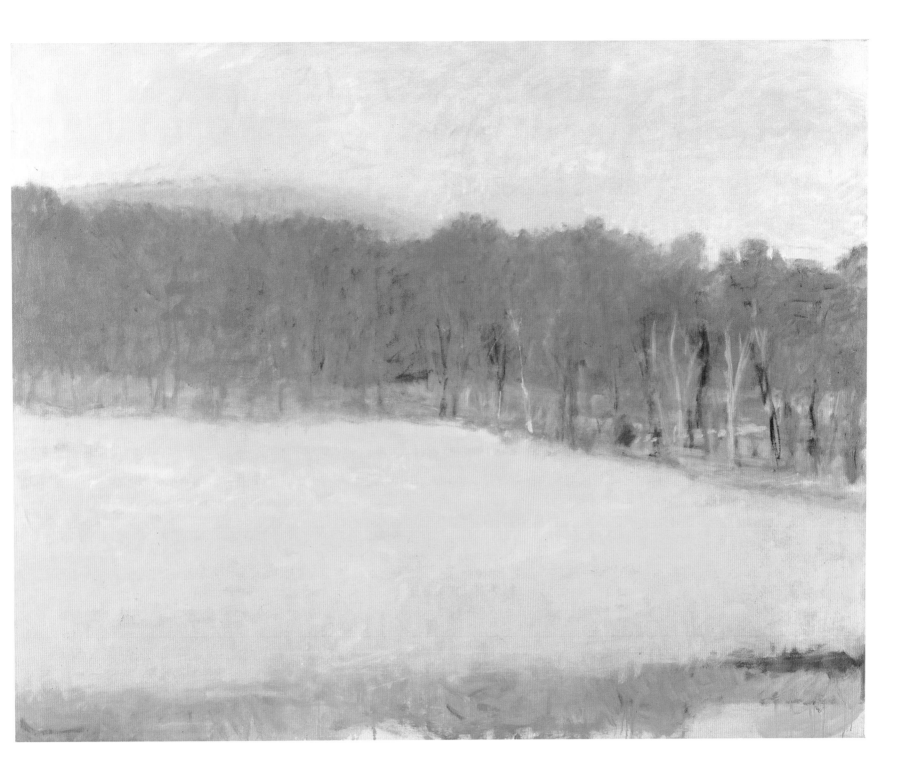

Pl. 62
Uphill (Spring)
1983. Oil on canvas, 52 x 66″
Collection of AT & T
Photo: Peter Muscato

Wolf Kahn 117

quality that reminds one of Rothko, so that instead of serving as a means to articulate a space developed by drawing, color becomes its chief feature.

Kahn has always been an avid collector of different colors of paint, like a gourmet cook who acquires exotic spices and oils. This is understandable for pastels, where each new stick makes the medium more capable. Most artists tend to restrict themselves to a limited selection of oil colors, depending on their intermixture and predictability. Some even regard a limited palette as a virtue, a stabilizing force in their work, using a standard set of pigments hallowed by tradition for specifiable roles. The art materials firm of Winsor and Newton even publishes a booklet of what colors to use where, mixtures for skies at different time of day, for foliage, water, flesh, and so on. Kahn, however, is constantly seeking the new color for skies, the new color for foliage, the color that has never been used there before.

Modern technology has greatly strengthened Kahn's hand and eye. Since World War II the chemical industry had increased the range of colors available for artists' pigments, some to supplant substances that have become scarce, some to provide stable substances for hues that were previously impermanent, and some to create hues and nuances not previously available. To the last group belong many hues among the seductive pinks and purples, the new brilliance and transparency of greens, blues, oranges, and golden yellows. Even the traditional earth colors— umbers, ochers, and siennas—have been augmented by dye-like hues of greater luminosity and juiciness. Paint makers have also produced ready-made intermixtures incorporating old and new pigments that yield new subtleties, particularly among the neutral colors: gray blue, gray violet and rose, gray yellows and oranges, where previously there had been a few mixed bright greens and a catchall for flesh. Kahn seems to collect them all.

Every time I visit his studio he has a new color to show me. He has responded to their seductions, not in Plato's sense of being "overcome by desire," but by raising his sights to new possibilities for what to seek. As with influences, it is not simply the acquisition of colors that is important, but the uses to which they are put.

In his later paintings, he poses the aim of simplicity, clarity, and austerity against the complexity and daring of using colors that have never been used before, for that purpose and in that combination, pushing the envelope of description by the most extravagant effects. All of the great colorists of the past have learned particular colors in distinctive ways. Veronese had his greens, Piero the airy glow of earth tones, Vermeer a golden brown made from peach pits, which, alas, has faded over time. Corot had a predilection for very closely differentiated cool gray greens. Renoir had a special way of using cobalt violet that he incorporated into his style almost as soon as the color came out. Bonnard said, "Golden yellow, you can never have too much of it."

What Kahn calls "beauty of color," and I call "color statement," is not achieved by seeking it directly. Rather it is a consequence of interrelating a number of other requirements. Interval is a serious concern, not only between adjacent colors, but scaled to the whole range of colors present on the canvas, particularly as each color participates in the enveloping airiness of the environment. Kahn adjusts the amount given to depth, the amount to lateral expansion, the amount given to luminosity, transparency, and density. He develops the internal voicings to colors that recall and augment each other as in a musical composition. Broken, blended, glazed, and scumbled colors are posed one against the other, not to approximate a particu-

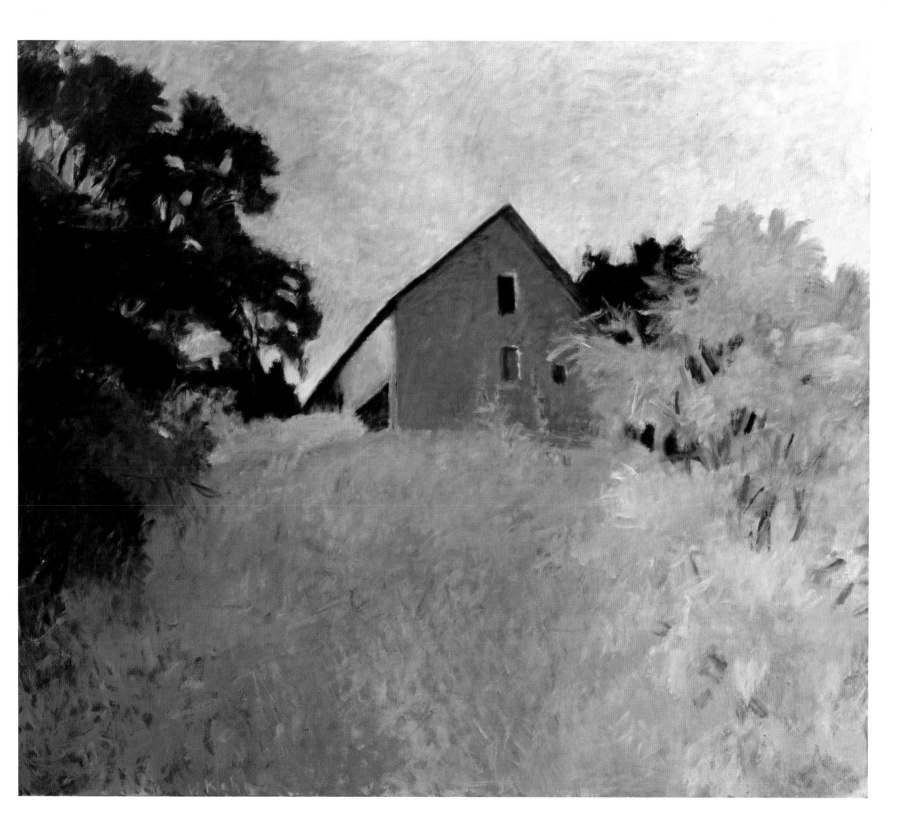

Pl. 63
Barn Atop a Ridge
1987. Oil on canvas, 72 x 86″
Collection of Chris and Maureen
Stenger, Lakeville, CT
Photo: Peter Muscato

Wolf Kahn 119

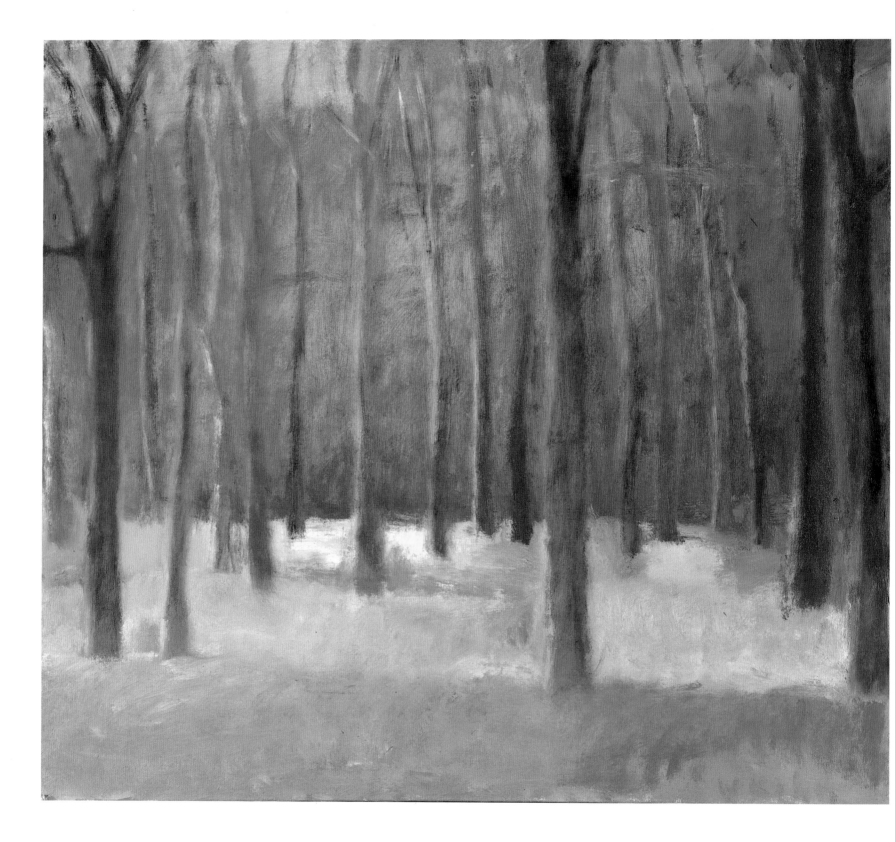

Pl. 64
Irregularly Back into a Wooded Space
1987. Oil on canvas, 26 x 30″
Collection of Dr. and Mrs. Robert M.
McKey, Coral Gables, FL
Photo: Peter Muscato

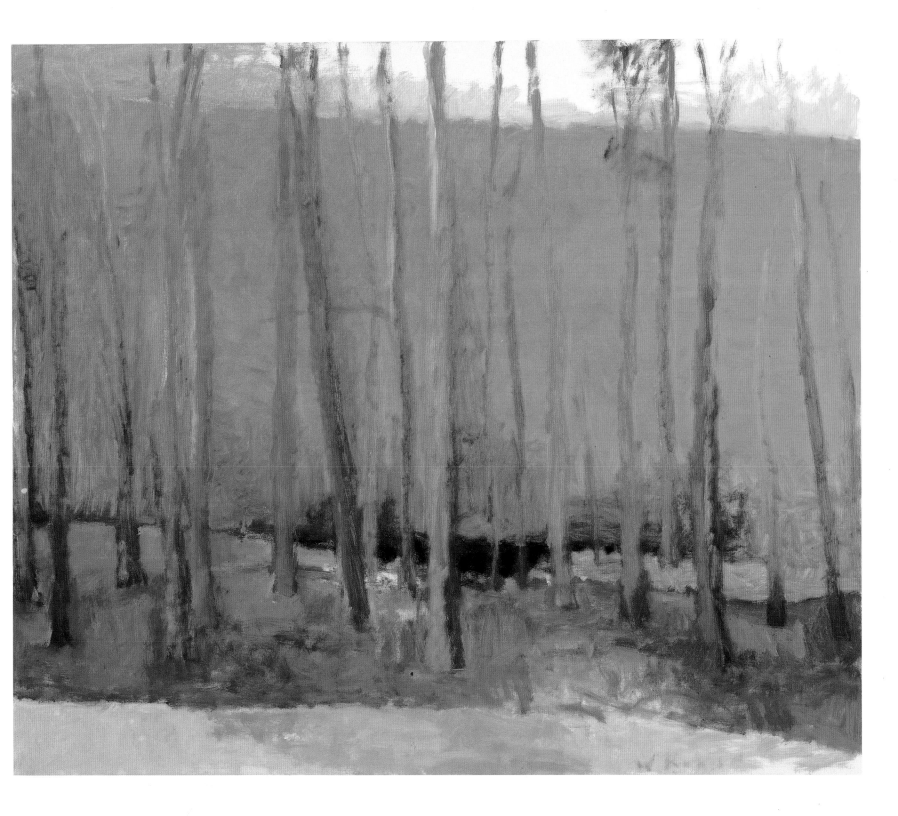

Pl. 65
In Praise of Perelyne Red II
1993. Oil on canvas, 50 x 60″
Collection of Pamela and Brian McIver
Photo: Peter Muscato

Wolf Kahn 121

lar appearance, but to make an internally rich and coherent structure.

The painting has to appeal to the mind and to the sense as a self-creating whole. In a formalist calculation every element is like a character in a novel, a voice in the chorus, or a stress within the meter of a poem. How forceful should the recession of the ground plane be in proportion to a curtain of trees? How dominant the profile of that curtain against the sky? Should the interstitial separation of the tree trunks be clarified or merged into the atmosphere of the woods? Themes are suggested by the practicality of one element against the other in the working process. As an outcome one comes across different titles for similar motifs implying a diversity of feelings. One grove of trees is alternatively called *Irregularly Back into a Wooded Space* (Pl. 64), another, *In Praise of Perelyne Red II* (Pl. 65), another, *In a Red Space* (Pl. 50).

As the color becomes more extravagant the interaction of each nuance becomes more critical in determining the thematic character of the whole, and each successive modification means the obliteration of a previous possibility. The writer and the musical composer can set down alternative versions; that is part of the delight of theme and variations. Similarly, Kahn paints many variations of the same motif. Recently he cited to me, with evident relish, the example of the novelist E.L. Doctorow, who, having found five different narrative voices to begin *The Book of Daniel*, continued the entire work using them all. The motifs that Kahn uses from the late Eighties on are generally broadly lateral, the open expanses of the Connecticut River with contrasting illumination of its opposite shores, open bays, vistas of imaginary lakes, large open fields with a fringe of trees at the edge or bottom, and open facades of trees containing an airy depth.

The disembodied glow of color in these later paintings creates a feeling of transcendence, which undoubtedly satisfies a kind of longing in the direction of inner and outer unity. Kahn's paintings represent transformations of matter, not only of the paint itself, but also of the appearances of the natural world.

Despite their generality and despite the subordination of the merely descriptive, or, as Kahn says, "anecdotal," the end result of the later paintings remains always particularly local. In Kahn's words, they are "the dramatic result of a real life experience." Even when we realize that this is a fiction of the artist's making, the effect is still there, of a particular moment of a day, or time of year, in a particular circumstance. In terms of a program this sounds much like that of Monet's Haystacks or even of his early *Impression, the Sun Rising*. The difference, which is the difference that demarcates modern painting, is the awareness that the medium itself, with its laws and internal requirements, is what directs and gives value to consciousness.

This is particularly so in the most recent paintings of woods, which glow from within, and seem to surpass what the artist had done before in the direction of transcendence and immanence. When Kahn paints the last glow of sunset in the sky (Pl. 66), or its last reflection on water (Pl. 67), or the contrasting illumination of the shores of the Connecticut River (Pl. 68), each will refer to some action of light directly. The woods scenes manifest light rather than depict it. Beneath the drive for density versus transparency, there is the feeling of simultaneous embodiment and disembodiment. This feeling recalls the meditations of Abbott Suger of St.-Denis, who, looking into the depth of the jewels ornamenting the reliquaries in the church's treasury, saw the intimation of a life beyond the material, which inspired the art of stained glass. Similarly the terms here are material, utilizing the resources of paint-

Pl. 66
Evening Glow II
1982. Oil on canvas, 52¼ x 76¼″
Memorial Art Gallery
University of Rochester,
Rochester, NY
Gift of Mr. and Mrs. Julius G. Kayser
Photo: Peter Muscato

Pl. 67
The Last Glow of Sunset
1989. Oil on canvas, 43 x 66″
Collection of Bart Longo,
New Brunswick, NJ
Photo: Peter Muscato

124 *Wolf Kahn*

ing, but at the same time referring to the natural world and the involvement of the spirit.

Throughout Kahn's work there is a continuity, both in his own development, and in respect to the outside influences of other artists whose work has helped form him. This flies in the face of the avant-gardist cliché of willful individualism; Kahn acknowledges tradition by giving it new meanings and expanding its territory. He is not imprisoned by its continuity, but through it is enabled to become more original. Through his command of the devices of abstract structuring he asserts the continuing vitality and relevance of formalist self-consciousness, and its essential optimism. Along with this, by expanding the vocabulary of color, he gives to nature new descriptions and new ways of being felt. Thus he returns to the formalist tradition the essential tension it has always held within it between art and life.

Pl. 68
Fall on the Connecticut River
1987. Oil on canvas, 40 x 72″
Collection of Mr. and Mrs. Rutgers
Barklay, Santa Fe, NM
Photo: Peter Muscato

Pl. 69
Whetstone Valley
1982. Oil on canvas, 44 x 72"
Collection: Peter and Turkey Stremmel,
Reno, NV
Courtesy: Stremmel Galleries,
Reno, NV
Photo: Peter Muscato

Pl. 70
Dark Fog Bank Out There
1992. Oil on canvas, 43 x 78″
Collection of Mr. and Mrs.
Michael Bienes
Courtesy: Carone Gallery, Fort
Lauderdale, FL
Photo: Peter Muscato

Pl. 71
Sun-Drenched Barn II
1981. Pastel, 22 x 30″
Courtesy: Carone Gallery, Fort
Lauderdale, FL
Photo: Peter Muscato

Wolf Kahn 129

Pl. 72
Beaver Swamp
1981. Oil on canvas, 42 x 72"
Hugel Collection, Melvin Village, NH
Photo: Peter Muscato

Pl. 73
Exuberant Fall
1993. Oil on canvas, 52 x 57″
Private collection, Charleston, WV
Courtesy: Addison Ripley Gallery,
Washington, D.C.
Photo: Peter Muscato

Wolf Kahn 131

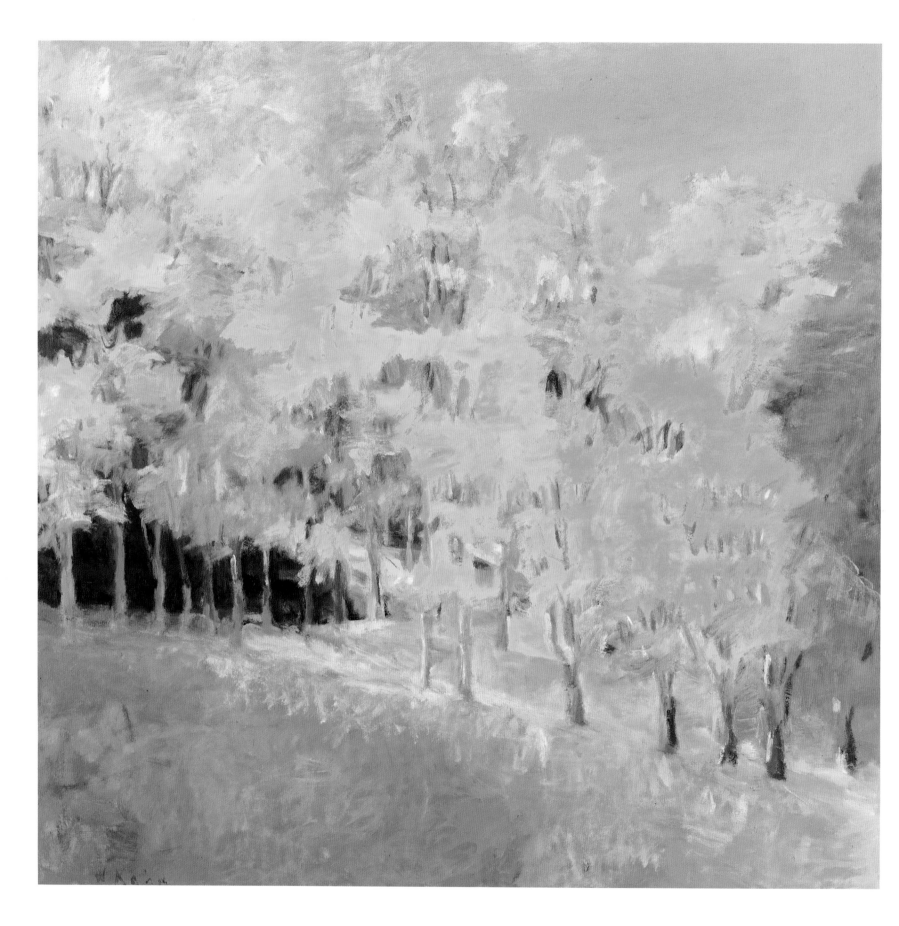

Pl. 74
Fall Splendor
1992. Oil on canvas, 50 x 52″
Collection the artist
Photo: Peter Muscato

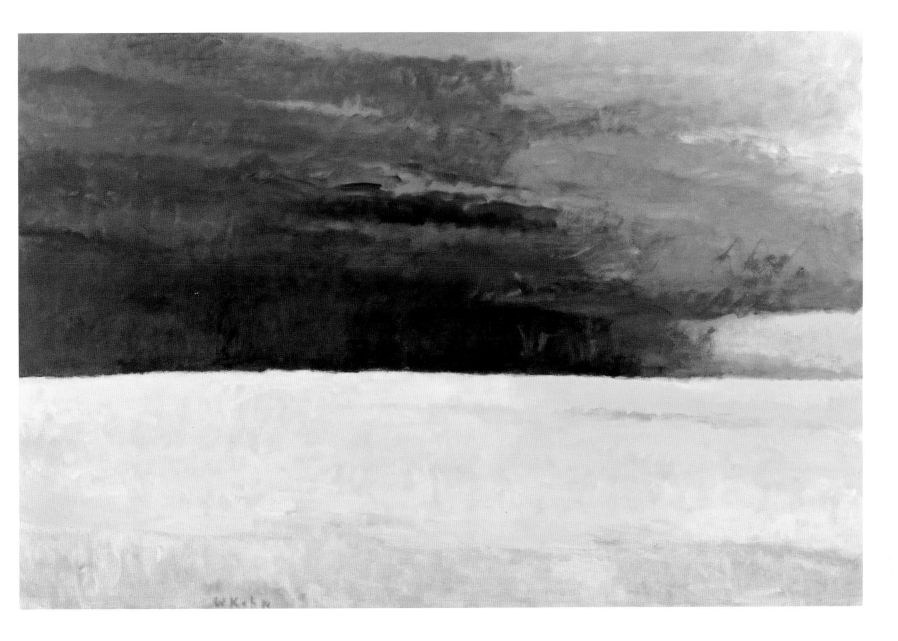

Pl. 75
Distant Rain (NM)
1992. Oil on canvas, 48 x 72″
Collection of Heidi Stamas Cox,
New York, NY
Photo: Peter Muscato

Wolf Kahn 133

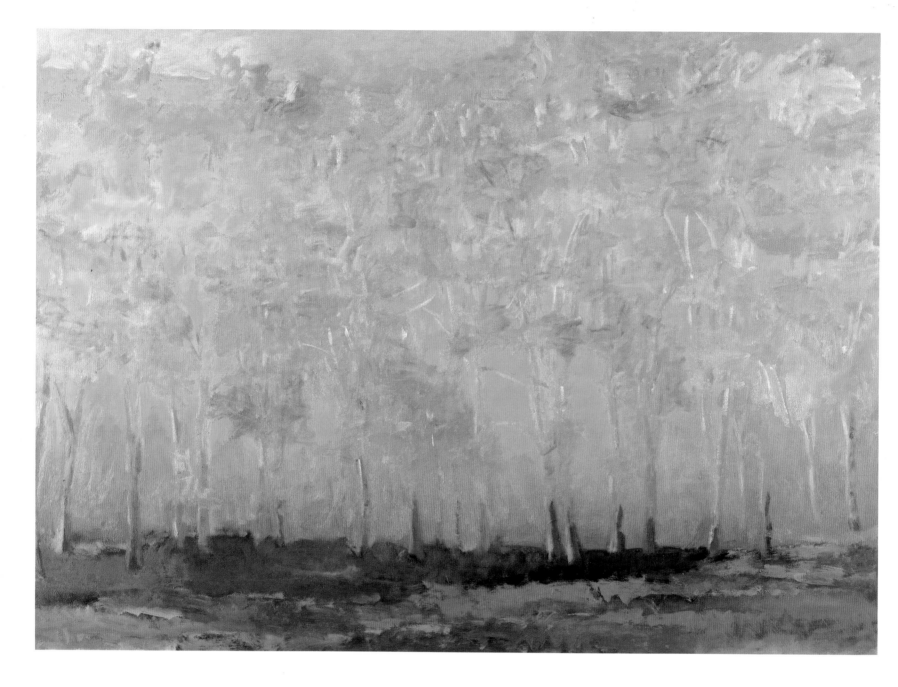

Pl. 76
Over-All Trees
1992. Oil on canvas, 52 x 72″
Collection of the Artist
Photo: Peter Muscato

134 *Wolf Kahn*

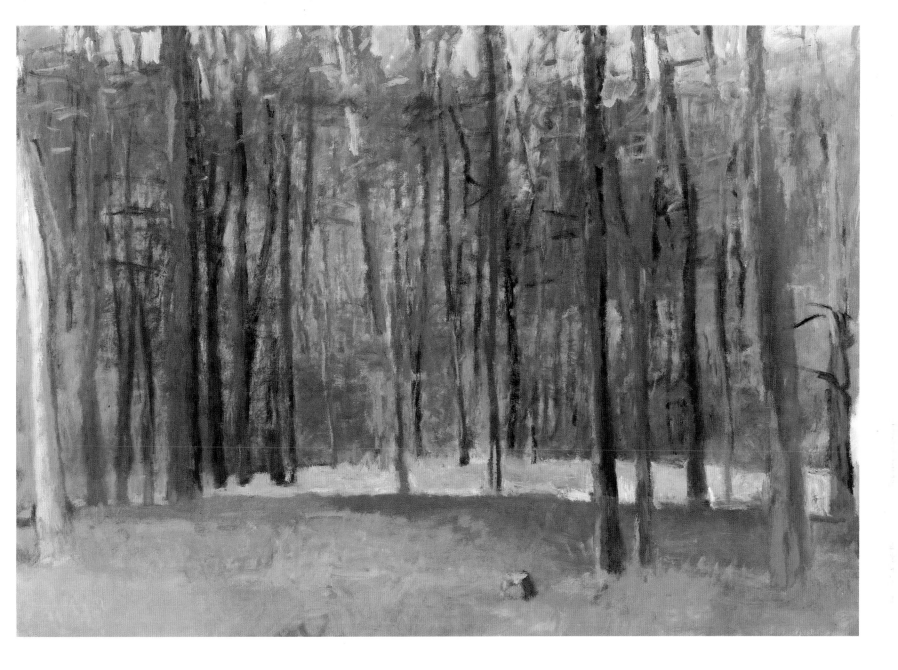

Pl. 77
Pinewoods in Marlboro, Vermont
1992. Oil on canvas, 43 x 60"
Collection of Joe Wasserman,
New Marlboro, MA
Photo: Peter Muscato

Pl. 78
Calm Sea
1995. Oil on canvas, 43 x 60″
Collection of the Artist
Photo: Peter Muscato

Pl. 79
Pinewoods in Spring II
1994. Oil on canvas, 48 x 62″
Collection of the Artist
Photo: Peter Muscato

Wolf Kahn 137

Pl. 80
Along the River
1992. Oil on canvas, 50 x 66″
Vered Gallery,
East Hampton, NY
Photo: Peter Muscato

Pl. 81
Fall 1985. A Good Foliage Season
1987. Oil on canvas, 53 x 78″
Collection of Dr. Steven and Susan
Bloch, Highland Park, IL
Courtesy: Thomas Segal Gallery,
Boston, MA
Photo: Peter Muscato

Pl. 82
Copse II
1992. Oil on canvas, 52 x 66″
Collection of Ted Desloge,
St. Louis, MO
Photo: Peter Muscato

140 *Wolf Kahn*

Pl. 83
A Yellow Meadow by the River
1991. Oil on canvas, 50 x 60"
Collection of Michael Tribble,
Charlotte, NC
Photo: Peter Muscato

142 *Wolf Kahn*

Pl. 84
Dark Complementaries II
1990. Oil on canvas, 30 x 42″
Collection of Mimi and Peter Santry
Courtesy: Jerald Melberg Gallery, Inc.,
Charlotte, NC
Photo: Peter Muscato

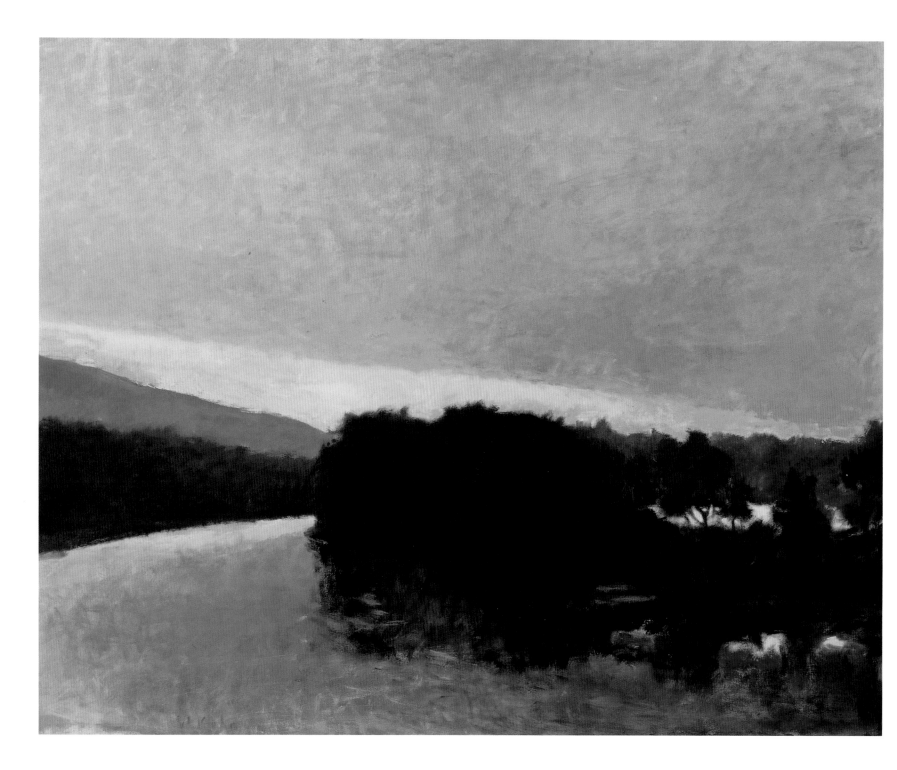

Pl. 85
The Point of the Putney Great Meadows
1989. Oil on canvas, 52 x 66″
Collection of Thomas G. Schueller,
New York, NY
Photo: Peter Muscato

Pl. 86
Marsh at Sunset
1989. Oil on canvas, 52 x 74"
Museum of Art, Fort Lauderdale, FL
Photo: Peter Muscato

Wolf Kahn 145

Pl. 87
Golden Shore
1987. Oil on canvas, 52½ x 74″
Private Collection
Courtesy: Gerald Peters Gallery,
Santa Fe, NM
Photo: Sarah Wells

146 *Wolf Kahn*

Pl. 88
Clump of Trees on the River
1989. Oil on canvas, 16 x 22″
Collection of Robert Redford
Courtesy: Gerald Peters Gallery,
Santa Fe, NM
Photo: Peter Muscato

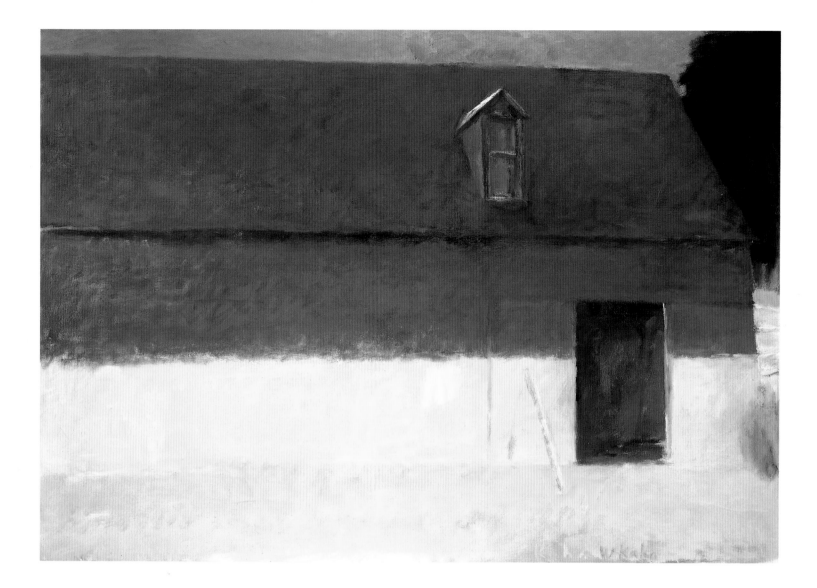

Pl. 89
My Barn on a Summer Night
1982. Oil on linen, 36⅛ x 52⅛″
Hirshhorn Museum and
Sculpture Garden
Smithsonian Institution,
Washington, DC
Gift of Mrs. Grace Borgenicht Brandt
and Mrs. Margarete Schultz, 1987
Photo: Lee Stalsworth

Pl. 90
Dusk
1981. Oil on canvas, 44 x 72″
Collection of Albert L. Zesiger,
Darien, CT
Photo: Peter Muscato

Wolf Kahn 149

Pl. 91
Autumn River
1979. Oil on canvas, 52 x 72″
The Metropolitan Museum of Art,
New York, NY.
Purchase, gift of Diane L. Ackerman
and Martin S. Ackerman, The
Martin S. Ackerman Foundation, 1979
Photo: Peter Muscato

Pl. 92
Across Alameida
1995. Oil on canvas, 26 x 30″
Collection of Mr. and Mrs. Conrad
Ambrette, Wayne, PA
Photo: Peter Muscato

Wolf Kahn 151

Pl. 93
Orange Glow on the Water
1995. Oil on canvas, 43 x 60″
Courtesy: Morgan Gallery,
Kansas City, MO
Photo: Peter Muscato

Pl. 94
The Neighbor's Farm
1981. Oil on canvas, 52 x 75″
Private Collection
Courtesy: Walker-Kornbluth Art
Gallery, Fair Lawn, NJ
Photo: Peter Jacobs

Pl. 96
Maples and Hickory Trees
1994. Oil on canvas, 66 x 80″
Collection, Pleasant Company
Photo: Peter Muscato

Pl. 95
In Praise of Yellow
1994. Oil on canvas, 36 x 52″
Courtesy: Gerald Peters Gallery,
Santa Fe, NM
Photo: Peter Muscato

Wolf Kahn 155

Pl. 97
Greenwood
1995. Oil on canvas, 72 x 72″
Collection of Pamela and Brian McIver
Photo: Peter Muscato

Wolf Kahn 157

Pl. 98
A New Mexico Sunset
1992. Oil on canvas, 16 x 28"
Collection of Ted Desloge,
St. Louis, MO
Photo: Peter Muscato

Pl. 99
October Light
1979. Oil on canvas, 30 x 41"
Private Collection
Photo: Peter Muscato

Wolf Kahn 159

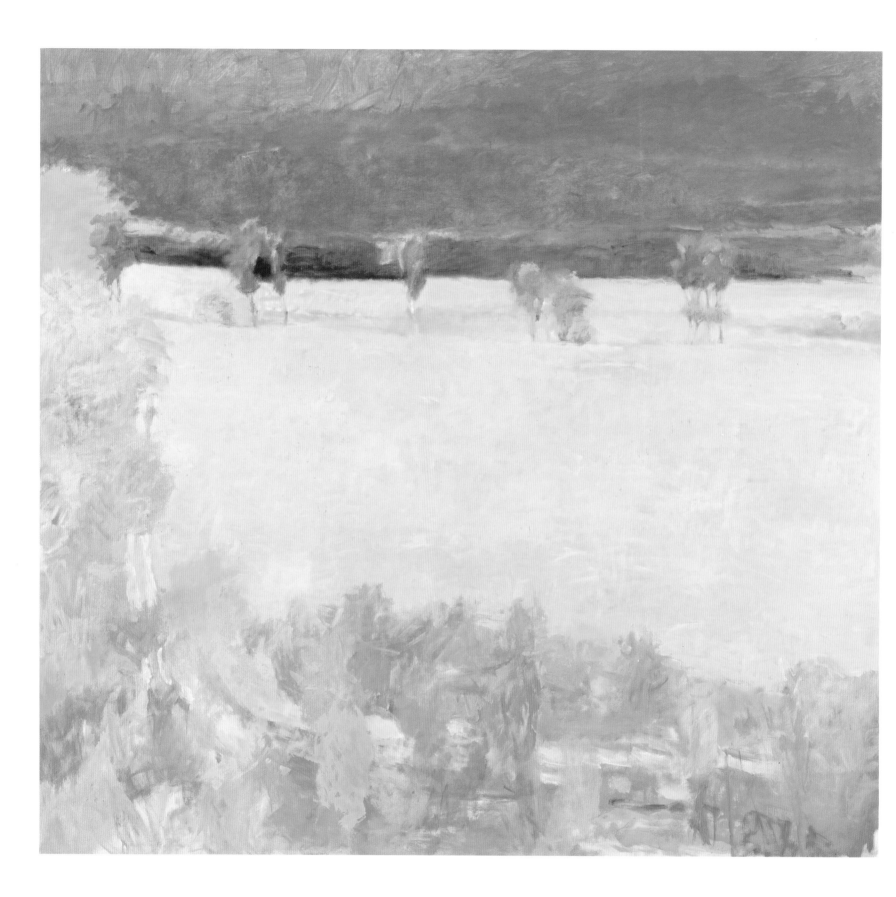

Pl. 100
Cornfield Near Northfield, Massachusetts
1995. Oil on canvas, 72 x 78"
Collection of D. C. Moore Gallery,
New York, NY
Photo: Peter Muscato

160 *Wolf Kahn*

Italic page numbers refer to illustrations.

Abstract Expressionism, 16, 26–28, 33, 34, 36, 38, 73, 94, 95, 100, 105, 108
abstraction, 26, 33, 39, 55, 56, 58, 82, 99, 100, 103, 108
Accademia delle Belle Arti, Venice, 39
Ackerman, Martin, 80
Across Alameida (Pl. 92), *151*
action painting, 17
Adams Farm, Evening IV (Pl. 37), 79; *78*
Addison, Chrls, 84–86
African-Americans, 25–26
Afterglow I (Pl. 34), 116; *72*
Albers, Joseph, 116
Along the River (Pl. 80), *138*
American Abstract Artists Group, 39
Amram, David, 42
Anthroposophy, 9
anti-Semitism, 10
Aristide Bruant (Toulouse-Lautrec), 30
Art Digest (periodical), 36
Art Forum (periodical), 76
Art in America (periodical), 15
Artists' Club, New York, 39
Art Journal (periodical), 42
Art News (periodical), 23, 29, 33, 34, 38
Ashton, Dore, 79
automatism, 17
Autumn River (Pl. 91), *150*
Avery, Milton, 42, 59, 95, 105–6
Avery, Sally, 42

Bach, Johann Sebastian, 116
Barker, Walter, 48
Barn and Apple Tree IV (Pl. 31), 69–73, 79; *69*
Barn Atop a Ridge (Pl. 63), 116; *119*
Barn Head On (Pl. 28), *67*
barns, 65–66, 74; Martha's Vineyard (Fig. 18), 57–59, 106–8; *57*; West Brattleboro, Vermont (Fig. 20), 60–61, 65, 68; *65*; *see also* Kahn: art of: barn paintings
Barn Through the Trees (Pl. 25), *63*
Beaver Swamp (Pl. 72), *130*
Beck, Ellen, *see* Kahn, Ellen
Between Two Islands (Pl. 16), 51, 53–54, 55; *52*
Bischoff, Elmer, 51, 55
Black Shadows of Summer (Pl. 33), 79; *71*
Bladen, Ronald, 49, 57
Blaine, Nell, 15, 20, 33, 38, 102
Blakelock, Ralph Albert, 66
Bonnard, Pierre, 21, 23, 28, 33, 39, 53, 73, 94, 101, 102, 103, 104, 118; *The Breakfast Room*, 39
Book of Daniel, The (novel; Doctorow), 122
Borgenicht, Grace, 38, 42, 80
Borgenicht Gallery, New York, 38; Kahn exhibitions (1956), 42–43; (1959), 49; (1967), 60
Brach, Paul, 110
Braque, Georges, 18, 94; Kahn's painting in the style of (Pl. 1), 18, 24; *19*
Breakfast Room, The (Bonnard), 39
Brodie, Gandy, 102, 104

Brush Pile in Early Spring (Pl. 39), 80, 112; *80*
Budge, Ella, 9, 10, 11
Budge, Siegfried, 9, 10, 11
Byzantine mosaics, 106

Ca' dei Tre Oci, Venice, 43
Calm Sea (Pl. 78), *136*
Cambridge and County High School, England, 12
Cambridge University, 11, 12
Campbell, Gretna, 42, 44
Campbell, Lawrence, 82, 93
Casa Frollo, Venice, 43
Cézanne, Paul, 10, 31, 100, 102, 103, 105, 106, 110
Chamberlain, John, 23
Chardin, Jean-Baptiste-Siméon, 105
Chesapeake and Ohio Canal, 86
Chicago, 22, 77
Churchill, Winston, 13
Cimabue (Cenni di Pepi), 16
Clump of Trees on the River (Pl. 88), *147*
Cold Sunset Over Santa Fe (Pl. 49), 89–90; *91*
College Art Association, 21
color(s), 29, 79, 82, 100, 101–102, 105, 110; associated with specific artists, 118; and form, 102; functions in paintings, 101–2; Hofmann's teaching, 20, 101, 102; Muller's sense, 43; new hues, 118; reevaluation in 1950s, 101; *see also* Kahn: art of: color
color field painting, 86, 93
"color statement," 102, 118
Columbia University, 15, 21
Communism, 38
composition, 20; use of diagonal, 112–16
Connecticut River, 77, 78, 116, 122
Connecticut River at Dusk, The (Pl. 35), *72*
Constable, John, 66
Cook, Bradford, 84
Cooper Union, New York, 39, 54
Copse II (Pl. 82), *141*
Cornfield Near Northfield, Massachusetts (Pl. 100), *160*
Corot, Jean-Baptiste-Camille, 43, 118
Cubism, 100, 102, 112

Dark Complementaries II (Pl. 84), *143*
Dark Fog Bank Out There (Pl. 70), *128*
Davis, Stuart, 15
Deadwood, Oregon, 22–23
Deer Isle, Maine, 54, 59, 110
de Kooning, Elaine, 30, 33, 38, 39
de Kooning, Willem, 15, 24, 33, 39, 42–43, 48, 101, 104, 106; *Woman I*, 101
Delacroix, Eugène, 103
De Niro, Robert, 15, 24, 38, 39, 102
Detroit Institute of Fine Arts, 102
diagonals, 112–16
Diebenkorn, Richard, 51
Diller, Burgoygne, 15
Distant Rain (NM) (Pl. 75), *133*
Doctorow, E. L., 122
Downtown Community School, New York, 49

drawing: vs. color, 101; at Hofmann school, 16, 99–100, 104; Kahn's early use of, 13
Dusk (Pl. 90), *149*

Eakins, Thomas, 57
Edge of the Woods (Pl. 18), 55–57, 74; *54*
Egyptian reliefs, 106
"813 Broadway" exhibition (New York, 1950), 23
Emerson, Ralph Waldo, 75
England: Jewish refugees in, 11; Kahn's life in, 12
Evening Glow (Pl. 66), 122; *123*
Evening Meadow (Pl. 46), 86–87, 116; *87*
Evening on Menemsha Pond (Pl. 21), 59; *58*
Expressionism, 15, 17, 20, 94, 104
Exuberant Fall (Pl. 73), *131*

Fall 1985. A Good Foliage Season (Pl. 81), *139–40*
Fall on the Connecticut River (Pl. 68), 122; *126*
Fall Splendor (Pl. 74), *132*
Farm Pond on a Summer Evening (Fig. 22), *75*
Field of Trees (Pl. 52), *94*
Fifth Annual Exhibition of Painting and Sculpture (Stable Gallery, 1955), 38
figurative art, 28, 33
Finkelstein, Louis, 42, 44, 45; depicted (Fig. 15), *44*; "The Development of Wolf Kahn's Painting Language," 99–125
Fire Path (Pl. 22), *60*
First Barn Painting (Pl. 20), 58–59, 66, 74, 106–8; *56*
First Greens of Spring, The (Pl. 40), 82–84, 90; *81*
Florentines, Renaissance, 101
form: and color, 102; integrated, 100; and space, 16
Forst, Barbara, 26
Forst, Miles, 23, 38
Frankenthaler, Helen, 38
Frankfurt-am-Main, Germany, 9–10
Frederick the Great, 11
Freilicher, Jane, 15, 20, 21, 33, 102
Freud, Sigmund, 59
Frontal Barn (Fig. 21), *74*
Fulbright fellows, 39, 42, 54
Further Shore, The (Pl. 14), 49; *50*

Gamblin paints, 79, 90–91
Georges, Paul, 21
German Expressionism, 17
German Romantics, 59
Germany, during Nazi era, 10, 11, 12
GI Bill, 14, 15, 18, 21
Ginsberg, Allen, 43–44
Giotto di Bondone, 100
Glimpse of a House by the Beach (Pl. 56), 106, 108; *107*
Goethe, Johann Wolfgang von, 10
Gogh, Vincent van, 22, 23, 25, 28, 30, 34, 94, 103
Golden Shore (Pl. 87), *146*

Goodnough, Robert, 38
Gorky, Arshile, 15, 101
Gottlieb, Adolf, 42
Goya, Francisco de, 103
Greco, El, 100
Greek sculpture, 106
Greenberg, Clement, 15, 21, 26, 33, 38, 103, 108
Greenwich Village, New York, 26
Greenwood (Pl. 97), *157*
Grillo, John, 23
Grimm Brothers, 55
Guggenheim fellowship, 59
Guston, Philip, 49, 55, 101, 103, 104

Hahn, Louis, Studio, 13
Hals, Frans, 103
Hansa Gallery Cooperative, New York, 23, 26, 36, 42; group exhibition (1952), 26; Kahn exhibitions (1953), 29; (1955), 33–36
Hanseatic League, 23
Hartigan, Grace, 39
Hartley, Marsden, 31
Havana Symphony, 12
Haydn, Franz Joseph, 116
Height of Autumn (Pl. 57), *109*
Hess, Thomas, 23, 38
High School of Music and Art, New York, 13, 21
High Summer (Pl. 43), *84*
Histon, England, 12
Hitler, Adolf, 10, 11, 13, 42
Hitler Youth, 10
Hodler, Ferdinand, 9
Hofmann, Hans, 15–20, 21, 22, 23, 24, 33, 36, 38, 49, 57, 67, 94, 99–100, 101, 102, 104
Hofmann, Mrs. Hans, 18
Hofmann School of Fine Arts, 15–20, 21, 22, 99–100; students and former students, 15, 20, 21, 23, 38, 42
Holland, 11, 12
Holty, Carl, 15
Holtzman, Harry, 15
Hopper, Edward, 42
Hot Summer (Pl. 48), 89; *90*
Hurricane Carol, 33

Imaginary Landscape (Pl. 19), 55
Imaginary Shore Line III (Pl. 47), 87; *89*
Impressionism, 21, 34, 73, 94, 101, 102, 103, 105, 106
Impression, the Sun Rising (Monet), 122
In a Red Space (Pl. 50), 90–91, 122; *92*
Inness, George, 66
In Praise of Perelyne Red II (Pl. 65), 122; *121*
In Praise of Yellow (Pl. 95), *155*
Interior (My Bedroom at Tepoztlán) (Fig. 11), *36*
In Westport, Connecticut (Winter) (Pl. 61), 116; *115*
Irregularly Back into a Wooded Space (Pl. 64), 122; *120*
Italian Renaissance painting, 106

Jackson, Robin, 31, 57; portrait of (Pl. 5), 29, 31, 57; *31*
Jacob Riis Park, New York, 14
Jelinek, Hans, 15

Jensen, Alfred, 15
Jewish Museum, New York, *The New York School: Second Generation* exhibition (1957), 43
Jews: British acceptance of refugee children, 11; in Nazi Germany, 10
Joeden, Fräulein von, 10
Johnson, Lester, 18, 23, 102, 104
Joint Distribution Committee, 11

Kahn, Anna (grandmother), 9, 10, 11, 12, 77
Kahn, Bernhard (grandfather), 9
Kahn, Cecily (daughter), 48; *49*
Kahn, Ellen (née Beck) (stepmother), 9, 10, 11, 13
Kahn, Emil (father), 9, 11, 12, 18, 23
Kahn, Emily (wife), *see* Mason, Emily
Kahn, Eric (cousin), 11, 12
Kahn, Eva (sister), 9, 11, 13
Kahn, Ida (aunt), 10, 11
Kahn, Max (great uncle), 9
Kahn, Melany (daughter), 55; *88*
Kahn, Nellie (neé Budge) (mother), 9
Kahn, Peter (brother), 9, 11, 13, 15, 21, 26; *85*
Kahn, Wolf (originally named Hans Wolfgang)
 art studies: as a boy in Frankfurt, 10–11; at Columbia University, 21; with Hofmann, 15–18, 20, 21, 22, 94, 99–100; at the New School, 15, 21
 as an art teacher: at Cooper Union, 54; at the Downtown Community School, 49; at the Manhattanville Settlement House/Neighborhood Center/Neighborhood House, 23, 25, 49; *25*; at the University of California at Berkeley, 49–51
 birth, 9
 childhood: with *Grossmutter* Anna Kahn in Frankfurt, 9–11; private art lessons, 10–11; as a refugee in England, 12; in the U.S., 12–13
 children: Cecily, 48; *49*; Melany, 55; *88*
 college and university studies, 14–15; at Columbia, 21; at the New School, 21; at the University of Chicago, 22, 23
 dealers: in New York, *see* Borgenicht; in Washington, D.C., 84–86
 debate with Tworkov, 100–101
 depicted: on first day at school (1934) (Fig. 1), *10*; at the Great Lakes Naval Training Center (1945) (Fig. 4), *14*; in his studio (1995) *frontispiece*; with P. Kahn (1980s) (Fig. 23), *85*; at Manhattanville Neighborhood Center (1954) (Fig. 6), 23, *25*; with Mason: and Cecily (1960) (Fig. 16), *49*; and Melany (1980s) (Fig. 24), *88*; in Provincetown (1956) (Fig. 12), *38*; at the Stratton Arts Festival (1990), *88*; in their Venice studio (1958) (Fig. 14), *43*; on their wedding day (1957) (Fig. 13), *42*; with Oliveira (1994) (Fig. 27), *88*; with Schapiro (ca. 1989) (Fig. 25), *88*; self-portraits (1954) (etching; Fig. 9), *29*; (oil; Pl. 6), *32*; with self-portrait (1953) (Fig. 8), *28*; in Spoleto (1958) (Fig. 15), *44*

employment: as a commercial artist, 13; as a farm worker, 21; as a lumberjack, 23; as a pea harvester, 22; in the U.S. Navy, 14; as a waiter and water–ski instructor, 14; *see also subentry* as an art teacher *above*
exhibitions, group: "813 Broadway" (1950), 23; Hansa Gallery Cooperative (1952), 26; Seligmann Gallery (1947), 21; Stable Gallery (1954), 33; (1955), 38; Whitney Museum (1960), 51
exhibitions, one–man: Berkeley (1960), 51; Borgenicht Gallery (1956), 42–43; (1959), 49; (1967), 60; Hansa Gallery (1953), 13, 29; (1955), 33–36
family background, 9
fellowships: Fullbright, 54; Guggenheim, 59
homes and studios: in Frankfurt, 9–10; in New York: Avenue B and Sixth Street, 18; 813 Broadway, 23, 30, 48, 51, 53, 57, 81; Jackson's third–floor walk–up, 57, 81; 102nd Street and Riverside Drive, 13; in Stuttgart, 9; in Venice, 43; West Brattleboro, Vermont, farm, 7, 60–65, 75, 81, 110, 112
illnesses: chilblains, 45; dysentery, 38, 57; ulcer, 57
immigration to U.S., 12
influences on, 18, 55, 104–6, 125; Abstract Expressionists, 34, 94, 95; Avery, 42, 59, 95, 105–6; Bischoff, 55; Bonnard, 23, 33, 39, 42, 73, 94; Brach, 110; Braque, 18, 94; Corot, 43; W. de Kooning, 48; Expressionism, 94, 104; family tradition and interests, 9, 10, 94; Finkelstein, 45; van Gogh, 22, 23, 25, 30, 37, 79, 94; Guston, 55; Hofmann, 15–20, 21, 22, 24, 33, 36, 49, 57, 67, 94, 100; Hopper, 42; Impressionism, 34, 94; Johnson, 18; Kokoschka, 37; Matisse, 28; Minimalism, 95; Monet, 43, 105, 106; Morandi, 44, 106; Muller, 42; New York paint, 104–5; Old Masters, 94; Pollock, 104, 105; Post-Impressionism, 34, 94; Reinhardt, 59; Rothko, 86, 92, 95, 105, 118; Soutine, 24–25, 26, 29, 34, 94; Turner, 43, 105; Vuillard, 42; Whistler, 43, 105
interests: African-American culture, 26; philosophy, 21, 22
marriage to Emily Mason, 43
quoted: on Avery, 42; on barns, 65, 66; on High School of Music and Art, 13; on his early sketching trips, 13–14; on his Venice studio, 43; on his work, 23, 43–44, 57, 73, 76, 79, 80, 81, 86, 87–89, 91, 92, 93; on his working methods, 53; on Hofmann, 15–17, 18, 20, 21; on landscape painting, 66–67, 96; on Morandi, 44; on teaching art, 49; "Wolf's First Law of Painting," 45
relationships with family members: brother Peter, *see* Kahn, Peter; cousin Eric, 12; father, 12; grandmother Anna, 10; sister, 13; stepmother, 9, 10
relationships with other artists: Avery, 42; Barker, 48; Blaine, 20; E. de Kooning, 30, 42–43; W. de Kooning, 39, 42–43; Finkelstein, 45, 110; Gottlieb, 42; Freilicher, 20; Johnson, 18; Kaprow, 13;

Morandi, 44; Muller, 20, 42; Pasilis, 23; Porter, 29; Rivers, 20; *see also* Mason, Emily
reviews and criticism of his work, 26, 29, 34–36, 57, 73–74, 76, 82, 93
schooling: in England, 12; in Germany, 10, 13; at the High School of Music and Art, 13–14
travels and stays: Chicago, 22, 49, 77; Italy, 95; (1957–58), 42–48, 104–5; (1962–65), 54–57, 60; Milan, 55; Rome, 55, 105; Spoleto/Umbria, 7, 44–48, 104; Tuscany, 7, 48; Venice, 7, 42–44, 48, 49, 77, 95, 104–5; Viterbo, 55; Louisiana, 26–29; Maine, 7, 49, 57, 77, 95; Cranberry Island, 110; Deer Isle, 110; (1962), 54; (1967), 59–60; Stonington, 51; Massachusetts, 95; Martha's Vineyard, 7, 77; (1959), 22, 49; (1965), 57; Provincetown and vicinity (1947), 18–20; (1953), 29; (1954), 31–33; (1956), 39–42; *38*; Oregon, 22–23; Santa Fe, 90–91; Tepoztlán, Mexico, 36–38, 57; Washington, D.C., 84–86; western U.S., 22
working methods, 44, 51–53, 67–68, 108–10
Kahn, Wolf, art of
 bare spot of canvas in, 29, 112
 barn paintings, 57–59, 65–73, 74, 76, 77–78, 106–8, 112, 116
 boyhood works, 10–11, 12, 13
 break with planarity, 106
 cartoons and caricatures, 13
 Chicago paintings, 22, 49, 77
 color: in aggressive masses, 65; bands, 91–92, 116–18; experiments with, 30–31, 59–60; focus on, 81, 82, 87–89, 100, 106; importance of, 29, 118; Johnson's influence, 18; Muller's influence, 42; palette, 25, 38, 41, 48, 49, 54, 58, 59, 60, 73, 79, 81, 82–83, 87–93, 106, 110–12, 118; and space, 108; square, 67–69; statement with, 59, 86–89, 92–93, 102, 118–22
 commissioned works, 29, 37, 76, 84
 Connecticut River paintings, 77–78, 116, 122
 diagonal organization of space, 112–16
 early sketches, 14–15
 forest and field paintings, 55
 interiors, 103
 Italian paintings, 48, 55–57, 104; *see also subentry* Venetian paintings *below*
 landscapes, 7, 26, 29, 34, 39, 48, 53, 55–57, 73–76, 80, 81, 82, 86, 89, 95, 103
 light, radiance, and luminosity effects, 41, 48, 49, 53–54, 55, 87, 95, 112–16, 122
 Maine paintings, 51–54, 57, 59–60, 65, 77, 110
 Martha's Vineyard paintings, 22, 49, 57–59, 77, 106–8
 "minimalism," 43, 104
 paint handling and brushwork, 18, 28, 24–25, 31, 33–34, 36, 38, 48, 49, 58, 59–60, 103
 pastels, 23, 34, 57, 59, 86, 103
 portraits, 34, 37, 103; of Jackson (Pl. 5), 29, 31, 57; *31*; of Mason (Fig. 19), *59*;

of naval officers and recruits (Fig. 5), 14; *14*; of O'Hara (Pl. 4), 29–30; *30*; of Penn (Pl. 7), 34, 104; *35*; of Porter (Fig. 10), *29*; of von Schöler (Pl. 8), *37*; *see also subentry* self-portraits *below*
 riverscapes, 77–78, 87
 sailboat paintings, 22, 49, 57, 59
 self-portraits (Fig. 9), *29*; (Pl. 6), 33–34, 35; *32*; in photograph (Fig. 8), *28*
 still lifes, 18, 24–25, 103; within a painting, 28
 Venetian paintings, 43–44, 48–49, 60, 74, 77, 104
 Vermont works, 65–75, 76, 77
 "visions of isolation and scale," 22, 49
Kahn & Company, Frankfurt, 9, 10
Kant, Immanuel, 22
Kaprow, Allan, 13, 15, 23
Kätchen (Anna Kahn's maid), 9, 12
Kelly, Elsworth, 106
Kline, Franz, 33, 42, 104
Kokoschka, Oskar, 31
Kozloff, Max, 74
Kramer, Hilton, 36, 73
Krasner, Lee, 15

landscape painting, 7, 16, 66–67, 95, 96, 100; minimalist, 58
Landscape Sequence (Pl. 55), *98*
Large Olive Grove (Pl. 11), 48, 104; *45*
Last Glow of Sunset, The (Pl. 67), 122; *124*
Late Afternoon (Pl. 9), 39–41, 103–4, 106; *40*
Leaves Underfoot (Pl. 27), 66
Leonardo da Vinci, 99
linear perspective, 99, 106
Locanda Montin, Venice, 43
Lorrain, Claude, 66, 74, 87, 112
Louisiana State University, 26, 28
Low, David, 13

Maine, 7, 49, 77
Main River, Germany, 9, 77
Manhattanville Neighborhood Center (Manhattanville Settlement House/Neighborhood House), 23, 25, 49; *25*
Maples and Hickory Trees (Pl. 96), *156*
Marignoli, Filippo (Fig. 15), *44*
Marsh at Sunset (Pl. 86), *145*
Martha's Vineyard, 7, 22, 49, 77; barn (Fig. 18), 57–59, 106–8; *57*
Martin, Agnes, 49
Mason, Alice Trumbull, 39
Mason, Emily, 39, 42–43, 44–45, 48, 49, 55, 57, 59, 61; depicted: with Kahn: and Cecily (1960) (Fig. 16), *49*; and Melany (mid-1980s) (Fig. 24), *88*; in Provincetown (1956) (Fig. 12), *38*; at the Stratton Arts Festival (1990), *88*; in their Venice studio (1958) (Fig. 14), *43*; on their wedding day (1957) (Fig. 13), *42*; in Rome (1964) (Fig. 17), *51*; in Kahn's paintings, 39, 42, 75; (Pl. 9), 39–41; *40*; (Pl. 10), 41–42; *41*; portrait (Fig. 19), *59*
Matisse, Henri, 28, 93, 101, 102, 103; *Open Window*, 103; *Siesta*, 103
Menotti, Giancarlo, 44
Menzel, Adolph von, 11
Metropolitan Museum of Art, New York, van Gogh exhibition, 22

Michelangelo, 101
Middeldorf, Ulrich, 22
Milan, Italy, 55
Miller, William Henry, 57
Minimalism, 49, 95
minimalist landscape, 58
Mitchell, Joan, 24, 38, 102, 104
modern formalism, 99–100
Modernism, 16, 100
Mondrian, Piet, 18, 106, 116
Monet, Claude, 28, 43, 73, 101, 102, 105, 106; haystack paintings, 106, 110, 122; *Impression, the Sun Rising*, 122; *Nympheas*, 59; Rouen cathedral facades, 110
Montclair State Teachers' College, 12
Morandi, Giorgio, 44, 106
Muller, Jan, 15, 20, 23, 25, 26, 42
Museum of Modern Art, New York, 30, 33, 59; Soutine retrospective, 23
My Barn on a Summer Night (Pl. 89), *148*
My Louisiana Studio (Pl. 3), 28–29; *27*

Napoleonic Wars, drawings of, 11
Nast, Thomas, 13
Nation (periodical), 21
National City Bank, New York, 13
nature, depiction of, 34–35, 100
"Nature and New Painting" (essay; O'Hara), 34–36
Navy Buddy, A (Fig. 5), 14; *15*
Nazis, 10
Neighbor's Farm, The (Pl. 94), *153–54*
Nevelson, Louise, 15
New Jersey, 11, 12
New Mexico Sunset, A (Pl. 98), *158*
"New Provincetown '47" exhibition (New York, 1947), 21
New School for Social Research, New York, 15, 21, 38–39
New York School, second generation, 38–39, 43
New York School: Second Generation, The, exhibition (New York, 1957), 43
New York paint, 104
New York Times, 26, 29, 73
Non-Objective art, 33
Norman, Mrs. Libby, 36–37
Nympheas (Monet), 59

October Barn (Pl. 53), *95*
October Light (Pl. 99), *159*
O'Hara, Frank, 30, 34; portrait of (Pl. 4), 29–30; *30*
oil colors, 118
Old Masters, 94, 100
Oliveira, Nathan, 51; *88*
On the Deck (Pl. 10), 41–42, 103; *41*
Open Window (Matisse), 103
Orange Glow on the Water (Pl. 93), *152*
Orange Maples (Pl. 51), 91–93; *93*
Oregon Apple Tree (Fig. 6), 23; *24*
Over-All Trees (Pl. 76), *134*
Overtone (school newspaper), 13

paint handling ("paint quality"), 102–3, 104–5; *see also* Kahn: art of: paint handling and brushwork
paints, new colors, 118

Paris Salon, 9
Parker, Charlie, 26
Pasilis, Felix, 23, 38, 102
pastels, 110, 118
Pavia, Philip, 32
Penn, Sara, 25–26, 36; portrait of (Pl. 7), 34, 104; *35*
Pennsylvania Academy of the Fine Arts, 57
Perugia, Italy, 42
Picasso, Pablo, 9
Pienza, Italy, 48
Piero della Francesca, 100, 118
Pinewoods in Marlboro, Vermont (Pl. 77), *135*
Pinewoods in Spring II (Pl. 79), *137*
planarity, 106
Plato, 101, 118
Point of the Putney Great Meadows, The (Pl. 85), *144*
Pollock, Jackson, 15, 48, 104, 105
Pond in November (Pl. 42), *83*
Pop art, 39, 57
Porter, Fairfield, 7, 29, 33, 34, 38, 42; portrait of (Fig. 10), *29*
Portrait of Baron W. W. von Schöler, Tepoztlán (Pl. 8), 37–38; *37*
Portrait of Emily Mason (Fig. 19), *59*
Portrait of Fairfield Porter (Fig. 10), *29*
Portrait of Frank O'Hara (Pl. 4), 29–30; *30*
Portrait of Robin Jackson (Pl. 5), 29, 31; *31*
Portrait of the Artist (etching) (Fig. 9), *29*
Portrait of the Artist (oil) (Pl. 6), 33–34, 35; *32*
Post-Impressionism, 29, 34, 94
Poussin, Nicolas, 66
Preston, Stuart, 29
Proust, Marcel, 39
Provincetown, Massachusetts, 18, 20, 21, 29, 31, 33, 39, 42
Purple Edge of the Woods (Pl. 59), 112–16; *113*
Purvis family, 12
"push and pull" theory, 16, 33–34

Raspi, Piero (Fig. 15), *44*
Ratcliff, Carter, 74
Rauschenberg, Robert, 38
realism, 33, 108
recession of forms, 106
Red Barn, The (Pl. 26), 65–66, 108; *64*
Reinhardt, Ad, 49, 59
Rembrandt van Rijn, 29, 100, 103, 106
Renaissance painting, 101, 106
Renoir, Pierre-Auguste, 106, 118
representational painting, 28, 34, 38–39, 99, 108
Resnick, Milton, 38, 49
Rhino (at the Museum of Natural History) (Fig. 3), 14; *14*
Rice-Pereira, Irene, 15
Ridgway, Helen, 21
Ripley, Sylvia, 84–86
Ritchie, Andrew Carduff, 33
River Bend I (Pl. 36), 78, 80, 86, 116; *77*
Rivers, Larry, 15, 20, 21, 29, 33, 38, 39
Rome, 55, 105
Roosevelt, Franklin D., 13
Rosenberg, Harold, 15, 16
Rothko, Mark, 39, 82, 86, 92, 93, 95, 101, 105, 106, 118
Rouault, Georges, 28, 101

Ruisdael, Jacob von, 29, 48, 86
Runner (Pl. 45), 116; *86*
Ryder, Albert Pinkham, 66

St. John's College, Cambridge, 12
Samaras, Lucas, 23
Sander, Ludwig, 15
Sara (Pl. 7), 34, 41, 104; *35*
Sawin, Martica, 73–74
Schapiro, Meyer, 21, 22, 38, 43, 99; *88*
Schiller, Johann Christoph Friedrich von, 10
Schjeldahl, Peter, 73
Schöler, Baron W. W. von, 37–38; portrait of (Pl. 8), 37–38; *37*
Second Annual Exhibition of Painting and Sculpture (Stable Gallery, 1954), 33
"Second Generation" New York School, 38–39, 43
Segal, George, 23
Segantini, Giovanni, 9
Seligmann Gallery, New York, 21; "New Provincetown '47" exhibition (1947), 21
Seurat, Georges, 103
Sfumatura (Pl. 32), 116; *70*
Shapiro, David, 74
Shoshone Indian reservation, 22
Siesta (Matisse), 103
simultaneous contrast, 101
Sioux Indianergruppe Mit Häuptling (Sioux Indian Group with Chief) (Fig. 2), 10, *11*
Slow Diagonal (Pl. 54), *96*
South German Radio, 9
Soutine, Chaïm, 24–25, 26, 28, 29, 34, 94, 101, 102, 103, 106
Soutine's Influence (Pl. 2), 24–25; *26*
space, 16; and color, 108; Hofmann's teaching, 16, 17, 33–34; organization on diagonals, 112; recession effect, 106
Spitzweg, Karl, 9
Spoleto, Italy, 42, 44–45
S.S. *Volendam*, 12
Stable Gallery, New York: *Second Annual Exhibition of Painting and Sculpture*, 33; *Fifth Annual Exhibition of Painting and Sculpture*, 38
stained glass, 122
Stankiewicz, Richard, 23, 26
Staten Island, 14
Steiner, Rudolf, 9
Stuttgart, Germany, 9
Stuttgart Philharmonic Orchestra, 9, 11
"Subject: What, How, or Who?" (essay; E. de Kooning), 33
Suger, Abbot of St.-Denis, 122
Sun-Drenched Barn II (Pl. 71), *129*
Sunset (Pl. 23), 59–60; *61*
Surrealism, 17

Theory of Money, The (book; Budge), 9
Theresienstadt concentration camp, 11
Thoma, Hans, 9
Thoreau, Henry David, 75
Through the Gap (Pl. 29), 67; *68*
Time magazine, 43
Tintoretto (Jacopo Robusti), 112
Titian (Tiziano Vecellio), 101

tonalism, 59
Toulouse-Lautrec, Henri de: *Aristide Bruant*, 30
Towpath, The (Pl. 44), 86; *85*
Trübner, Wilhelm, 9
Turner, Joseph Mallard William, 43, 66, 102, 105
Tuscany, 7, 48
25th Art News Annual, 38
Tworkov, Jack, 100–101

Umbria, 7, 48
Umbrian Hilltown #2 (Pl. 12), 48, 104; *46*
United States, refugee immigration quotas, 11, 12
University of California at Berkeley, 49, 51
University of Chicago, 22, 23
University of Frankfurt, 9
Untitled Landscape (Martha's Vineyard) (Pl. 15), 106; *51*
Uphill (Spring) (Pl. 62), 116; *117*
U.S. Army, 13
"U.S. Painting: Some Recent Directions" (article; Hess), 38

Venice, 7, 42, 43, 48, 77, 104, 105
Venice *Biennale*, 105
Vermeer, Jan, 29, 42, 118
Vermont, *see* West Brattleboro, Vermont, farm; Kahn: art of: Vermont works
Veronese, Paul, 118
View Across the Plain (Pl. 13), 48, 104; *47*
View to Eagle Island, Deer Island, Maine, I, (Pl. 17), 54; *53*
Viterbo, Italy, 55
Vuillard, Édouard, 42, 101

Wade, Professor, 12
Wade family (Cambridge), 12
Walden (book; Thoreau), 75
Wall of Trees, A (Pl. 60), 112–16; *114*
Websters (Kahn's Maine neighbors), 60
West Brattleboro, Vermont, farm, 7, 60–65, 75, 81, 110, 112; barn (Fig. 20), 60–61, 65, 68; *65*
Whetstone Valley (Pl. 69), *127*
Whistler, James Abbott McNeill, 43, 105
White Roof, The (Pl. 38), 79; *79*
Whitman, Robert, 23
Whitney Museum of American Art, New York, 21; annuals, 16; *Young America 1960: 30 Painters Under 36* exhibition (1960), 51
Wilkins, Ethel "Mim," 9
Wilson, Jane, 23, 26
Winsor and Newton firm, 118
Winterhalter, Franz Xaver, 9
Woman I (W. de Kooning), 101
Woodshed, The (Pl. 58), 110–12; *111*
Wordsworth, William, 53

Yellow House, Maine (Pl. 24), 60, 68; *62*
Yellow Meadow by the River, A (Pl. 83), *142*
Yellow Square, The (Pl. 30), 67–69, 116; *6*
Yellow Trees Along a River (Pl. 41), *82*
Young America 1960: 30 Painters Under 36 exhibition (New York, 1960), 51